Folk Art

Robert Young

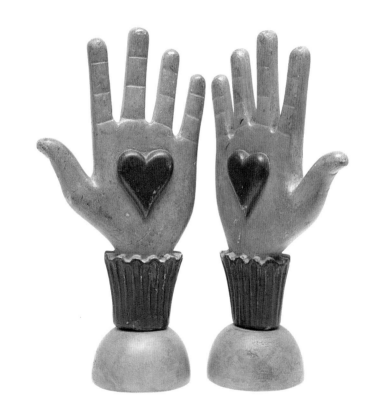

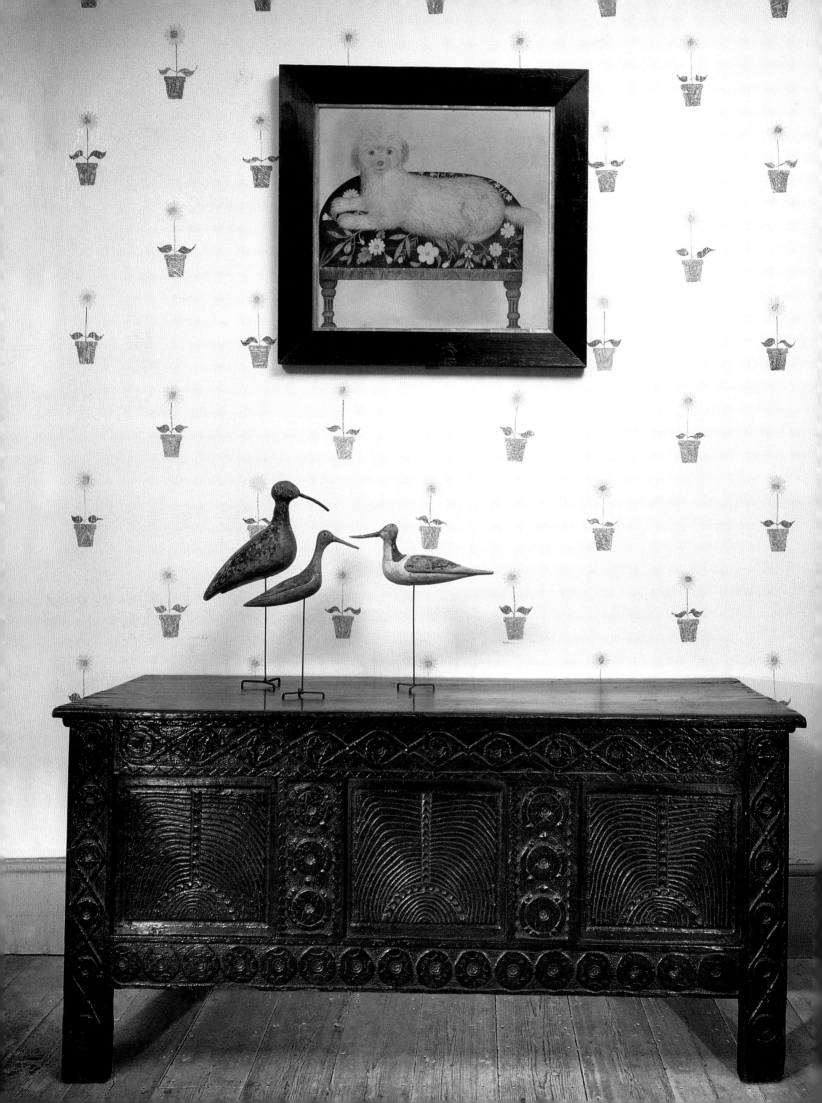

MITCHELL BEAZLEY

Folk Art

Robert Young

For Froglette, Sam and Yan

Folk Art
by **Robert Young**

Contributing Editor **Frankie Leibe**
Specially commissioned photography by **Nicholas Kane**

First published in Great Britain in 1999 by Mitchell Beazley,
an imprint of Octopus Publishing Group Ltd, 2–4 Heron Quays,
London E14 4JP

Executive Editor **Alison Starling**
Executive Art Editor **Vivienne Brar**
Senior Editor **Anthea Snow**
Editor **Kirsty Seymour-Ure**
Page Designer **Kendal Osborn**
Picture Research **Claire Gouldstone**
Production **Karen Farquhar**
Indexer **Hilary Bird**

ISBN 1 84000 136 4

A CIP catalogue record for this book is available from the British Library

Set in Simoncini Garamond
Colour reproduction by HK Scanner Arts Int'l Ltd.
Produced by Toppan Printing Co., (HK) Ltd.
Printed and bound in China

Contents

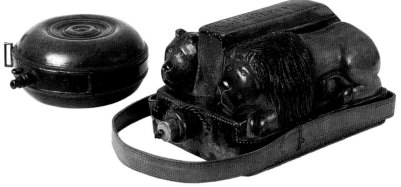

Introduction

This book is about the unselfconscious creativity of academically untrained artists and craftsmen and the simple, functional and decorative objects they made. These objects rarely formed part of an academic tradition or "school", and this book is not an academic study. We do not set out to define or redefine "folk art", nor to duplicate or challenge acknowledged reference books on the specialist disciplines represented. We have, though, carefully and individually selected items in a wide range of materials and media in an attempt to illustrate a common thread, a look and a feel shared by what is in effect the ethnic, tribal and vernacular art of different European communities, and to explore their world of form, line, colour and surface.

It is a visual description: a book about seeing (the vision of the maker) and looking (the eye of the beholder). The vision of the maker (a sculptural form, a quirky design, a bold silhouette, a sensitive line, carved and painted decoration) may reflect the deliberate if unskilled hand of a shepherd, sailor, fisherman or gamekeeper; or it may display the technical confidence of the trained craftsman – blacksmith, woodcarver, signwriter – working with styles, methods and materials handed down through generations. The pieces they made were rarely fashionable or valuable, and, apart from certain personal objects with strong sentimental value such as samplers or love tokens, were not cherished as precious objects. As a result, relatively few have survived.

The "art" and aesthetic qualities of those that have are in the eye of the beholder, and this book is about ways of looking at many different objects in order to discover

BELOW This charming wooden money-box (c.1800), carved and painted in imitation of a bow-fronted Georgian house, has been made with loving attention to detail. It has retained its original paint and now has an attractive untouched surface, and an engagingly worn slot, where generations of children have "posted" their coins.

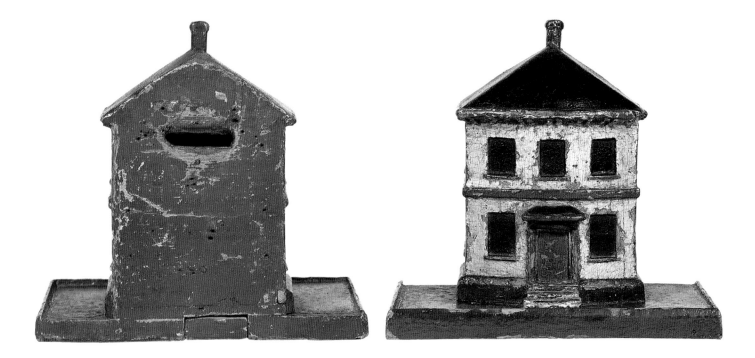

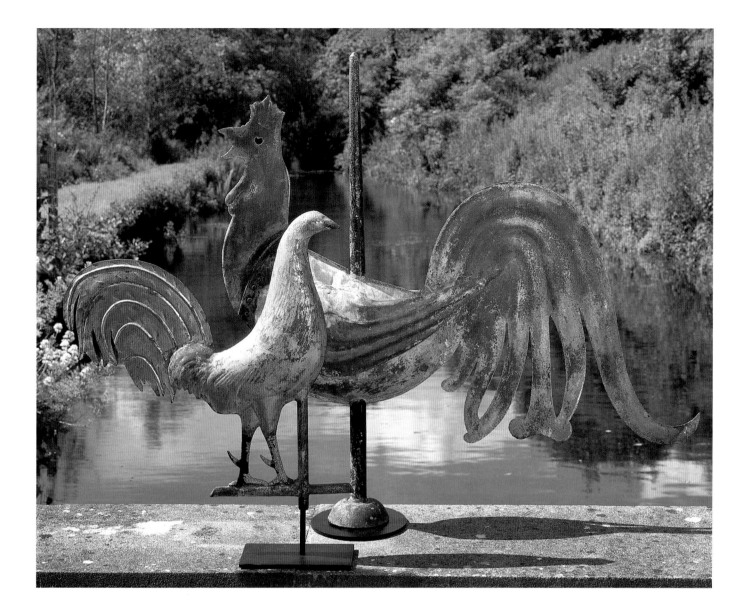

ABOVE *Originally made as working tools to help predict the weather, these weathercocks can now also be enjoyed as sculpture, with their distinctive and individual interpretations of form, and their wonderful worn gilt and verdigris copper surfaces.*

both the qualities that reflect the maker's vision and the qualities lent by time and nature. The passage of time may have given rise to dry, crusty original paint, a richly patinated wooden surface, a collapsed leather form, a copper body weathered and covered in verdigris. Years of wear may have resulted in stretchers worn smooth and thin, an ingenious repair on a willow basket handle, a worn base to a pottery ale jug. There may be aesthetic appeal in the rusting surface of an iron bucket as much as in the glorious blue paint on a wooden chest; in the delightful patch on a home-made soft toy as well as in the colours of old silk thread on a sampler; and in the salt-pitted varnish on a sea-front trade sign as well as in the thick treacle glaze on a storage crock.

These unpretentious objects were not created as art; what art they have is in their forms, their surfaces and their stories. Once commonplace, they are now increasingly rare and increasingly treasured for their essentially visual appeal of line, form, surface and an unselfconscious purity; for their personality, charm and intimacy; and for what they tell us about those who made and used them, and their own often useful lives.

Household objects

The alchemy that transforms an ordinary household object into something special and elevates it to the realm of folk art is a blend of form, decoration and surface. The form may reflect the maker's skill and vision – the sculptural profile of a wrought-iron rushlight – or the passage of time, as in the gentle warping of a wooden dish. Decoration may be a fine design on a box, or a simple coat of paint for a favourite basket. A "special" surface reflects natural ageing or years of useful life: softly fading paint, or the patina on a willow basket-handle carried by work-stained hands.

BELOW *This French oak cutting-board with attached blade was specially designed to accommodate the typical stick-shaped French loaf. The years of service are signalled by the worn, scarred surface, with its wavelike pattern, where the bread was fed through from the left. The owner's initials are carved flanking the date when it was made – 1782.*

OPPOSITE *These largely 18th-century English platters and bowls of sycamore show the variety of colour and texture that time and use have created. The soft honey colour and pronounced grain of the square trencher and the large central circular "common" plate contrast with the wonderful dry, washed, silvery surface and slightly warped form of the large round eating bowl and the rich patinated surfaces of the well-handled smaller bowls and the traditional Welsh cawl spoon. The wrought-iron English candelabra was inspired by a Dutch brass precedent.*

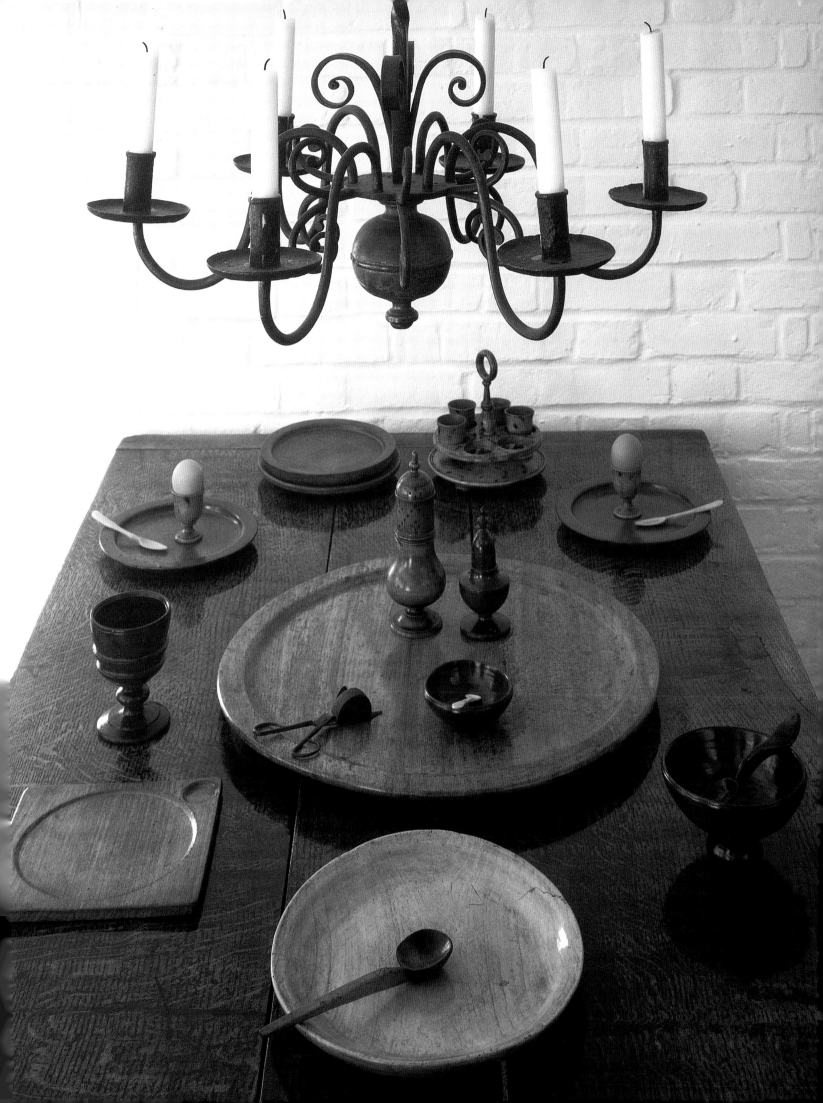

Drinking vessels

The northern European tradition of communal drinking has produced a rich variety of distinctive vessels, from everyday tankards to large, animal-shaped bowls used only on special occasions. In Scandinavia, particularly Norway, home-brewed ale was carried to the table to fill jugs, tankards or goblets, which were made and decorated by itinerant craftsmen in the distinctive styles of the region.

Ale jugs were of pine or birch, either carved from a solid piece of wood or in a more modest stave construction and banded with split birch roots or sapling shoots. The two traditional shapes were straight-sided and the more technically difficult (and sought-after) steamed and bent "pot-belly" shape. Lids and handles often display virtuoso carving; the technically demanding "jelly-mould" lid (below: upper shelf, second left) is a quality feature, here matched and balanced by carving on the handle and spout.

Other vessels include circular ale bowls, twin horse-headed "kasas" or "kjenge", or rarer bird-shaped bowls. Carved or turned from the solid, these prestigious pieces held quantities of ale, on the surface of which floated small individual ale hens used as dippers to fill tankards or as drinking vessels. The spectacular ale hen (opposite, far right) has the stylized painting and scratch-carved detail associated with Telemark and Setesdal in Norway. Its finely carved head and tail, meticulous detail (including initials and dates on the rim) and proportions provide a marked contrast to the ale hen next to

ABOVE *The Gudbrandsdal valley in Norway is known for Rococo-style carving, as on this painted ale jug, carved and turned from solid burr birch. Made as a special commission, it was influenced by precious-metal precedents.*

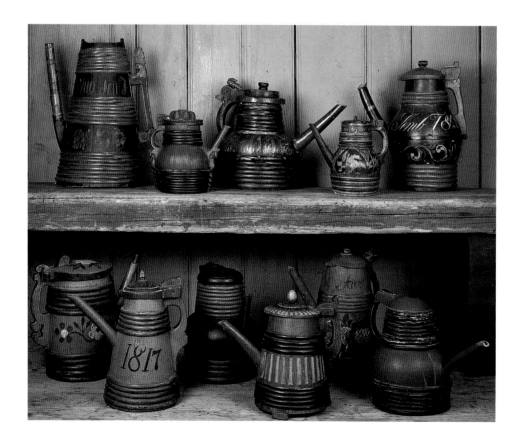

LEFT *Made of pine or birch staves bound with split sapling shoots, these ale jugs show the diversity of shape, size and decoration associated with the regions of Norway. The straight-sided jug (c.1800; top left), some 51cm (20in) tall, is a typical northern valley shape; the smaller pot-bellied jugs (both c.1770; upper shelf, second and fourth from left) show, respectively, the precise, stylized, carved and painted decoration associated with the Telemark and the Setesdal valleys in the south-west.*

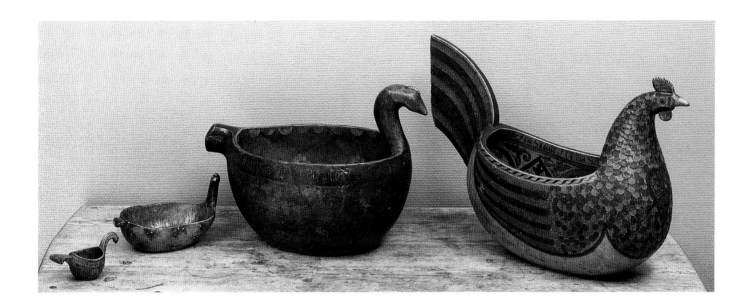

ABOVE *Large ale hens were status symbols. The superb, very rare birch-wood hen on the right (l. 60cm/23in) was carved in Setesdal in 1756 and painted in 1760. The late 18th-century bird dipper (left) is from the same area.*

RIGHT *Wooden Norwegian drinking vessels: (upper shelf) a turned goblet of solid wood is flanked by stave-construction communal tankards (ht 25cm/10in; second half 18th century); (lower shelf) a solid carved-wood peg tankard (ht 19cm/7in), with a row of pegs on the inside to demarcate each drinker's quota of beer, is flanked by a turned and painted goblet and an early prototype mug.*

it. There the appeal is precisely the mismatch of proportions, and its apparent imperfections give it a robust vitality, emphasized by minimal yet vigorous painted decoration, which is also found in the prototype mug form (below, bottom left).

Other carved and turned drinking vessels evolved from the bowl; it developed a foot, and then became a goblet. The primary appeal may be form, or painted decoration, or intricate carving as on the peg tankard (below, centre) with the lion motif on its lid, thumbpiece finial and feet. Such carving became formulaic, and the slight blandness of this tankard contrasts with the vitality of the two large tankards above it.

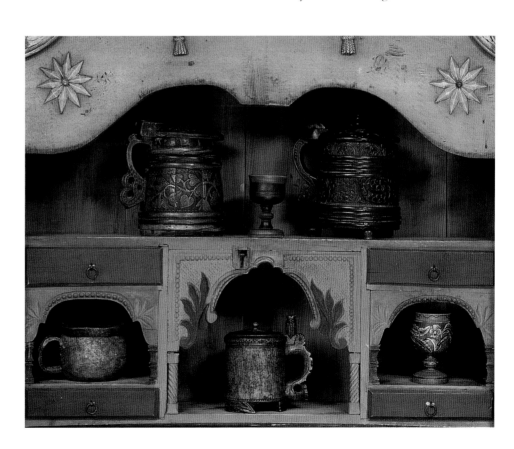

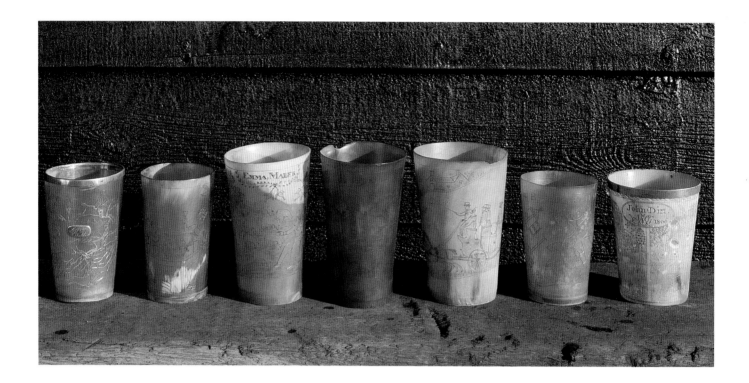

ABOVE *A group of horn beakers made in England c.1775–1845. These show the luminosity of horn, and the soft transparency that highlights the incised decoration.*

BELOW *An English 18th-century leather blackjack, with a shapely decorated handle, a silver rim, and a pleasingly slumped sculptural form.*

They share the staved and banded construction seen in the ale jugs, but can be distinguished from them by their round lips, lack of spouts and the fact that the banding does not continue to the rim, allowing space for the drinker's lip. Most staved tankards have small feet that are continuations of three staves; more interesting examples have separately applied round ball feet.

Condition is important with staved pieces; once the wood has shrunk and loosened all the banding it is difficult to restore. Original paint is imperative on any piece and can be recognized by subtle changes in tone and depth of colour (as on the blue ale jug on page 10), and a softness and textural graininess characteristic of hand-ground and hand-blended paint. It will reflect ageing and damage: woodworm holes should be paint-free; if the wood has shrunk, the paint surface should have split or "popped" as it contracted; above all it will have acquired a patina from years of handling. Good condition, high-quality construction, decoration, initials and dates, original paint and an interesting surface – internal or external – all blend to create the distinctive character of wooden Scandinavian drinking vessels

Small, individual horn beakers, probably derived from the larger communal drinking horn, were made from pieces of cylindrical horn into each of which a separate disc of wood or horn was pushed to form a self-sealing bottom; better-quality beakers had thicker bottoms, pinned into place. These beakers were light, washable and inexpensive. More importantly, from the folk-art collector's point of view, they offered wonderful surfaces for decoration – not simply for the dates and initials found on so many personal effects but also for pictorial genre scenes. Depictions of national costume, boats, houses, churches and hayricks range from the highly detailed and

precise to the well-intentioned efforts of amateurs; both are equally interesting. Some were probably decorated at source, as there are recognizable schools of regional decoration based on local interests such as hunting and nautical scenes. The incised decoration was either made with a hot needle or scratch carved and is sometimes filled with a coloured wax. Other beakers have applied silver rims, or applied silver shields or medallions engraved with initials or dates. The translucent quality of the horn and the appeal of the decoration – be it sophisticated or naive – are what distinguish the most interesting pieces; plain, undecorated beakers rarely appeal to collectors.

Unique to Ireland is the mether: a large four-handled drinking vessel whittled from a single piece of wood, with a round bottom and square top. More readily found, though still rare, is its cousin the lamhog, whose place in Irish hospitality may be confirmed by the Gaelic inscription *Cead mile failte* ("A hundred thousand welcomes"). A lamhog's surface tells its history: it may be richly patinated from years of contact with greasy fingers, or the willow may have faded and developed a fine, dry, driftwood-like surface, perhaps with tiny cracks. Both surfaces are of equal integrity and interest.

ABOVE *An Irish lamhog (c.1700; ht 21cm/8in;) turned from a single piece of willow. It has an integral lug handle, and a distinctive conical, slightly top-heavy shape.*

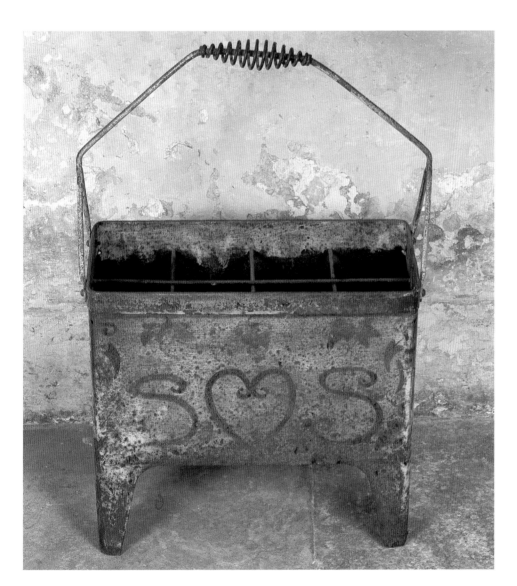

LEFT *Most French wire bottle carriers had open-sided designs, unlike the solid sides of this late 19th-century example. This unusual feature has been embellished by the owner with painted decoration that includes a heart flanked by initials. With the addition of the somewhat jarring line of the spiral-turned handle, a quirky combination of disparate elements is created, as in so many pieces of folk art.*

Storage and preparation

In northern Europe simple round or oval bentwood storage boxes, usually of pine (sometimes ash in Britain), were made in various sizes, often painted in single colours (unpainted examples are rarely of interest to collectors). Good condition and quality are vital. An indication of the latter is the type of joint used on the overlap; a woven finger joint is more interesting than a simple lap or pinned one. Early boxes (mid-18th century to 1800) usually have more character and surface interest, subtler colours and better-quality construction, as in the use of square pegs to pin the bottom and lid.

In Scandinavia, dry-storage boxes were made from strips of conifer by itinerant craftsmen, who painted and carved the large flat surfaces. Size and shape were dictated by function. Tall, coopered, staved and bound pudding or "porridge" boxes stored grain or flour and had locking handles. Shallow oval boxes were placed on the table for bread; "tine" boxes with small loop handles were used to store oddments; pocket-sized bookboxes for snuff and tobacco had secret opening mechanisms.

OPPOSITE *The austere simplicity of these bentwood pine storage boxes (c.1750–1900) is relieved by the variety of curves and proportions, subtle colours and patinated surfaces.*

BELOW *Norwegian dry-storage boxes: (bottom right) a staved and bound pudding box (1835; ht 76cm/30in); (left) a shallow bread box (mid-19th century) with floral decoration.*

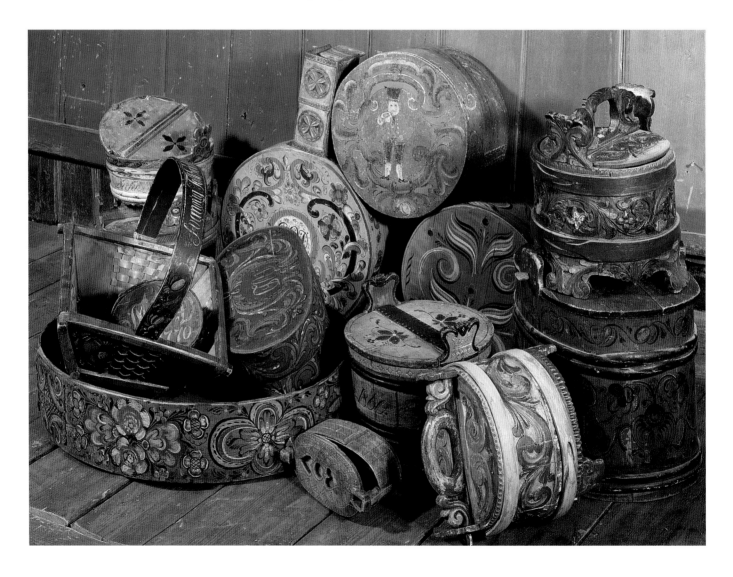

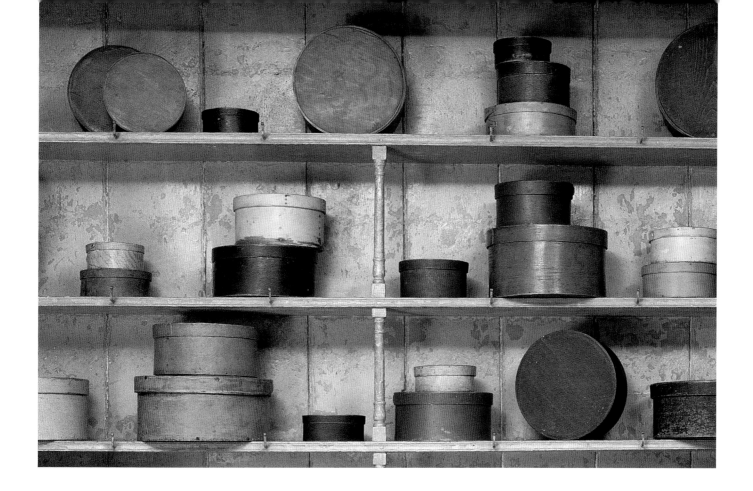

The decorative styles reflect the traditions of different Norwegian valleys. Boxes from Hallingdal are associated with polychrome floral painting in the *rosemaling* tradition; Gudbrandsdal boxes combine bold scrolling decoration with elaborate carved handles and carved and painted decoration on the sides. Initials (usually ending in D or S, for daughter or son) and dates are common to all valleys and always add to interest, as do beautifully aged painted surfaces with mellow, faded colours.

Other Norwegian boxes (below) are even more special, combining all the hallmarks of quality – woven overlaps, well-fitting lids, carved handles with functioning locks – with an originality of design that imbues each box with the personality of the maker. Here, for example, the locking devices have been transformed into the head and tail of a sprightly chicken – a rare and sought-after device – or an equally rare soldier's head, which has been amusingly elongated, with a foreshortened nose to avoid its being knocked when the lid is removed. The elegant black box has a wonderful, almost leather-like surface, with a woven overlap enhanced with heart motifs. The figure on the right may have been designed to cut sugar, spice or tobacco: his left hand acts as a chopper on a block. The originality of the boxes is matched by that of the rare wall-hanging spice shelves from Trondelag; stylized rope-carved supports, faded blue paint and worn lettering combine with the inspired use of carved soldiers'

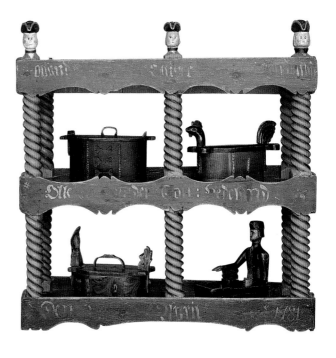

heads as finials to illustrate the blend of originality of design, superb construction and beautifully aged original surface that is found in the best Norwegian folk art.

Bread was the staple food in most communities, and the breadboards on which it was cut evolved from simple pieces of wood, many of which have wonderful surfaces somewhat battered and worn from years of contact with a sharp blade. The simplest type of decoration, applied either purely for pleasure or to distinguish between different usages, was a decorative shape, especially animal forms.

The distinctive shape of the French baguette and other stick-shaped loaves gave rise to a particular type of cutting board with an integral blade (see p.8). When not in use the board could be hung on the wall, and it was perhaps this method of storage that encouraged the use of decorative outlines. The charm of much French folk art is the slightly ostentatious, self-important quality of the decoration, which can be far grander than the occasion demands. The board on page 8 shows a mixture of decorative techniques that are not quite compatible, and have not been particularly skilfully applied, but which give a highly individual and quirky appeal to a fine oak surface with a character that has developed over years of cutting and owes nothing to extraneous decoration.

Nuts were the portable snacks of their day, and many people owned and carried with them either base-metal or carved-wood nutcrackers, often dated or initialled. There were two main types: screw action, in which the nut was crushed by screwing down onto it, and lever action, usually found on earlier examples, in which the nut was crushed between two jaws; a third variation was a double lever action, where smaller nuts were crushed between two jaws and larger nuts were crushed between the handle and a small indentation on the back of the nutcracker. Although wooden

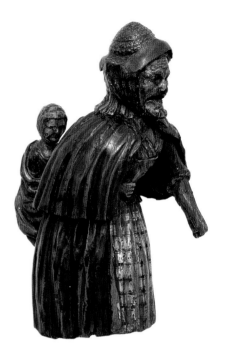

ABOVE *In this mid-18th-century hardwood Tyrolean nutcracker (ht 21.5cm/8in) the nut is crushed between the jaws of the crone, which open when the baby is lifted up.*

LEFT *Animal shapes were popular for breadboards, although it is possible that this late 19th-century English pine board (l. 37cm/14in) may have been carved into a pig shape because it was used for cutting bacon or pork.*

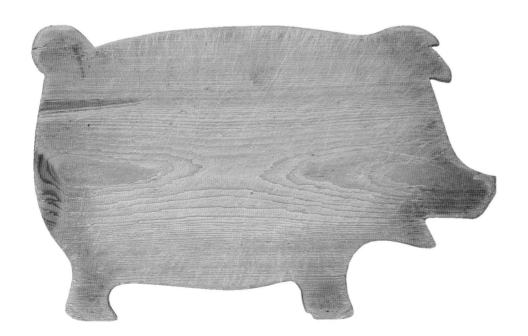

examples were almost invariably made of a hardwood (usually boxwood or yew in Britain), and often carved in the form of stylized people, the nature of the decoration helps identify the country of origin. English nutcrackers tend to be more compact and sombre than the more exuberant continental designs, with flatter, shallower carving. Surface interest – original paint in particular – and the quality and character of the design distinguish exceptional examples. The lever-action Tyrolean nutcracker shown opposite has both. The design encapsulates the darker side of northern European folk art, with an accent on the grotesque and strange, further emphasized by heavy, detailed carving and thickly painted detail on both the crone's apron and the baby. Whom the old woman represents and why she is carrying the baby are unanswered questions, as is the riddle of what the missing element from her right arm might be.

Metal bottle carriers are a predominantly French phenomenon, used to transport several bottles of wine at a time: either from the *cave* (cellar) to the table, or from home to market. An average-size domestic bottle carrier took six bottles; others were made to accommodate jars used for jams and other bottled preserves. More pleasing to the eye are the earlier examples (early 19th century), which were made of flat section hammered metal rather than the commercially produced round section used from *c*.1880, as seen on the handle of the bottle carrier shown on page 13. However, there the solid flat sides compensate by providing an interesting rusty, flaking surface, with the additional appeal of painted decoration, which gives the carrier a history, a character, and a quirky originality. The essence particular to French folk art is reflected also in the papier-mâché storage box (below) in the form of a fish. Traditionally, these handmade "fish" were used for storing confectionery, an unlikely combination that may have something to do with the French expression *poisson d'Avril* (April Fool).

BELOW *This French papier-mâché fish (c.1880; l. 25cm/10in), a confectionery box, has a wonderful dry surface whose painted detail has worn sufficiently to reveal the gesso ground. The unseen side has a plain painted surface, with no moulded decoration, and an oval section that lifts up to allow the confectionery to be placed inside.*

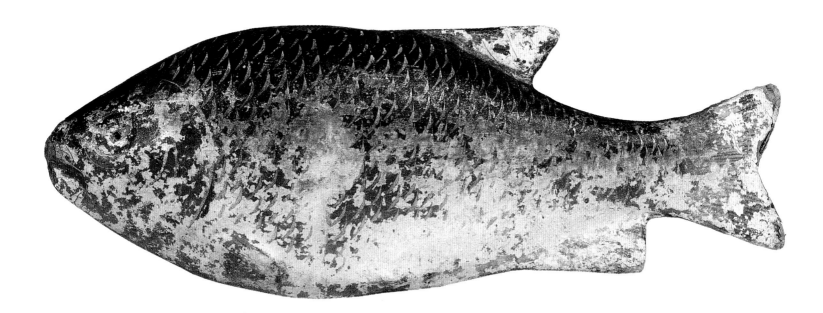

Baskets

Baskets played a vital part in rural life – for gathering food, for storage and for carrying goods. Although produced in quantity, they have a short working life; most found today date from the mid-19th century onwards.

In northern Europe most baskets were made of willow – pliable and quick to grow. Willow rods were used as unstripped twigs to make "green" baskets or stripped of bark to make "white" baskets. "Brown" baskets were made from unstripped twigs boiled in water; this strengthened them and added colour, as the tannin in the bark dyed the rods a golden buff colour before falling off into the water.

Function dictated form. "Splint" baskets for soft fruit were small, usually round and deep, closely woven from split willow so that the soft cut face of the willow made a smooth, soft interior. By contrast, the shallow open baskets for root vegetables were often of ribbed structure, for added strength, and the sharp cut ends of the willow could be used on the inside without damaging the tough skins. Closely woven baskets were used for storing fine grains, as were baskets made from coiled woven rush fibres, which gave a dense, smooth and virtually impenetrable surface. Rush-fibre baskets

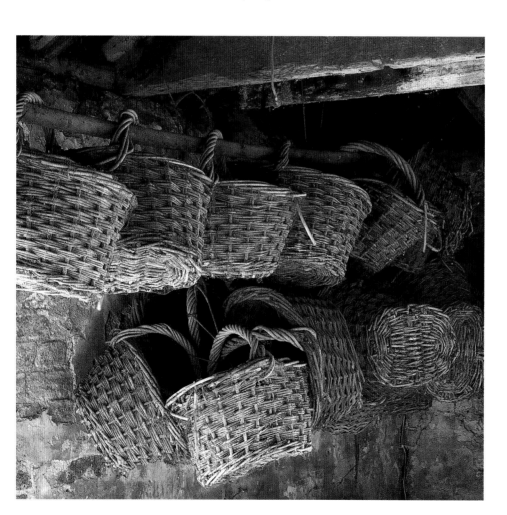

ABOVE *This double eel trap (c.1930; l. 81cm/32in) has the looser shape and weave of French traps and is made of unstripped willow. English traps were usually made of brown or white stripped rods.*

LEFT *These commercial-scale potato baskets (c.1930) are from the fenlands of England. They were found as shown and are at their best in their natural location, in quantity. One displayed individually in a domestic environment would show its flaws all too clearly.*

OPPOSITE *Clockwise from top: English domestic orchard basket (c.1900), with white-painted surface; French heavy woven rush basket; English oval basket with old painted surface (late 19th century); French "splint" willow basket (c.1890); French fisherman's creel (c.1920).*

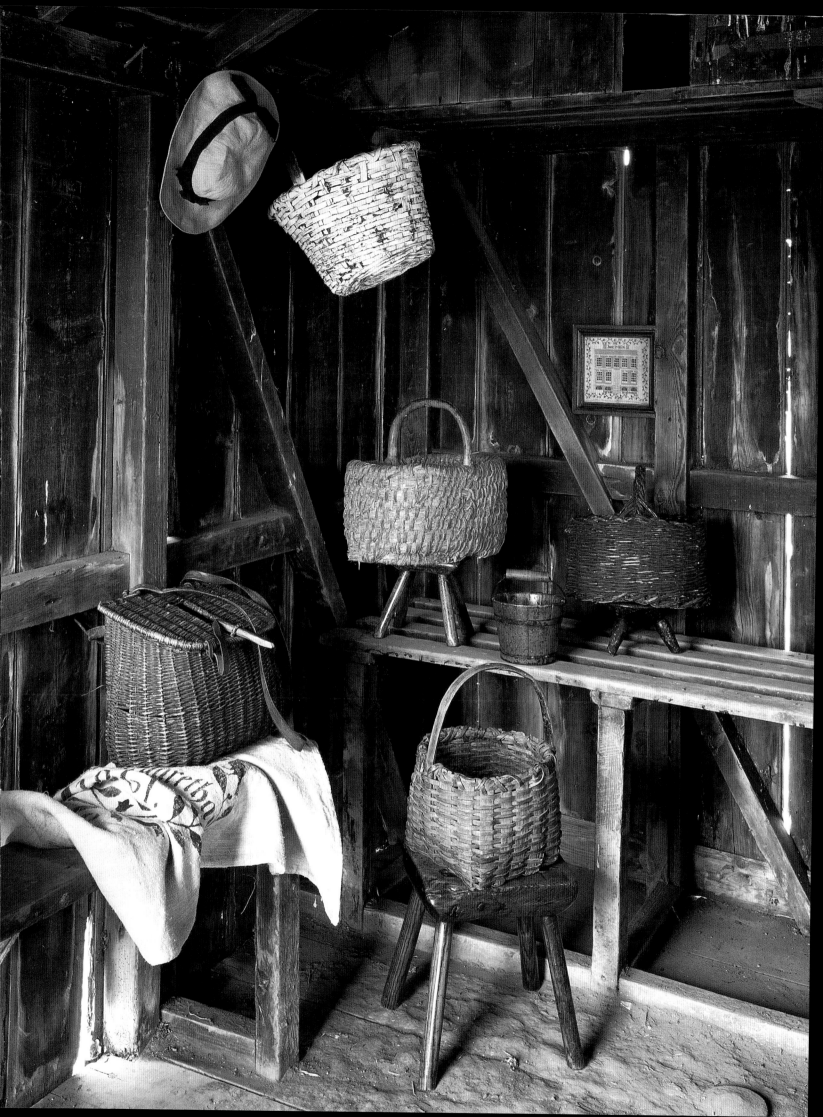

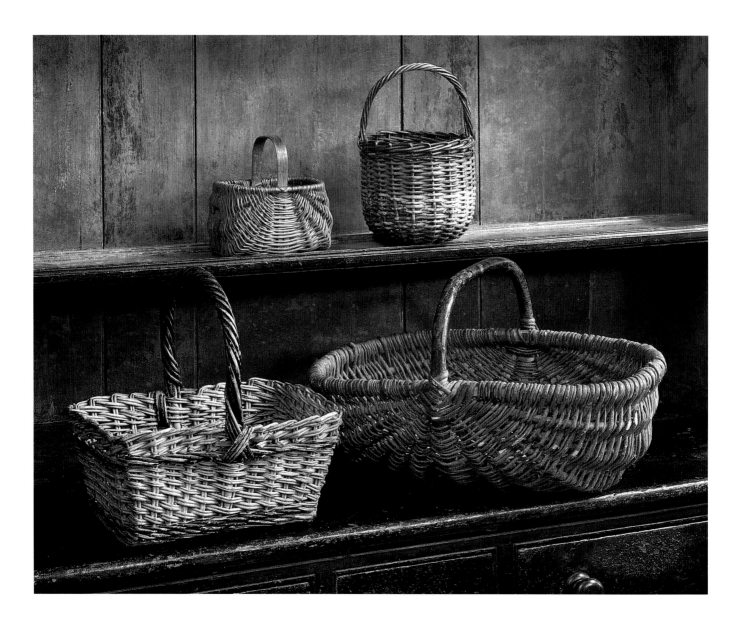

ABOVE *The forms of these early 20th-century baskets fit their function. The fine French basket (upper left; ht 20cm/8in without handle) was probably for quails' eggs; the painted basket next to it was for collecting berries; the ribbed French frame basket (lower right) was strong enough to carry root vegetables; its neighbour is a classic English domestic frame basket.*

were heavy, so were used for collecting eggs or garden produce. Fish baskets came in many shapes and sizes, but all were of open weave so that their contents could be splashed and kept fresh. The fisherman's creel, used to store and carry the catch, was a pouch-shaped, finely woven willow basket usually with leather trimmings.

Heavy-duty working baskets, such as potato baskets and eel traps, were made by hand, rapidly and in quantity. They may look wonderful in context, but they remain essentially anonymous and rarely survive scrutiny as individual pieces of folk art; rims and handles tend to be poorly finished and attached, and idiosyncracies of shape and colour are more likely to be the result of poor quality and neglect than the character derived from a hard and useful life, loving handling, and repairs or decoration.

Other working baskets were given identities, and thus histories and spirits that transform them into folk art; some have painted farmers' initials, or stencilled details of contents, or allotment numbers or owners' names. Many domestic working baskets became family favourites. Those used for eggs or dairy produce were often given coats

of white paint that made them easy to identify, protected them and allowed them to be washed. Years of daily sluicing may have mellowed the white to a soft cream, or even removed areas of paint, allowing the wood to show through. General-purpose baskets were also often painted. Over the years these painted surfaces will have become intrinsic parts of the characters of the baskets. Unpainted baskets have an appeal based on the colour and ageing of the woods themselves as they have been exposed to light, heat and weather. A well-used handle will have a patina and surface that reflect years of contact with workstained hands; it may have an interesting repair (a replacement handle detracts from appeal). The interior may have acquired a surface built up of the residue of a myriad annual harvests of fruit, or been given a lining.

Poor condition does not constitute character. A good basket should be intact and relatively solid, with good close weaving even if the design is open; the handle should be original, well woven and securely attached. Sculptural form and shape are an integral part of appeal, although "settling" and gentle warping add to interest if the basket has retained its solidity – a densely woven rush basket that has sat on a stone floor may have gently "settled". An interesting domestic working basket, whether used for fruit and vegetables, grain, eggs, dairy produce, laundry or logs, will, over the years, have accumulated evidence of use that has become an integral part of its character.

Such everyday working baskets offer a marked contrast to the small, neat, densely woven Norwegian storage baskets, made from the roots of birch trees and ranging from tiny pieces for jewellery to large baskets for hats. Decoration varied according to region. Some baskets were associated with presents: the lady of the house would visit friends and proffer her gift in a beautifully made loop-handled basket with open-weave sides, allowing her to display not only her generosity but also her superb basket.

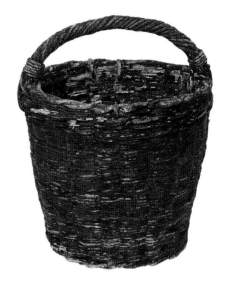

ABOVE *French well baskets were usually made in pairs to be carried on yokes. Tightly woven and sealed with tar, they were strong but light so they could be moved when full of water. This example (ht 50cm/20in) was made in northern France c.1890.*

LEFT *In Norway, superb lidded baskets of birch root were used to store precious items associated with traditional costume. Decorations varied; the woven geometric motifs seen here were used in the Setesdal and Telemark valleys. The tiny loop-handled basket, made for a child, was based on larger models used by adults to deliver presents to neighbours and friends.*

Lighting

Before the development in the 19th century of first gas and then electric light, oil lamps, candles, splints and rushlights were the major types of lighting that made social and working life after daylight hours possible. Income and locality determined the choice. Working families used what natural resources were at hand: people in coastal areas used fish oil or whale oil for lamps; vegetable oil was available in Mediterranean countries; and the cheapest oil of all was the residue of fat used for cooking. From the beginning of the 17th century a type of oil lamp known in Scotland as a "cruisie" and in the USA as a "betty" lamp was common. Produced in huge quantities, generally in iron, these lamps consisted of two leaf-shaped containers or pans mounted one above the other. The top pan, which could be tilted to give a steady supply, contained oil on which floated a cotton wick that projected from a spout, while the larger "leaf" below caught any excess oil or ash from the top pan. These lamps were found in most homes

BELOW, LEFT TO RIGHT *French wrought-iron* rat de cave *with wood base and hanging handle (c.1830); English turned-wood candlestick (c.1840); English wrought-iron tripod rushnip with candleholder counter-balance (late 18th century); English tin "hogscraper" candlestick with wedding band (c.1840); in foreground, tin candle snuffers.*

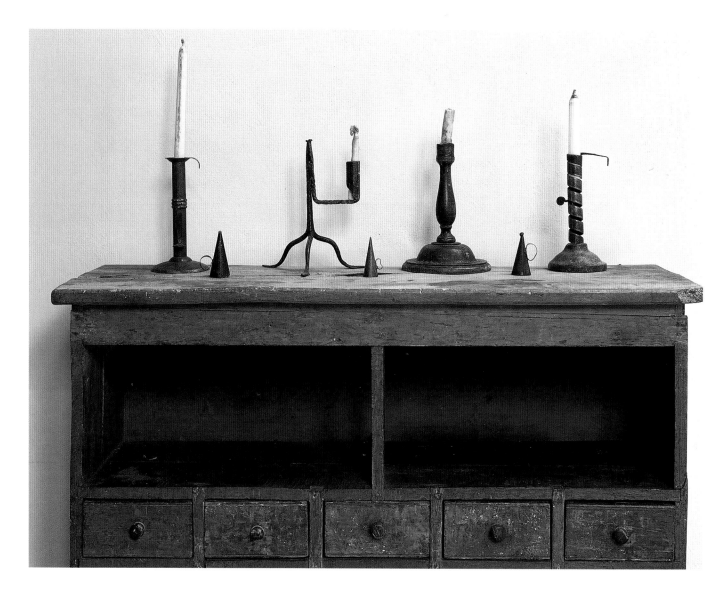

LEFT *These rare 18th-century hand-whittled rushlight nips are British. The square-based oak light (ht 15cm/6in) uses a wooden spring mechanism; on the blue-painted light the arm acts as a counterbalance.*

BELOW *These English 18th-century floor-standing rushlight nips have devices for adjusting the height of the light: a spring-loaded mechanism (left; ht 130cm/51in), a ratchet (right).*

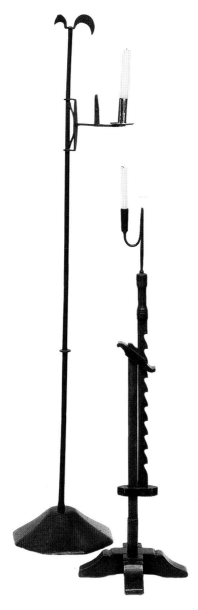

and have survived in quantity, but rarely have the sculptural forms or interesting surfaces or decorations that make them appeal to collectors.

Candles, expensive but longer lasting, were used alongside other forms of lighting, but the candle tax introduced in Britain in 1709 made working families more dependent on home-made alternatives. In wetland areas, bulrushes were soaked and stripped to leave central lengths of pith 60–90cm (24–36in) long, each with a supporting strand of stem at the side. These improvised wicks were drawn through an iron grisset pan filled with liquefied residue cooking fat. Once "dunked", the rushes were stored for the winter evenings. They burnt with a fierce bright light for about 30 minutes, often producing a sooty atmosphere. The holders used to support them were called "rushlight nips" after the jaws that held the rushes, keeping them in place using counterweights in the forms of balls or hexagons, or candle sockets that also allowed them to be used as candlesticks. Most rushlight nips were made to stand on tables; floor-standing examples tended to be more refined and expensive. Bulrushes burn best when held almost vertical; the resin-rich splints of conifer used in Scotland and areas with plentiful conifer burnt best at an angle of 30 degrees and were wedged into the fixed jaws of metal holders known in Scotland as "puirmen" – presumably a reference to the fact that such devices were used by people too "puir" (poor) to buy candles.

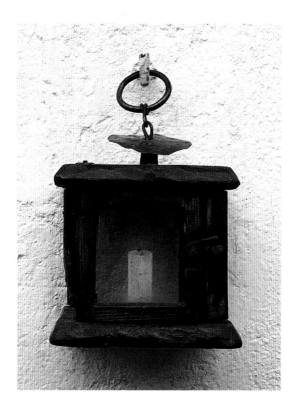

LEFT *The appeal of this rural French lantern (c.1800; ht 18cm/7in) lies in its pleasing proportions and the well-worn surfaces of the leather catch, the tinware collar to keep the handle cool and, above all, the roughly hewn chunky wooden frame.*

BELOW *The purity of form and the decoration of this wrought-iron, hand-painted candelabra (c.1760), probably created for a special occasion, are typical of fine Norwegian folk art.*

There were many ingenious variations on the rushlight holder. Some were attached to fixed rods and could be hooked to a ceiling rail; others had long spikes that were inserted into holes in a beam or wall; still others had ratchet devices for adjusting the level of the light. Stability was a major safety consideration: a metal tripod base remained stable on a warped table surface or uneven floors; wooden bases needed a wide surface area or a more sophisticated cruciform base (see p.23).

An original turned wooden base has the characteristic irregular marks of a pole-lathe, unlike the regular even turning of the mechanical lathe which was often employed on replacement or "faked" bases. Another guarantee of authenticity and finer construction is when the spiked end of the metal holder has been pushed down through the wooden base and then folded over. The surface of an original wooden base may have a rich patination – a combination of burn scars and hot wax dripping onto a dusty, greasy surface; bruises from knocks or falls; natural shrinkage; and interesting wear from contact with a rusty iron stem.

Rushlights were probably made in medieval times, and in Ireland were still produced in the late 19th century. No two are the same; each has a unique sculptural profile made up of stem and base. The ironwork was hand-wrought by blacksmiths – skilled metalworkers, prior to soldering, pinned and riveted their pieces, embellishing each with twists, curves and stylized finials, or producing an austere profile of minimalist simplicity. Wooden bases were produced by different makers, and it is uncertain where the metal and wood

were assembled. Some exceptionally fine lights reflect the skilled precision of gunsmiths and may have desirable inlaid initials in brass and/or fine etched detailing.

There are distinct national differences. English lights are generally of good quality; their wooden bases are found in fruit wood, oak, ash or elm, with fuller forms and finer turning than their French counterparts, which are usually of walnut, beech, poplar or chestnut and vary greatly in quality. English table lights tend to be smaller (20–30cm/8–12in high) than French examples (41–61cm/16–24in); floorstanding rushlights are rare in France, and are generally rather awkward, with rough, rustic ironwork. Irish lights have characteristic open bell-shaped feet to support what may be slightly fat and clumsy forms; German, Austrian and Swiss lights are often loosely classified as "Alpine" ironwork, and are typically, if somewhat clumsily, decorated with a profusion of curlicues, spirals and chiselled or gouged decoration.

Candles and candlesticks were made in a range of styles and quality. There were two basic types: the pricket candlestick, known from the Middle Ages, in which the candle was stuck onto a spike or "pricket", and the later socket candlestick. At the top end of the market were beeswax candles and the sophisticated precious-metal,

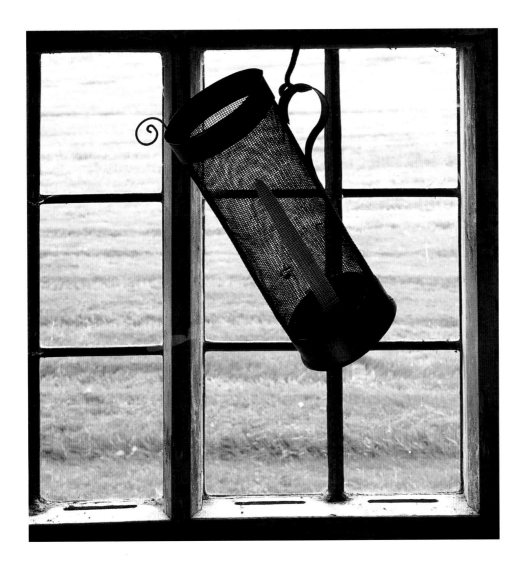

LEFT *The combination of tinware and gauze used to make meatsafes has been adopted in this English stable light (c.1840). The gauze acted as a windbreak and a safety factor when the candle was being carried. The scrolling ram's-horn is attached to a pan with a fixed candle socket and can be used to lift it up for replacing or lighting the candle.*

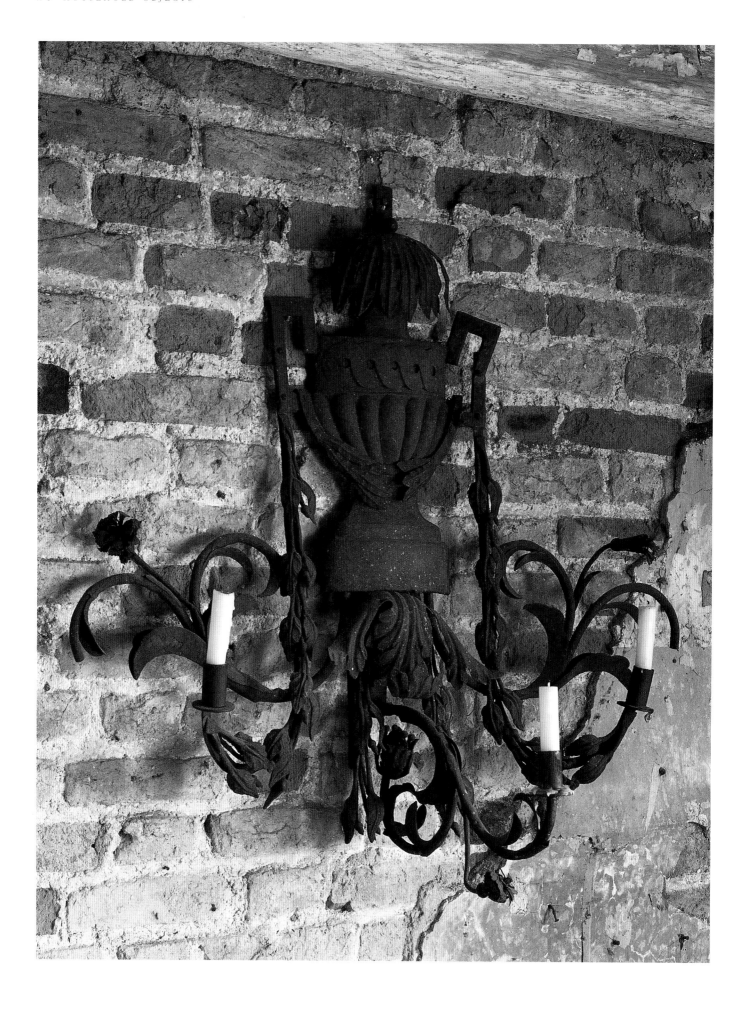

bronze or ormolu candlesticks produced by master craftsmen and reflecting the design style of the day. Working people generally used tallow (rendered animal fat) candles and a variety of base-metal holders adapted for a working life that continued after the sun had set. Many candleholders had spiral devices that allowed the precious candles to be wound higher as they burned down. These spiral candleholders were rarer in England and were generally not produced after the early 19th century; they were more common in France, where they were known as *rats de cave* (a reference to the "tails" that allowed the holders to be hung on wine racks while the *patron* inspected his cellar, or *cave*) and made until the last quarter of the 19th century. Another ingenious device, seen on the candleholder on page 25, was a "ram's-horn" handle that was attached to a pan with a fixed socket so that it could be lifted out to replace or light the candle. The "hogscraper" candlestick was supposedly used first to scorch the hairs on a pig's carcass and then, upended, to scrape the skin with the sharp metal edge of the wide base. A better-quality example would have a brass "wedding band" – a binding device to secure the sheet iron and act as a seat for the candle ejector handle, which may have been stamped with initials or a name.

Journeys after dark were lit by lanterns. Early lanterns were generally made of metal, which was non-combustible and could be pierced to let the light shine through. Metal and wood frames were also used with panels of cow-horn, which were often subsequently replaced with glass, as cow-horn ages badly and may blister and become opaque when heated. Wooden lanterns became more common after the development of cheap sheet glass following the Industrial Revolution in Britain. The lantern on page 24 has the thick wooden frame typical of rural French lanterns (English frames tend to be finer) and has great appeal, due in large part to its chunky proportions

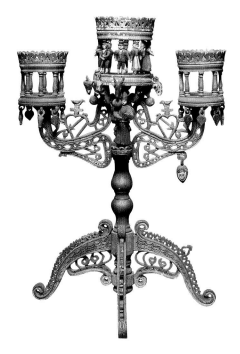

ABOVE *Made in the second half of the 19th century, this Scandinavian candelabra (ht 61cm/24in) with its extravagant carved and original polychrome decoration combines traces of Viking influence with the whimsical informality of tiny figures.*

LEFT *These 18th-century candlesticks exemplify two strands in Norwegian folk art. The birch polychrome candlesticks (ht 36cm/14in) follow northern European metal precedents; the lion piece, conceived and created in wood, is free from external influence.*

OPPOSITE *This grandiose wrought-iron sconce (w. 152cm/60in) is a bravura display of French folk art.*

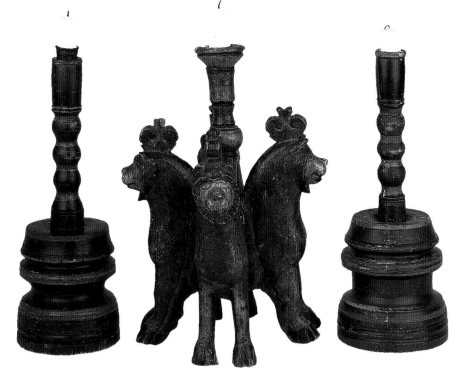

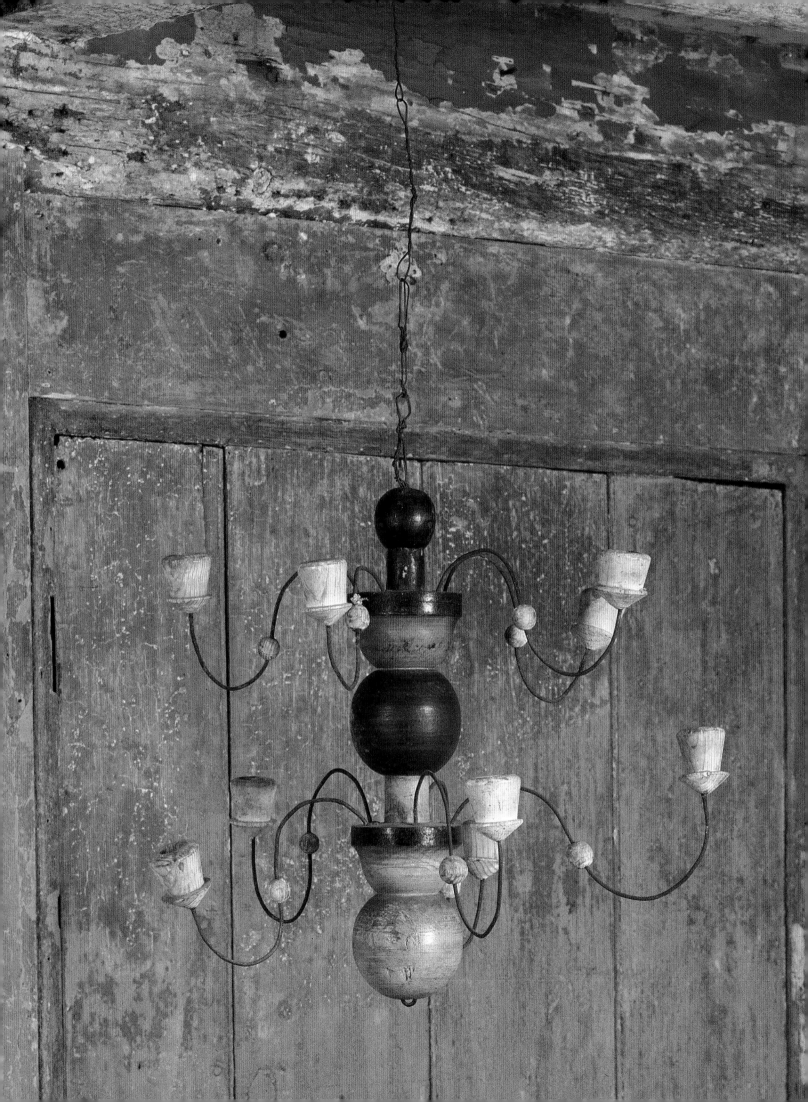

accentuated by the scorched frame and the wide uneven base with robust gouge marks. It is easy to imagine such a compact, square lantern being put together from scrap material and carried by someone built on the same compact, chunky scale.

Wooden candlesticks were whittled, turned and carved in various sizes and types of timber. They were often based on base- or precious-metal precedents or established shapes, but by the 19th century they had become increasingly formulaic and therefore less interesting. Additional surface interest – staining, original paint, repair, decoration or patination – will add character, but restoration of scorched or burnt sockets will not.

In Norway, able craftsmen, who might in less isolated communities have become part of the mainstream, continued to work as artisans until the late 19th century. Each valley community had its traditions, and many pieces of folk art of outstanding purity of form and decoration were produced. An example is the wrought-iron candelabra on page 24. The paint has retained its brilliance but has the added interest of areas of rust, chipping and fading. Pure, sculptural form, original paintwork and surface integrity are combined. The rare wooden candlestick on page 27 is equally free from external influence. Traditional symbols of loyalty, these crowned lions with their somewhat heavy form were probably an important commission. Their proportions and grandeur cry out for large-scale marble or cast metal, but they have been designed, carved and painted by one person, whose free response to a traditional motif has created a notable piece of folk art.

Just as such Norwegian pieces illustrate the purity of much Scandinavian folk art, so the handsome wall sconce on page 26 captures the spirit of much French folk art. This extraordinary device was probably made by a highly skilled artisan, who has combined a Neoclassical urn and formal, guilloche decoration with extravagant Rococo curves to create in wrought and beaten iron a grandiose piece that would have been far more "appropriate" in ormolu or gilded wood and in a grand house. Possibly a commission, or perhaps simply a display of virtuoso artisanship, it displays a self-confidence and bravura that transcend the uneasy marriage of styles and material.

The same confidence is evident in the candlestick (right), an eclectic mix of materials, with wood-block base and spine embellished with a tin oval-profile cruciform section, flowers and a socket with open panels tacked to the stem. Although crudely constructed, this improvised candlestick has the spirit and gaiety of a true piece of folk art made by someone who just added what took his fancy as he went along.

The spirit of improvisation also shines through in the Scandinavian candelabra shown opposite, with its bold, bright wooden form combined with spidery wire arms and gessoed beads and sconces, and in the extravagant carved wooden form and lavish decoration of the candelabra on page 27. They represent the opposite end of the spectrum from the pure sculptural form of other Scandinavian lighting, but have an individuality, charm and spirit that make them equally appealing.

OPPOSITE *Although the central turned-wood stem of this mid-19th-century Scandinavian candelabra (ht 46cm/18in) still has its original paint, the gessoed sconces and bead decoration may originally have been silvered. The light can be raised or lowered by adjusting the woven-wire linked chain.*

BELOW *The painted decoration on this late 19th-century candlestick (ht 46cm/18in) suggests that it was made in southern Europe. It may have been intended to illuminate a domestic icon.*

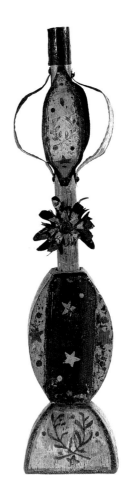

Sculpture

The tilt of a decoy bird's head, the bold silhouette of a weathervane, the scratched decoration on a small love token are all evidence of the creative response which the three-dimensional form can evoke in both the skilled and the untrained maker. And the fusion of creative qualities with an organic ageing process – dry, crusty original paint, faded verdigris on weathered copper, or a wooden surface glowing with a rich patina – can produce unique objects that embody the elusive essence of folk art.

BELOW *The combination of a fish and a cross motif suggests that this mid-19th-century English weathervane (l. 122cm/48in) was intended for a fishermen's chapel. The cast-iron stem supports a sheet-iron body, with a double layer at the front and a bolted lead eye to exaggerate the "printing" (pointing) end.*

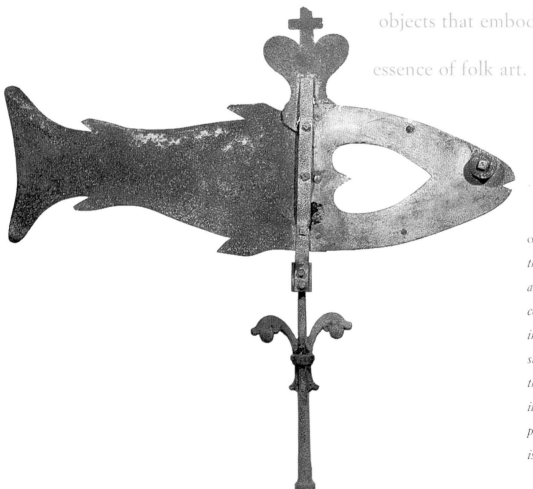

OPPOSITE *Ships' figureheads in the form of ordinary seamen are rare. This sailor (mid-19th century; 122cm/48in), found in Devon, England, carries the ship's name – Undaunted – on the hatband. Carved in wood, it retains much of its original paint and displays a character-istic vitality of execution.*

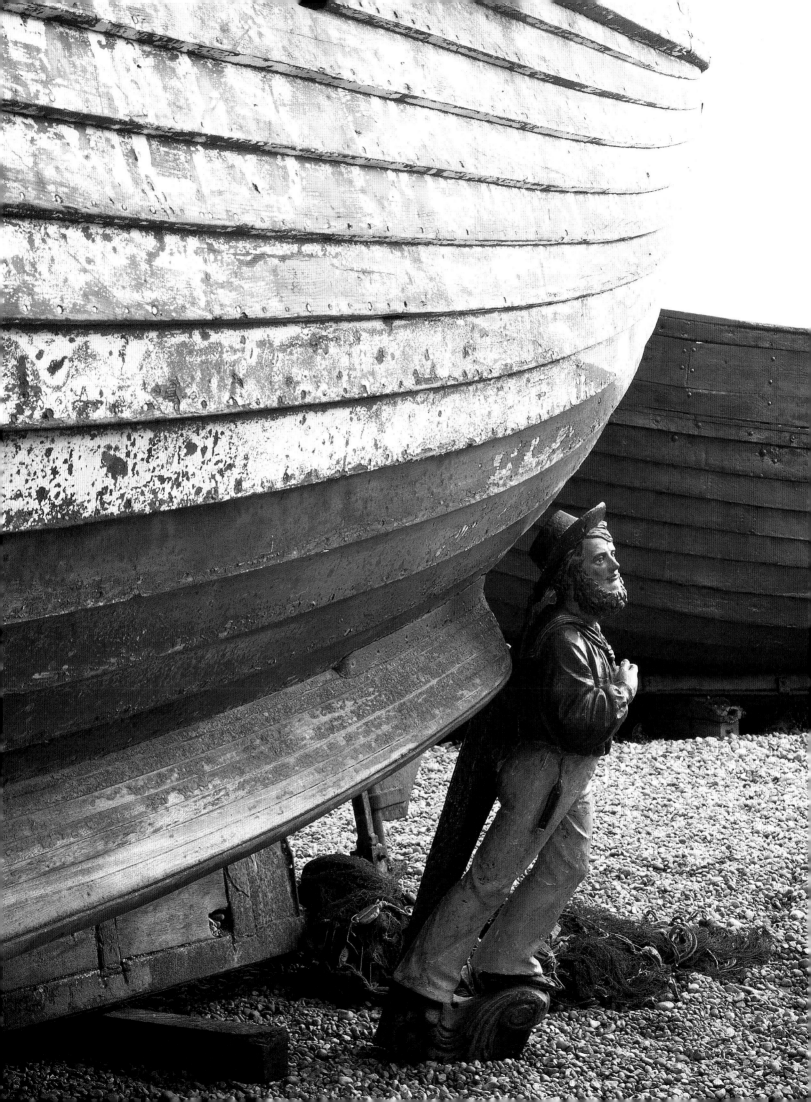

Love tokens

The tradition of love tokens – objects made and given as symbols of esteem – was particularly strong in rural communities. A young man, who perhaps found it difficult to put his feelings into words, would either make, or commission a craftsman to make, or buy, a love token that would express his sentiments for him and would present it to the young woman of his fancy as a prelude to courtship. Love tokens were usually intimate presents associated with daily activities, useful household objects particularly associated with women's work, and were decorated with initials, names, dates and, above all, motifs such as hearts, birds, keys, chains, knots, bands, ribbons, rings, joined hands and the "tear" or "soul" one, which were all part of the symbolic language of love. Many different materials were used, including precious and base metals, textiles, glass, pottery and wood; sailors at sea made scrimshaw stay busks, lace bobbins and knitting sheaths, or, when in port, bought glass rolling-pins or pottery decorated with their girls' names.

In traditional farming communities in Scandinavia, the path leading to marriage was marked with a series of courting gifts in both directions that reflected the working year. A young woman might receive a knife for scutching flax in the autumn, a distaff

RIGHT *Scandinavian braid looms were working tools, but the painted and carved hearts identify these examples as love tokens. The two smaller looms (left, c.1800; right, 18th century) have been well used, while the pristine condition of the two larger looms (right, w. 28cm/11in), with their initials and dates, suggests that they have been used for display only.*

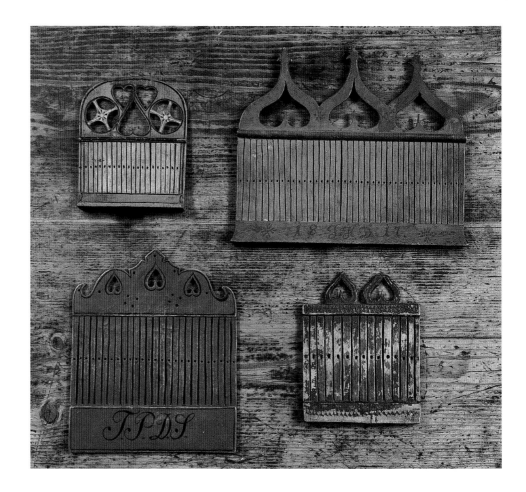

or spinning wheel for indoor winter work, and a loom for spring, all of which, if she liked the young man in question, she would proudly use and show off. If the couple married, the love tokens were no longer used and became keepsakes; if they did not, the gifts would be returned, and the unfortunate young man would have to begin all over again with a new set of love tokens and a new girl.

In Scandinavia wood enjoyed as much status as precious metal, and skilled itinerant craftsmen were commissioned to make carved and painted wooden love tokens of exceptional quality. Elaborately decorated mangle boards (pieces of wood with raised handles that were used to force water out of wet linen wrapped round another piece of cylindrical wood) were given as love tokens between couples, or commissioned as betrothal gifts and wedding presents for the couple by their families; in the latter case the initials D or S will feature, indicating a daughter and a son respectively. Other prestigious joint gifts included large double-handed "kasas" or drinking bowls made for the wedding, or even cupboards and chests. Mirrors with elaborately carved and

RIGHT *At night this home-made watchstand (c.1820; ht 23cm/9in) became a miniature mantel clock when the pocket watch was hung in place. A charmingly individual love token, it is a typically French combination of disparate motifs (hearts, ribbons, shepherd and shepherdess) and materials (brass and fruitwood).*

BELOW *Both men and women took snuff, and this fine-quality boxwood snuff box (c.1800; ht 15cm/6in) was commercially made in Holland, Friesland or southern Scandinavia, and given either to or by the lady depicted.*

painted frames were rare, expensive (the glass was imported) and intimate (they would reflect the image of the woman), and much care and detail went into their making. They are often gloriously worked and beautifully painted, and are keenly collected. More readily given, and now found, were braid looms: everyday working tools for most women, transformed into love tokens by the addition of painted or carved personal initials and dates, double hearts and other love motifs.

The style of decoration is often associated with the valley or locality where the love token was made: a mirror or mangle board made in Gudbrandsdal is invariably carved with vigorous scrolling foliate decoration, as seen on the previous page in the mangle board on the far right and the bottom mirror. The stylized horse-shaped handle can also reflect regional differences: the Norwegian fjord stallion with a characteristic arched neck and straight mane – a symbol both of virility and of protection against fire – seen on the middle mangle is from Telemark.

Home-made love tokens, such as the French watchstand above, make up in sentiment (and in this example, wonderful colour) what they may lack in expertise. There is a particular intimacy in the choice of symbols. Here, the open fret carving, backed by a sheet of brass, includes such conventional love symbols as doves and a heart, but in true French folk-art fashion, the maker has added a ribbon capital and

two pastoral figures – possibly a shepherd and a shepherdess – with a dog and a lamb: a truly eclectic mix of styles and motifs applied to a simple watchstand.

Snuff boxes and tobacco boxes were popular love tokens or sentimental mementos. Snuff-taking was common among men and women, and snuff boxes were made in a great variety of styles and designs, in both silver and wood, often decorated with initials, and given as gifts between the sexes. The style and design can vary from the professionally made, imposing, upright carved snuff lady shown opposite (a type also made in silver) whose stylized tight waist and bonnet suggest that it was made in Holland, Friesland or possibly southern Scandinavia, to the tiny, heart-shaped boxwood snuff box on page 37, also professionally made, with intricate geometric chip carving. Less elaborate boxes, such as oval bentwood storage boxes, simply painted with figures, dates, initials or sentimental mottoes, were also presented as courtship gifts.

Most love spoons were carved messages of love rather than functional objects. Although known in Scandinavia, Switzerland and elsewhere, they are traditionally

ABOVE *This fruitwood tobacco box carries the date 1772 and the initials of the owner. The carved decoration in the form of hearts and stylized fleurs-de-lis is typical of examples from northern France, probably in this case Normandy.*

LEFT *Love spoons were primarily vehicles for carved love motifs rather than functional objects. These 19th-century Welsh love spoons in fruitwood and sycamore, which show a wide variety of shapes and motifs, were probably carved by village carpenters or enthusiastic suitors.*

associated with Wales, where they were made as early as the 17th century; most of the examples collected today, however, date from the mid-18th and the 19th centuries. They were usually made from local hardwoods, often sycamore. The handles were carved with various motifs that could be read like a love letter by the initiated, including hearts, twin hearts, comma-shaped soul motifs (an Egyptian symbol representing the nostrils, through which the soul was thought to escape at death), chains symbolizing the links of marriage, houses and keyholes indicating "My house is yours", spades or a spade-shaped bowl ("I will dig for you"), and wheels (possibly "I will work for you"). Whether simply carved, or with double heads, large pierced handles and chain links, such spoons would be offered to the young woman, who might accept and display spoons from more than one aspiring suitor as proof of her attractions.

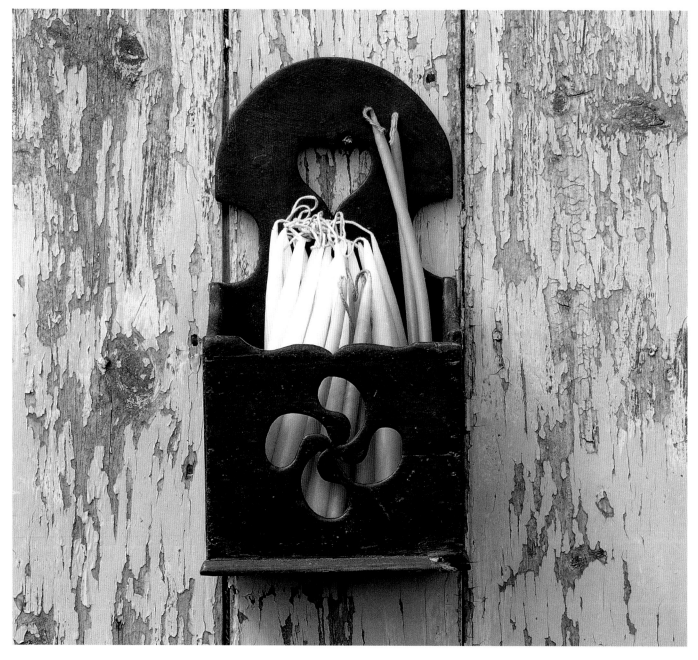

RIGHT *A variety of heart-shaped British love tokens. Clockwise from top left: geometrically carved plum-wood tobacco box (c.1780); home-made oak money-box (c.1800); chip-carved boxwood snuff box (c.1800; ht 5cm/2in); pine double heart, possibly Scottish, inspired by oatcake boards (mid-18th century).*

OPPOSITE, TOP *A candle box was a practical love token that offered scope for individual creativity. The charm of this simple English home-made pine example (c.1820) is in its strong silhouette, simple decoration of pierced hearts and richly patinated buttermilk-painted surface.*

OPPOSITE, BOTTOM *This British pine candle box has an elaborate silhouette incorporating a waisted backboard with a shaped cresting, a delightful combination of pierced soul and heart motifs, and its original paint.*

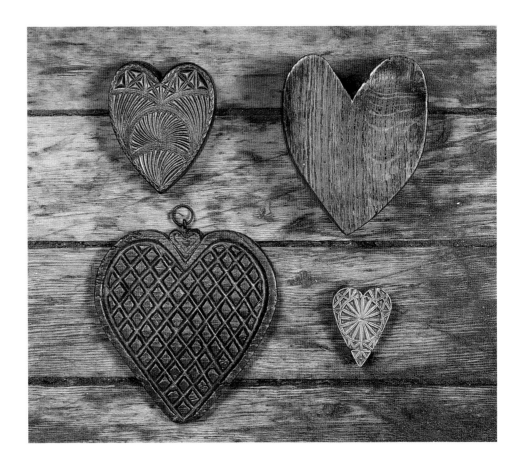

The "comma" or soul motif, together with the heart, was also often used on wooden candle boxes – a peculiarly British love token. These were eminently practical and also offered great scope for variety and individuality of forms, silhouettes and decorations, which may now be complemented by equally interesting aged surfaces, whether original paint, or carving, initials and dates, or rich patination, as these boxes were in daily contact with hands greasy with candle wax.

The heart was an extremely popular and versatile symbol which was relatively easy to use as either a shape or an applied motif. Heart-shaped storage boxes included money-boxes, such as the the example above gouged out of a solid piece of oak with a charming lack of accuracy, which could be stood upright to reveal the slot for the coin at the base of the heart (making it as easy to retrieve money as to save it). Other heart-shaped love tokens may have been inspired by objects associated with food preparation, such as the oatcake or riddle boards indigenous to Northumberland. The example above is very finely geometrically carved, which suggests that it was primarily decorative and intended to be hung on the wall rather than used.

Whether made by a young man as a demonstration of his feelings and competence, or commissioned from a craftsman, a love token is an intensely personal object – a special piece made for a particular person as an expression of love and affection. And it is this romantic history, combined with either fine-quality craftsmanship or loving, if inexpert, careful making, that explains their timeless appeal.

Wood carving

The brightly painted and gilded trade signs, ships' figureheads and fairground animals that are among the acknowledged masterpieces of carved folk-art sculpture were part of the long tradition of wood-carving practised by skilled craftsmen who served a long apprenticeship; decoy birds (see p.42), although largely made by the hunters who used them rather than by skilled woodcarvers, have an equally strong tradition. At the other end of the scale are pieces carved in wood that appear to follow no uniform pattern and to obey no known rules, and which were made by untrained (and sometimes comparatively unskilled), enthusiastic amateurs as a leisure-time activity, either purely for the joy of making or as a way of realizing a specific vision of a particular object. The result is often a very detailed, highly worked piece – perhaps functional, perhaps solely decorative – that simply speaks for itself.

The figure of Napoleon shown on the right, for example, may well have been inspired by a more formal bronze academic sculpture. Here he has been carved in walnut, but has acquired a slightly humorous nature in the translation, with primitive features that suggest that the figure was made by an untrained amateur – in particular its almond-shaped eyes and its stiff, naive doll-like quality, further emphasized by the inaccurate proportions. Its only purpose is, presumably, decorative; it was not made to serve a specific function other than to provide a creative outlet for a competent, if not highly skilled, maker.

Similarly, it is difficult to understand what purpose the row of houses below was intended to serve. The strong silhouettes, the inaccuracies of architectural scale and proportion – the impossibly large central roof window and the pierced chimneys – and the delightfully inaccurate rendering of perspective give it much of the visual appeal of great naive painting. Although the houses are not sufficiently accurate to be

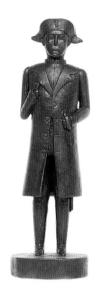

ABOVE *This mid-19th century French figure of Napoleon (ht 23cm/9in) is carved in unpainted walnut.*

OPPOSITE *An unusual English pedlar's pack stick (c.1830) has a relief-carved finial in the form of a man and a dog, with original polychrome decoration.*

BELOW *This delightful scratch-decorated and relief-carved panel (c.1780; l. 56cm/22in) retains its original paint.*

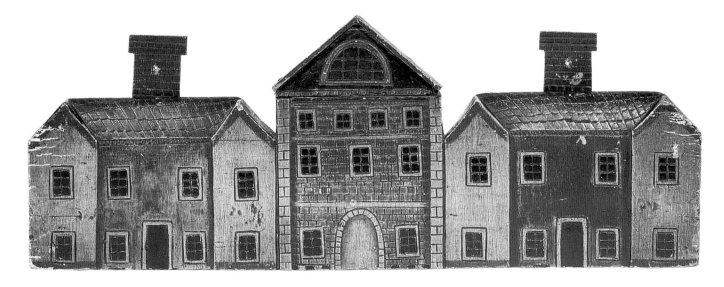

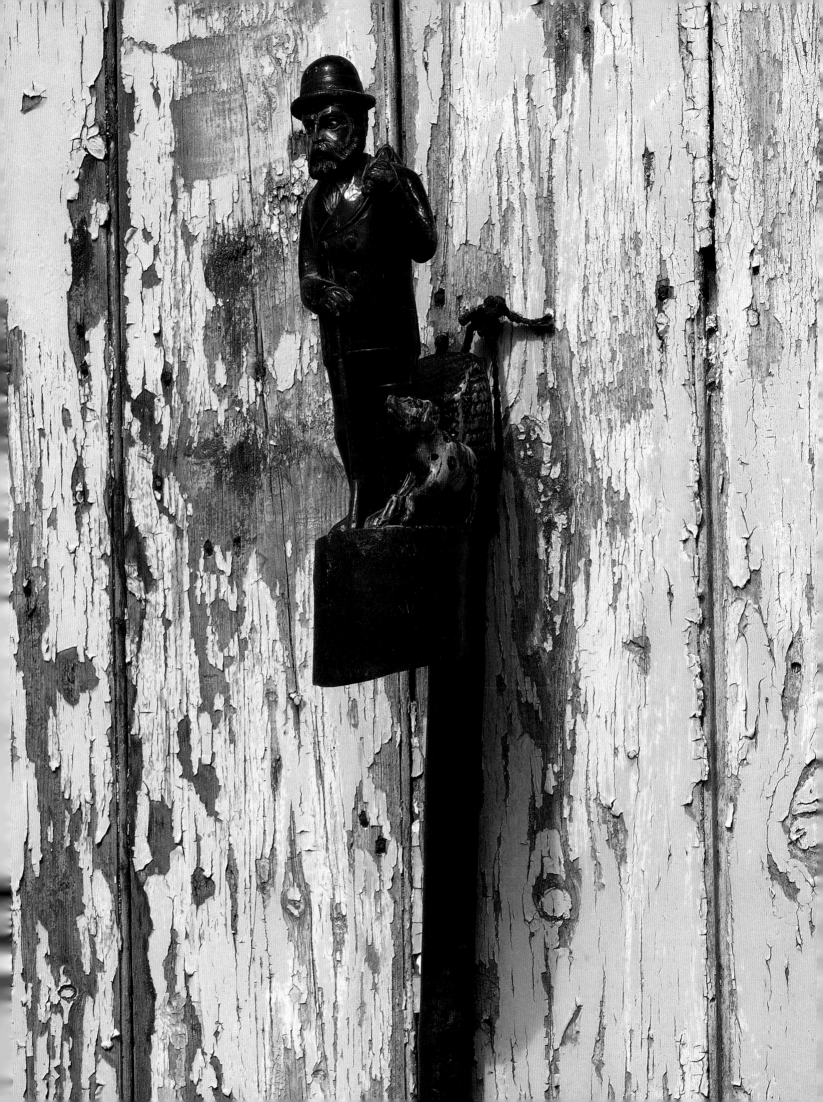

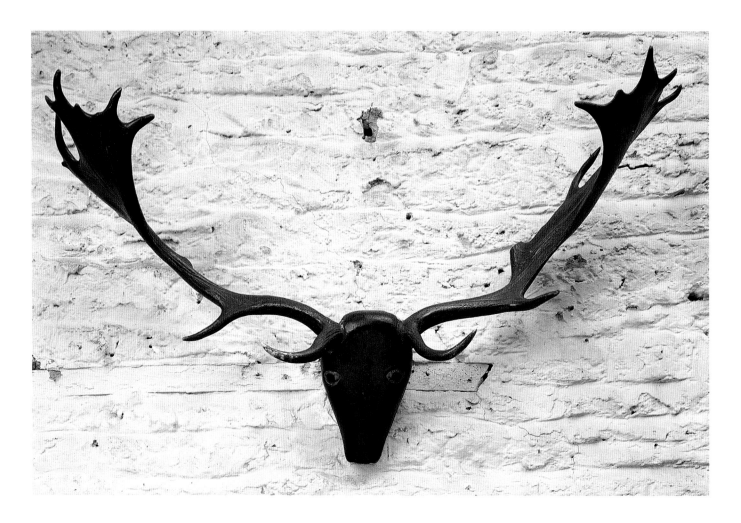

architectural models, they are well made, with finely painted detail. The holes in the chimneys suggest that the panel might have been designed to be hung on a wall, but speculation as to its purpose is far less rewarding than an appreciation of its unique form, surface and decoration.

The same attention to detail is seen on the finial of the pedlar's pack stick on page 39. Unlike the traditional walking stick, the pedlar's stick or packman's staff was carried over the shoulder and had a V-shaped notch from which the rope that held his pack could be suspended. The figure of the man, who is holding a stick and carrying a sack on his back, shows the same vagaries of proportion as the figure of Napoleon, but has been much more competently carved in a more ambitious design, with an engagingly outsized hat, inlaid eyes and a companionable dog. Nor is it entirely without precedent: a similar stick (dated 1810–20 and in the collection of the Birmingham Museum and Art Gallery) has a finial in the form of a seated old woman, wearing a mob cap, who looks as if she may be taking snuff. These two sticks were almost certainly carved by the same maker and may represent a small school of portable trade signs or symbols.

There is a strong tradition of trophies in the form of wooden game-animal heads, with fine examples found in Germany, Austria, England and Scotland and even as far

ABOVE *Carved wooden game-trophy heads served as mounts for antlers or horns. This example, with its bold silhouette and large painted eyes, was made in either Scotland or Ireland c.1800.*

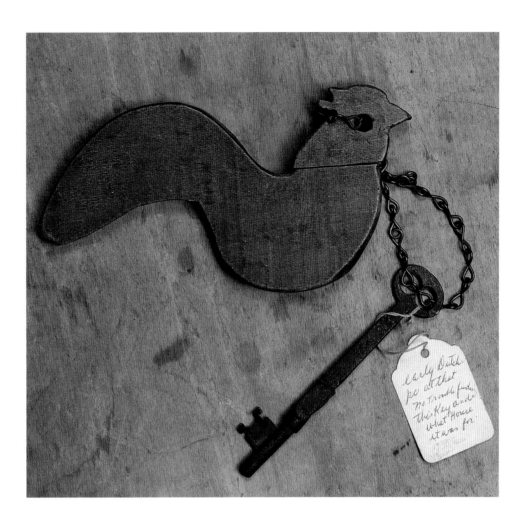

RIGHT *This two-dimensional keyring with its strong silhouette was used to identify the key to the chicken coop. It still has an old handwritten label bearing the words: "no trouble finding this key and what house it was for."*

BELOW *This portrait sculpture of a favourite dog (mid-18th century; l. 25cm/10in) was painstakingly carved from one piece of wood and retains much of its original paint.*

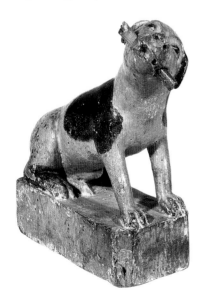

afield as the Indian subcontinent and Southeast Asia. The wooden heads were carved with varying degrees of sophistication by huntsmen or gamekeepers to act as mounts for the antlers or horns of the specimens they had shot and provided an alternative to having real heads stuffed and mounted. Again, there is little attempt at anatomical correctness; what was wanted was a safe, strong mount for the antlers. The result, as seen opposite, is very often an appealing stylized naive sculpture.

The effectively two-dimensional, unpainted chicken-shaped keyring above has a similar naive, stylized quality, and again the strength of the silhouette and the overall charm more than compensate for the lack of fine detail. The carved dog, left, provides a complete contrast. Its rounded three-dimensional form and pose make it clear that it is primarily a sculpture and essentially a very personal portrait of a particular dog. Its anatomical inaccuracies and stiff, naive pose, together with the fact that both dog and plinth have been carved from a single piece of wood, reflect the untrained enthusiasm of the carver, as does the stylized painted decoration.

Such disparate pieces rarely form part of any recognized tradition other than the desire to make, and the enjoyment of making. They must be judged on their own merits, not least of which are the painstaking care and patience that went into their creation, and their unpretentious, informal presence.

Decoy birds

A fine decoy bird is a unique blend of unselfconscious aesthetic appeal and fitness for purpose that translates into a bold silhouette, sensitive line and a raw untouched surface reflecting a history and working life – the very qualities that capture the elusive essence of fine folk art. Decoys were working tools, carved and painted by hunters who modelled them on local quarry with an emphasis on a form that, if rudimentary, captured the essence of a bird rather than ornithological correctness. More compact birds, such as ducks or pigeons, were sometimes carved from a solid piece of wood, whereas the elegant lines of shore birds generally necessitated two-piece construction. Most decoys were made of the lightest wood so that several could be carried in a sack. Vulnerable long, slender beaks were carried separately in a beak box and slotted into a hole in the head on site. If necessary, the decoy was fitted onto a stick to raise it to the appropriate height. Ducks were fitted with lead weights to ensure they floated properly, then tied together in groups, or rigs, and thrown into the water.

Decoys were made of local materials, usually wood in Britain, France, Belgium and The Netherlands. In parts of Spain and on the Mediterranean coast, decoys were made of palm leaves with crude wooden heads, and even of cork (see p.46). From 1920, wood was gradually superseded by moulded canvas, papier-mâché and then rubber. The finest surviving examples were made between 1875 and 1925, of wood, and have eye-catching sculptural shapes and purity that capture both the essence of the bird and the personality of the maker. Original paint (initially used as much for

OPPOSITE *Among this group of late 19th-century wooden decoys are English pigeons, including the fine hardwood bird hanging on the left, the one-piece ash pigeon in the basket and the pine feeding pigeon lying on its back; and a distinctive black-and-white poplar avocet from the Camargue region of France.*

LEFT *These two English decoys offer an interesting contrast to the group on page 47. The more engaging, deep-bodied pigeon with a skinny tail, which may have been commercially produced, has more character and individuality than the bird with the sleek, realistic profile, which was commercially produced c.1910 – but neither has the vitality of home-made pigeon decoys.*

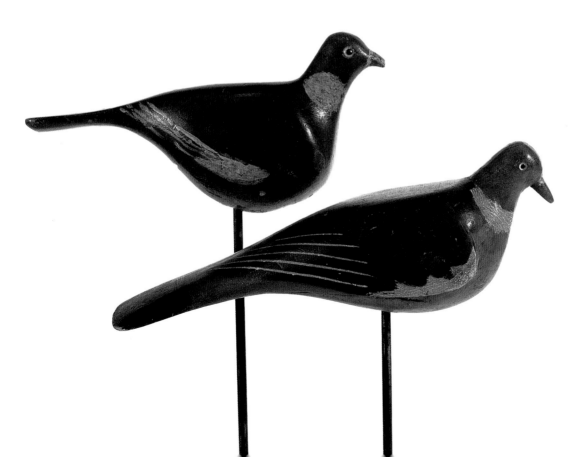

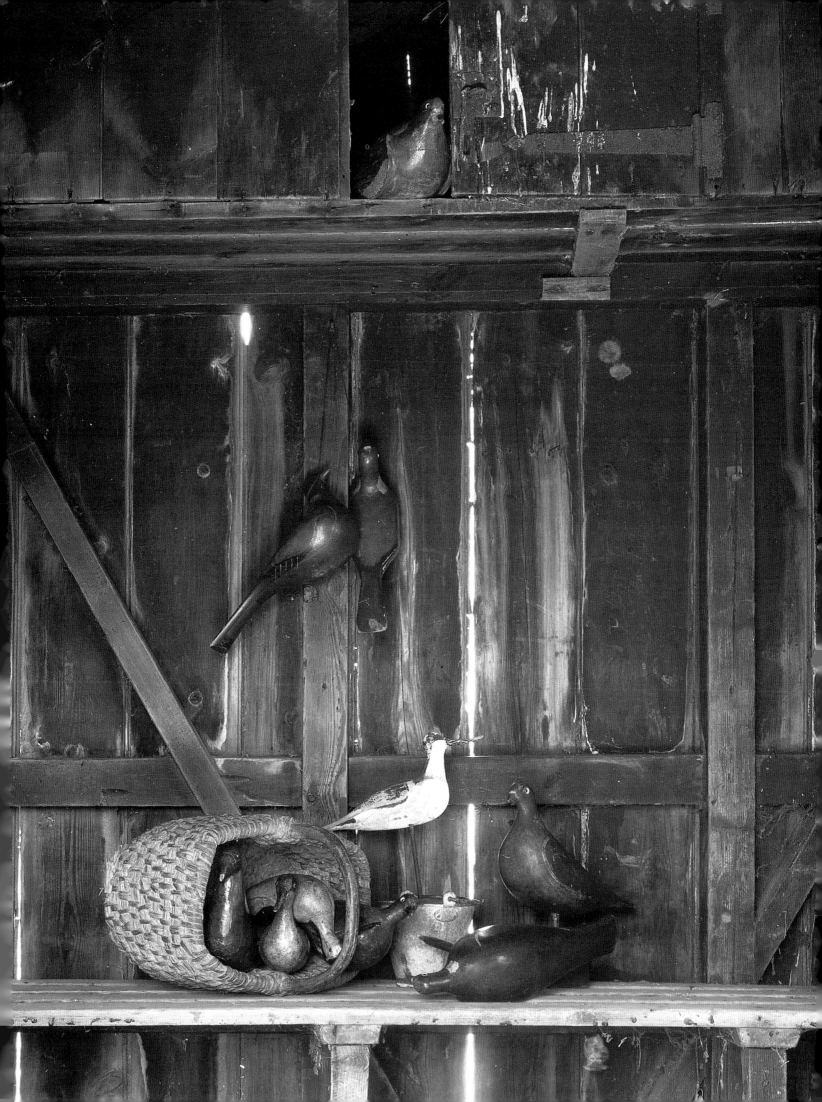

protection as to deceive) is an important feature, as are original eyes. Precise dating is difficult, but early (pre-1880) decoys tend to have painted, carved or iron "clout" eyes; on later birds, blown glass, pinhead or commercially made taxidermist eyes were used.

Few decoys have survived harsh working conditions and exposure to the elements unscathed. A working repaint may be acceptable, if undesirable; a replacement working beak is another sensitive area. The smaller of the two fine French decoys below has been fitted with a later working beak (a glue and sawdust compound often used as a filler is visible) that is slightly too heavy for the sensitive, streamlined, elegant line of the body and head, whereas the larger bird has retained its original beak and with it a lovely balance of line and form. Other interesting comparisons are the paint surfaces. The surface on the larger bird is dry, slightly crusty and faded; it has an elusive, fragile, driftwood-like quality that only time and weathering can achieve. The smaller bird has a rich patinated surface built up from coats of oil applied to protect it (not to be confused with the heavy dark wax used to "antique" decoys).

This gentle, haphazard, natural fading of colour (sometimes poorly imitated on fakes) is a distinctive and an attractive feature of earlier birds, as is a somewhat casual approach to ornithological detail. The painted decoration on later birds (such as those on the top step, opposite) may have a precision and an attention to detail that suggest the eye and hand of an artist-craftsman, rather than the instinctive stylization and originality of form of the hunter-carver seen on the curlew and avocet. Even less sophisticated in design and realization, but with an idiosyncratic charm, are "confidence decoys" fashioned from feathers, and straw waterfowl decoys.

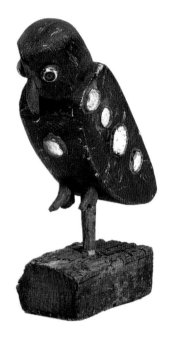

ABOVE *Not all decoys were used to attract birds. Made in France in the early 20th century, this hand-carved pine owl, with its staring eyes and fragments of mirror glass stuck on with putty, was placed in a tree to frighten off crows.*

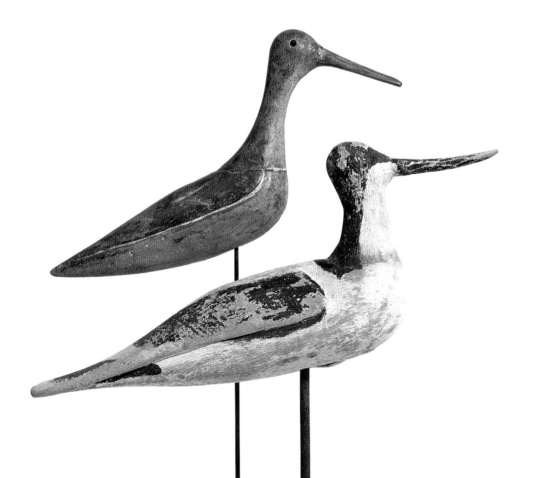

LEFT *These late 19th-century French poplar decoys, with their elegant line, original paint and hand-blown glass eyes, are of exceptional quality.*

OPPOSITE *French decoys. Top step: (left) redshank, (right) wood-cock, both poplar, early 20th century; second step: poplar curlew, c.1880; third step: (left) pine-cone and feathers confidence bird, 20th century, (right) poplar avocet, c.1900; bottom step: wire-bound straw waterfowl, c.1920.*

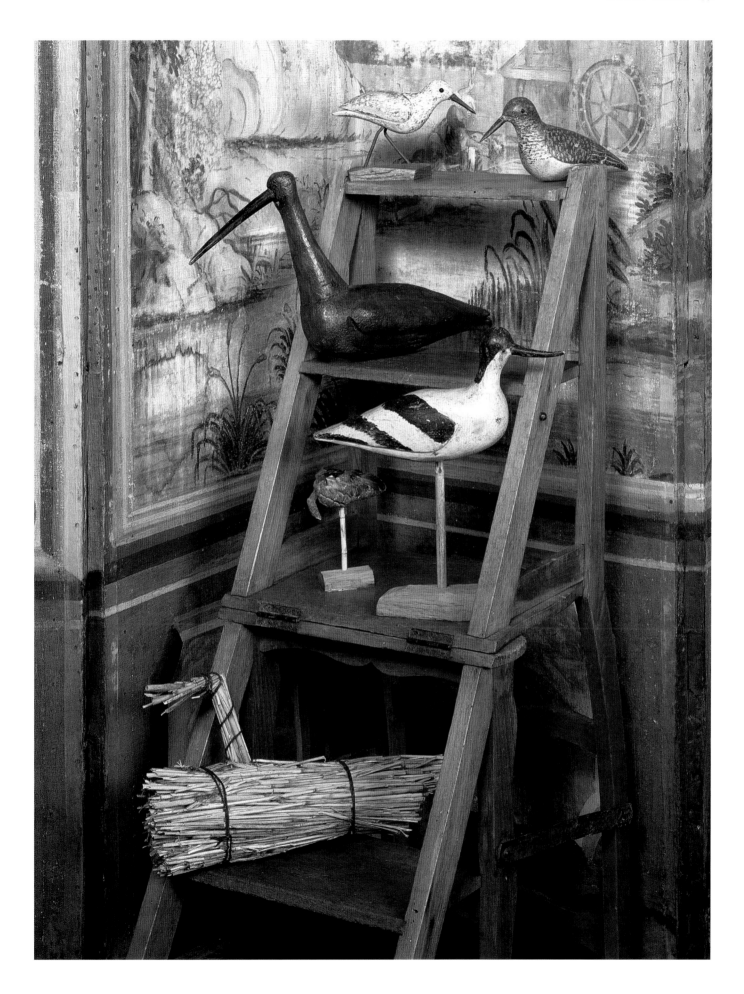

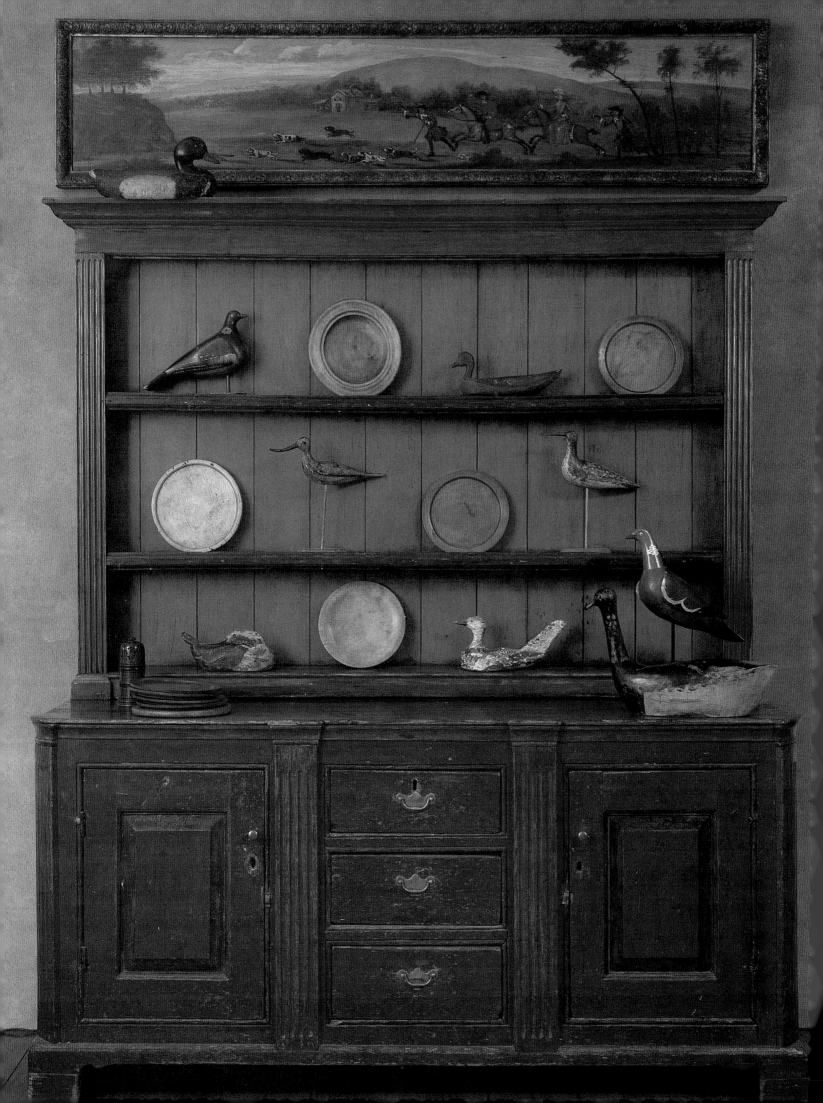

OPPOSITE *Top: English mallard drake, with retouched paint, c.1920; top shelf: (left) English woodpigeon, c.1900, (right) 20th-century Spanish palm-leaf and cork decoy duck; middle shelf: two Camargue shore birds, c.1890; bottom shelf: two possibly Spanish softwood waterfowl; front: (with support) bizarre pine pigeon with removable neck, c.1920, (sitting) Canada goose.*

LEFT *Top: a French home-made pine duck with original paint; middle: a British pine duck, with working repaint on head, made in northern England or Scotland; bottom: a life-size commercially produced softwood snakehead mallard, either imported from the USA or an English copy of an American bird.*

BELOW *These hand-carved 19th-century English decoy pigeons show the variety of poses, full-bodied shapes and decoration that were used while still producing recognizable pigeon forms. Made of (left to right) elm, pine and an unknown wood, their vitality is enhanced by the out-of-scale taxidermist eyes.*

Regional and national differences are reflected in the types of bird. Fine avocets were made in the Camargue region of France, while pigeons are almost exclusively English, but were made in a wide range of styles, poses and treatments.

In the 20th century hand-made decoy pigeons were sold through retail outlets, whose names were sometimes marked on the underside. Ducks were another popular retail line, although many of those sold through British retailers were high-quality American imports, usually recognizable by their sleeker tails, humped backs and flowing lines. The differences between home-made and commercially produced decoy ducks, national styles and associated collecting appeal are clearly illustrated above. The earlier, smaller French duck is the least sophisticated but bears the unmistakable stamp of the working decoy simply made to do a job of work by a hunter-carver; the British duck in the centre is more deliberately fussy, with both original and repainted decoration, and taxidermist eyes; the sophisticated snakehead mallard has exceptionally fine modelling and tiny, beautifully placed hand-made glass eyes. All three are fine decoys: the individual collector will make the choice between the impeccable folk-art pedigree of a wooden decoy carved and painted by the hunter who used it, and a beautifully crafted decoy produced by a craftsman for a hunter.

Decorative metalwork

The technical skills of the blacksmith, who worked with hot metal, and the tinsmith, who worked with cold sheet metal, were often matched by a creative imagination that resulted in virtuoso displays of craftsmanship and design, such as candelabra and rushlights (see pp.22–9), gates, fenders, garden benches, tables, window grilles and architectural metalwork. Base metal was not a valuable material, and much craftsmanship and decoration reflect the maker's pride in his art rather than the desire to produce an expensive piece.

In Scandinavia, for example, some skilled artisan blacksmiths produced exceptionally fine metalwork in regional styles that included candelabra (see p.24), sleigh and architectural fittings, and horses' tack such as the horse hames crown, right. Probably made for a festive occasion, this is a magnificent piece, embellished with rose-painted decoration, and would have sat on the horse's neck, raised on two curved pieces of iron or wood to which the traces were attached.

The balcony grille below was also the work of a skilled rural blacksmith, who may have specialized in architectural metalwork. He may well have also been responsible for the design – a translation of the Rococo style that lingered on in rural areas for some time after it became *démodé*. The grille is damaged – the central space for a monogram or symbol is empty, and the right-hand C scroll is broken – but it still retains the strong graphic quality fundamental to the appeal of wrought iron.

That graphic quality is equally strong in the rare English "spook" signs shown opposite, although here it takes the form of dramatic silhouette – a monkey-like figure and an owl about to devour a mouse – rather than an elegant line. The metalwork is

ABOVE *A wrought-iron horse hames crown made in Telemark, Norway, c.1800.*

OPPOSITE *These late 19th-century metal "spook" signs, mounted on poles, were meant to ward off evil spirits.*

BELOW *This early 19th-century wrought-iron balcony grille was probably designed and made by a rural blacksmith for a smart local house.*

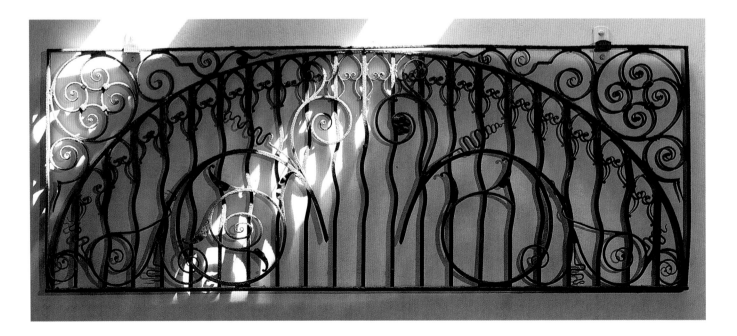

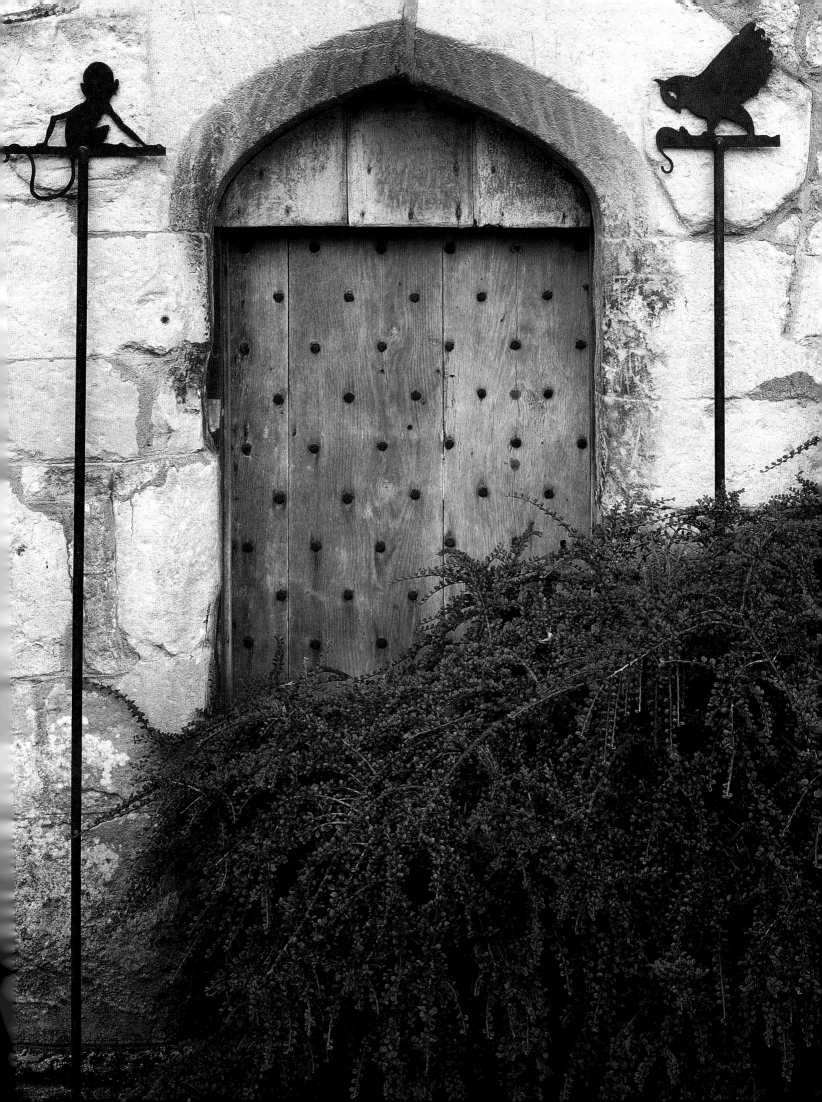

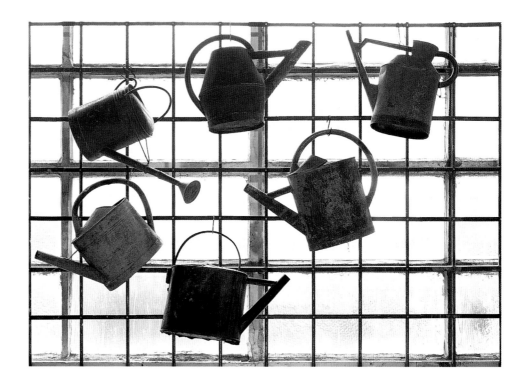

RIGHT *This group of French galvanized watering-cans, all made in the early 20th century, illustrates the subtle differences of form and wonderful painted and textured surfaces to be found in everyday utilitarian objects.*

BELOW *These 20th-century French hods, or* hottes, *were used for gathering grapes. Designed as working tools, they have an unselfconscious aesthetic appeal.*

elementary – simple hand-cut silhouettes, painted and mounted on spiked metal poles. Far more interesting is the folklore element: they were placed outside the front door to ward off evil spirits. Made in East Sussex, these signs form part of the fascinating tradition that included hanging glass "witch balls" in the window as a protection against witchcraft, and keeping in the home glass walking sticks that were supposed to absorb disease or evil influences and so were never dusted.

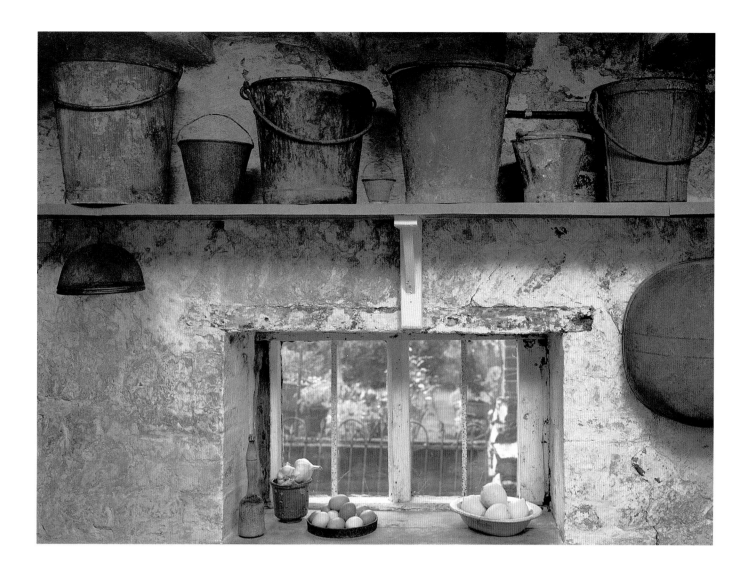

With much decorative metalwork the "art" lies in the skill of the manufacturer: although made with varying degrees of sophistication, all early pieces are constructed with rivets, collars, sleeves or tenon joints rather than solder or welding. Metalwork was often painted, as much for protection as for decoration, and traces of original paint, especially polychrome, or gilding always add to the appeal.

Everyday working tools and utensils such as buckets, watering-cans and *hottes* (hods for gathering grapes) were produced in huge quantities and varieties of shape; initially plain, they were often subsequently painted by their owners. These objects were not intended as "art"; unlike the hames and grille there was no self-conscious artistic element or desire to embellish, but they can, nevertheless, have a certain aesthetic appeal. When they are grouped together subtle differences of form, colour or textured weathered surface become apparent. When new, these objects would have had less to recommend them; age and use transform them into pieces that can have great charm – part nostalgia for a simpler way of life, part appreciation of the organic process of ageing, and part enjoyment of a way of looking that can find an unselfconscious aesthetic appeal in a group of everyday objects never intended to be decorative.

ABOVE *These plain metal buckets, made in the late 19th/early 20th century, originally had none of the appeal of colour, surface and wear that they have acquired over years of use and which lends them such character and charm.*

Weathervanes, together with decoy birds, are one of the most popular folk art collecting areas, and for similar reasons – a blend of fitness for purpose, creative input and aesthetic appeal made up of a strong silhouette that "reads" from a distance, a sculptural, often highly individualistic form, and a surface that reflects years of exposure to the elements. Although made in quantity and throughout Europe, surviving examples no longer *in situ* are rare and date largely from the 18th and 19th centuries.

In early rural and seafaring communities, an awareness of wind direction was needed in order to predict the weather, and the weathervane was one of the few meteorological instruments. Set high on exposed vantage points, weathervanes combined function and decorativeness and also often acted as signs that indicated the statuses and purposes of particular buildings. They were usually made, by local blacksmiths, out of solid, strong materials which had to be balanced to work efficiently. The format usually included a fixed cross or bar, often with initials for the cardinal points of the compass (north, south, east and west), that indicated the direction of the wind. The design needed to provide a large surface area that could catch the wind, usually at the back, with a weighted front to provide stability. A spindle and sleeve was the standard way of ensuring that the weathervane pivoted successfully; the vane would be either attached to an outer sleeve that pivoted over a fixed inner rod, or attached to an inner rod that pivoted within a fixed outer sleeve. Correct balance of the vane was essential and generally required two-thirds of the area of the vane to be behind the spindle and one-third in front, with extra weight fore to hold the vane into the wind (the fish weathervane on page 30, for example, has a bolted lead eye).

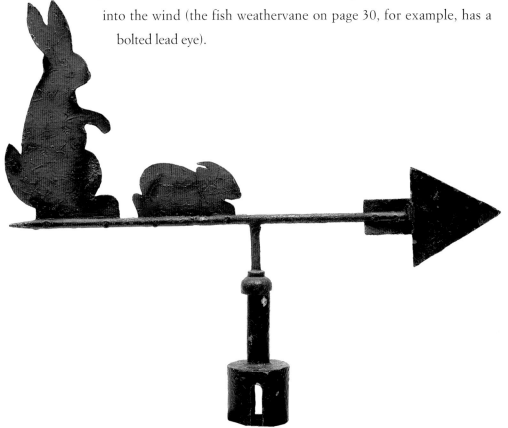

OPPOSITE *This charming weathervane (c.1860) of French origin, raised on a decorative oak finial, was made for a dog kennel. Its tiny size (l. 20cm/8in) in no way detracts from its sculptural form and weathered copper surface with natural verdigris.*

LEFT *This two-dimensional painted wrought-iron English weathervane (c.1900; l. 64cm/25in) has a bold silhouette – an upright and a crouching rabbit balanced by a dramatic arrowhead.*

Sound technical knowledge and craftsmanship went hand in hand with an immense variety of forms, one of the earliest and most enduring of which is the cockerel. A weathercock is shown on the Bayeux Tapestry and was used on church spires (often without arms, as churches had a known east–west orientation) throughout Europe, where it not only indicated the direction of the wind but also acted as a reminder of human frailty (Peter's betrayal of Jesus) and the need for Christian vigilance. The word "vane" is derived from the Old English *fana*, meaning flag or banner, and by the 13th century revolving metal banners were found as weathervane forms in Britain; arrows and pennants, sometimes cut with initials and dates, are also common forms, especially in Germany. Other designs might symbolize the function of the building – horses for stables, cows for dairy farms, pipes for tobacconists, cannons on

BELOW *This English weathercock (l. 89cm/35in) has a fully rounded repoussé copper body with a sheet-metal head and tail. Exposure to the elements has necessitated soldered repairs to the front end but has also given a wonderfully weathered surface.*

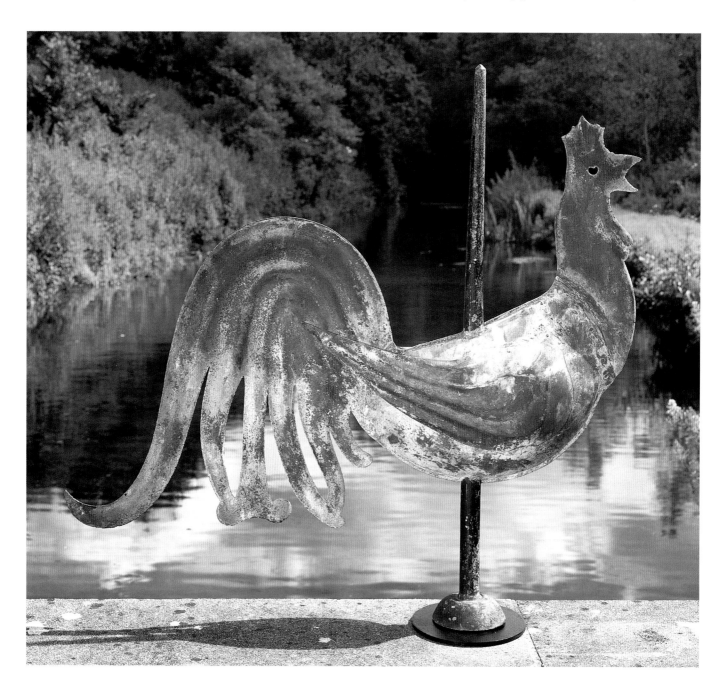

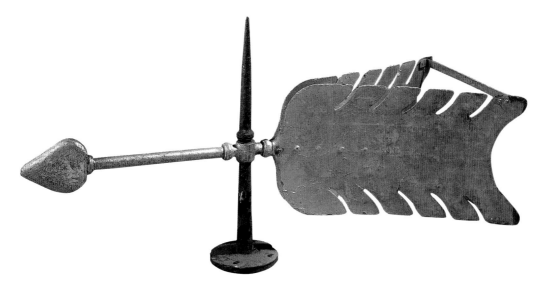

barracks – or occupations – ploughmen, shepherds, blacksmiths, farriers – or the idiosyncrasies of the owner. Weathervanes in coastal areas often feature fish (see p.30) or ships, and town halls or public buildings may have vanes that depict coats of arms or are rebuses on the name of the town. In general, figurative designs are more popular than geometric or abstract ones, and animals – dogs, horses and pigs in particular – are especially popular and appropriate as their heads and tails are useful pointers.

Full-bodied weathervanes were more complicated to construct and more expensive to produce than flat-bodied two-dimensional designs, but were inherently more sculptural and better suited to surface decoration. Being hollow, they were lighter, more vulnerable and needed extra weight at the front. Early examples of half- or fully rounded forms were usually made from sheet copper. During the 18th century wrought iron was increasingly used; it was both stronger and more suitable for flat shapes, such as the flags and banners that were particularly popular in Britain during this period. By the 19th century cast and sheet iron had become increasingly commonplace, and weathervanes, along with other architectural metalwork, were massproduced and sold through catalogues, becoming ever more formulaic and less interesting. Wood, although plentiful and readily available, was less suitable than metal as it was especially vulnerable to weathering, and the regular repainting needed to protect it was often difficult; surviving wooden weathervanes are very keenly collected. In France zinc, or zinc and copper, were more frequently employed.

Size varied depending on location. Weathervanes need to be read from a distance, and the scale and weight of a weathercock on top of an English church spire are altogether in a different league from some of the tiny, charming weathervanes found on, for example,

BELOW *This magnificent fullbodied English heraldic lion passant weathervane (mid-18th century; l. 152cm/60in), with a regilded copper body, was probably made as an important commission. Unfortunately, the top of its tail is now missing.*

BELOW *This detailed late 19th-century zinc weathervane (ht 86cm/34in) is typical of the genre and occupational scenes found on French weathervanes of this period.*

horses' stables, dog kennels or French birdcages. What they will have in common, however, is the same immediate appeal of strong silhouette and graphic quality as is seen in the weathervane on page 52, with its dramatic silhouette, albeit of somewhat formulaic animal shapes, set into the straight stick line with its bold arrow. The other important feature is surface. Set high on the top of buildings, where they were exposed to the full force of the weather and were difficult to maintain, most weathervanes have acquired the most wonderful weathered surfaces, as seen on the tiny copper dog weathervane on page 53 and the weathercock on page 54. The latter's hollow three-dimensional repoussé copper body has a two-dimensional flat-section sheet-metal tail, with a large surface area to catch the wind. Rusted rivets and pitted edges are other signs of age and weathering, and weathervanes often proved irresistible targets for any missile that might catch the tail and set it spinning round.

Once constructed by the blacksmith, many weathervanes were then gilded by a gilder or colourman, to embellish, to hide inferior metal or generally to dazzle. Whatever its purpose, traces of original gilding, especially double thickness where the leaves overlap, add greatly to appeal, as does a combination of gilding and verdigris, as seen on the lion passant on page 55. Both the lion and the arrow on the same page are designed to impress. Built on an imposing scale, they were probably important commissions, and have been regilded several times.

At the opposite end of the scale from the massive, heavy, gilded weathervanes produced to commission by blacksmiths are the hand-carved, painted, articulated weathervanes known as whirligigs. They are generally home-made, of wood (sometimes tin plate in France), and the originality and ingenuity of design, together with the obvious care and pleasure taken in their making, can give them an intimate charm that makes them just as appealing in their way as the dramatic large-scale sculptural weathervanes. They were of course more vulnerable than metal weathervanes: the Norwegian figure opposite has lost the paddles on the end of its arms that would have caught the wind and whirled it round. Nonetheless it remains full of character, with neat little goatee beard, dapper moustache, intricate carved hat and glorious original paint. This solo figure offers a marked contrast to the English whirligig, right, in which four rudimentary, naive sailors and an imposing central figure whirl round on their metal supports on a beautifully made wheel, which is turned by the painted tin sails of the carefully modelled wooden boats. Here most of the attention is focused on the construction. The neatness and precision of this nautical folly suggests that the maker was a boat-builder.

Both these whirligigs clearly reflect both the hand and the character of the person who made them, as does the French weathervane shown left. It is in effect a weather-

vane within a weathervane, and was probably made by the two metalworkers depicted plying their trade – probably the construction of architectural fitments. The fine detail – the leaves and flowers growing out from the decorative finial, the tiny initials (O for *ouest*) and pennant on the miniature weathervane, the bellows and brazier – would be difficult to read from a distance, but have been made as much for personal enjoyment and display of skill as for function, and the ensemble has much the same virtuoso spirit and appeal as the French locksmith's sign on page 68.

Few working weathervanes survived years of exposure to the weather unscathed. Those that could be reached were maintained and repaired; welded, soldered and lead repairs are all acceptable, if not necessarily desirable, while rust, verdigris and traces of original gilding or a "working" regild are both evidence of a long working life and aesthetically pleasing, but ideally a weathervane should be in working order and have a surface as close to its original state as possible. Character, decorative appeal and a known provenance are more important than age.

The most interesting weathervanes display the fitness for purpose, skilful construction, creative design and traces of history that characterize the finest folk art. These two- or three-dimensional sculptures that once enjoyed unchallenged positions on the skyline may combine strength of silhouette, wonderful surfaces and dramatic scale that more than explain their status as some of the most impressive of all folk art.

ABOVE *This charming mid-19th-century Norwegian whirligig (ht 41cm/16in) of carved and painted wood is of exceptional quality and full of character, but has lost the paddles fixed to the end of the arms that would have caught the wind.*

LEFT *Made on the south coast of England c.1880, this rare, unusual whirligig (diam. 97cm/38in), with its superbly constructed wooden frame, naive carved sailors and boats with painted tin sails, retains much of its original paint, with some retouching.*

Outdoor sculpture

Many of the structures designed to house animals reflect a desire to create a shelter that closely resembles the human house. Made as a leisure pursuit by skilled amateurs, such shelters often go far beyond what is actually needed in their design and realization. Ostensibly intended to serve a traditional function – to house a pet squirrel, or birds, or a colony of bees – these pieces make no attempt to replicate or imitate the natural habitat. On the contrary, the form, architecture and construction often became more important than the function, with imagination taking precedence over purpose, and the creative process taking precedence over the object. These are unique pieces; having satisfied their functional requirements, they go on to become tangible realizations of particular and highly individual visions of what beehives or squirrel houses might be. Made from whatever materials were at hand, they were not designed as precious objects, and their value lies in the blend of function and imagination that reflects the individual character and creativity of the maker.

For example, the oak beehive shown opposite has an extraordinary plethora of superfluous decoration – split turned balusters, a shaped frieze, fret-cut decoration, and what were originally cabriole legs; but this decoration, applied purely for pleasure and to satisfy the maker rather than the bees, is combined with such practical details as carrying handles, to lift it off the plinth, and a waterproof galvanized zinc roof, hinged for human access. What might originally have been a brash extravaganza has been mellowed by time and weathering, and the peeling paint, bleached driftwood-like quality of the oak, oxidization of the zinc roof and crumbling legs have given this grandiose beehive a dignity and an appeal that it could not have enjoyed when new.

OPPOSITE *The extravagance of the design and decorative detail of this French oak beehive (second half of 19th century) is gently tempered by the wonderfully weathered surface with traces of original paint, the oxidization of the zinc roof, and the decaying of its cabriole legs.*

BELOW *This French pine squirrel house (l. 102cm/40in), with its accurate proportions and precise construction, has much of the charm of an architectural model. Made in the late 19th century, it retains its original paint.*

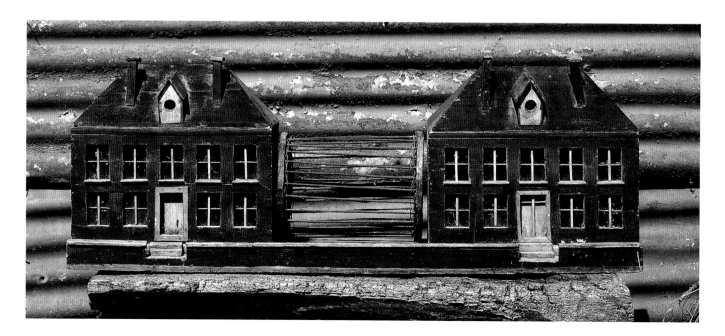

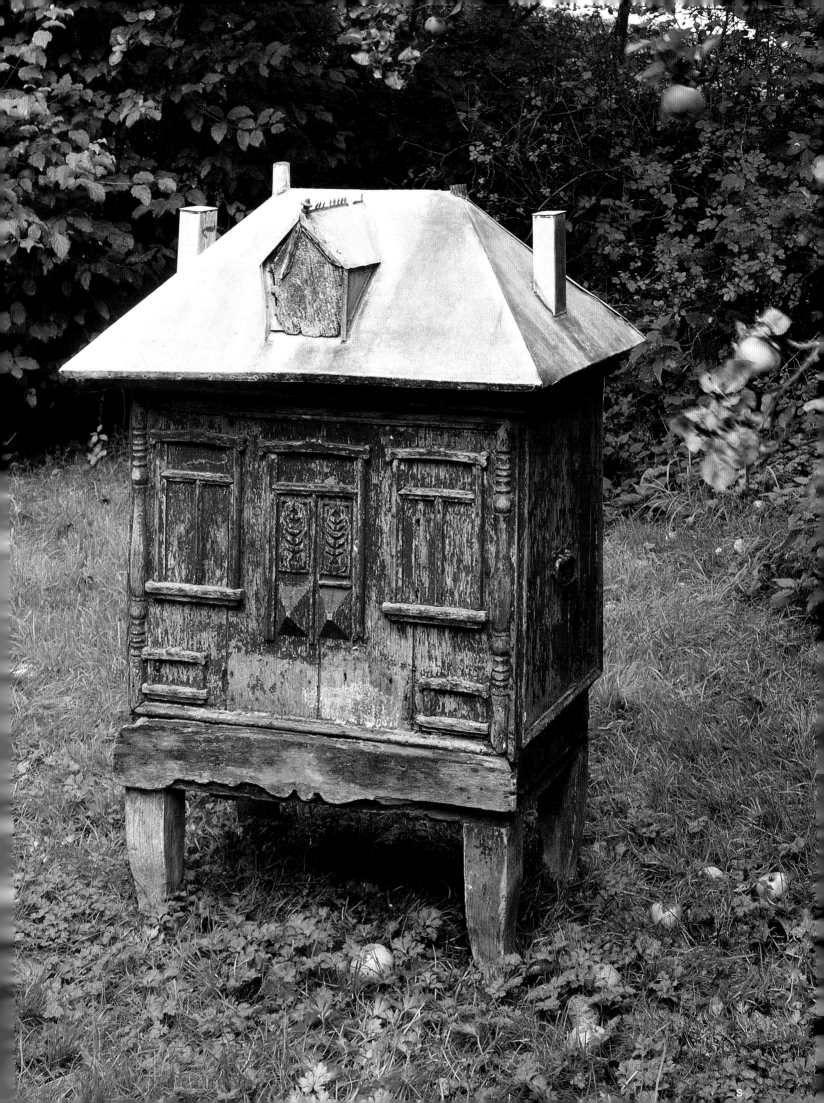

RIGHT *This pine English weatherhouse (c.1840), with its original painted decoration, naive carved figures and boldly painted if implausible architectural detail, has retained all its character and charm.*

LEFT *The sturdy, stable base and many-coated painted stem of this 20th-century English bird-table support a well-constructed, unpainted bird-house in the form of a country market hall with a lapped plank roof.*

The squirrel house on page 58 is a far more precise, neat construction. The architectural details – doors, steps, windows complete with glazing bars, dormer windows and chimneys – are all to scale, and the symmetrical design reflects much of the municipal French architecture of the period. Such accuracy, and the fine paintwork, had little relevance for the occupant, who moved between the two houses via the metal exercise wheel, harmoniously designed to reach just to roof level.

The English pedestal bird-table (left) combines two distinct contrasting elements. The sturdy, heavy, eminently practical and stable base and stem, covered with several layers of thick protective paint, each slapped on top of each other, support a small, delightfully weathered, unpainted house, with imposed architectural elements, carefully constructed with a lapped plank roof to withstand the weather, and tenon-jointed to the stand. The house seems to have been modelled on a provincial market hall and is topped with a charming little pierced turret, only the roof of which has been painted, with a white spire finial that serves no functional purpose other than to satisfy the whim of the maker and which, now, adds considerably to the charm and appeal of the whole structure.

The bow-fronted English weatherhouse (above), with its painted Regency-style railings, displays a similar blend of vagaries of scale and careful painted surface to that seen in the wooden houses on page 38. The naive figures are roughly carved, and, unlike the French squirrel house, the architectural detail is totally unviable – for example, the arches over the figures have been crushed by the uneven courses of brickwork – but the ensemble has a vitality and a highly individual character that were

lost in the more formulaic weatherhouses that were produced and exported in quantity from the Black Forest region of Germany in the mid- and late 19th century.

The English dovecote below has neither the pretensions of the French beehive nor the elegance of the squirrel house, the quirkiness of the weatherhouse or the juxtaposition of styles and surfaces of the birdhouse. It is entirely without self-conscious artistry or superfluous decoration: the simplicity and integrity of the design and the symmetry of the proportions are enhanced by the wonderful raw, dry, unvarnished, unpainted, unoiled elm surface.

Such one-off pieces are by their very nature unique and rare. The only tradition they follow is the desire to create something special, to use an everyday object as a vehicle for an unselfconscious creativity. The beehive, the bird-table and the dovecote are the beginning of the process rather than the end; the art and act of making have become more important than the object itself. And the unmistakable character of such pieces derives from this blend of personal vision, serious, deliberate construction and surface integrity, be it raw dry wood, peeling paint, original paint in good condition, or a thickly coated surface built up of layers of protective paint.

BELOW *The appeal of this English dovecote (c.1800), seen here with two hand-carved and painted 19th-century decoy pigeons, lies in the symmetry and simplicity of form, and the wonderful grain, colour and weathered surface of the unpainted and unvarnished elm.*

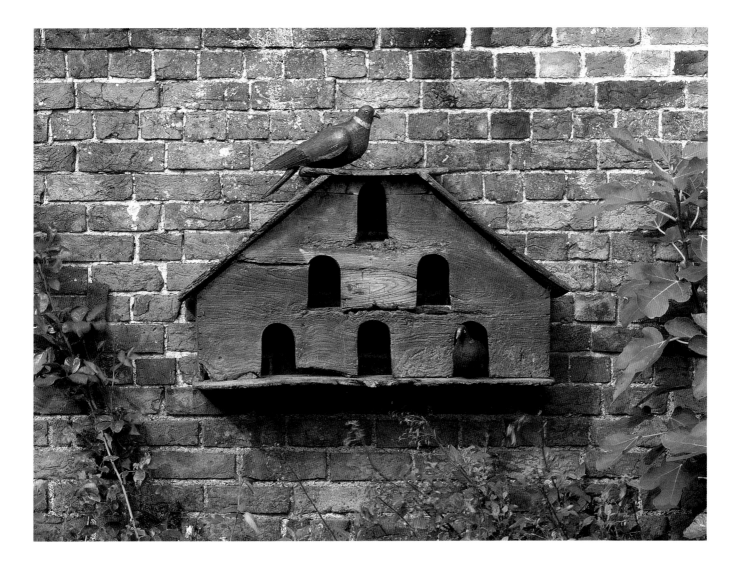

Many sailors relieved the monotony of the long sea voyage by making objects – woolwork pictures (see p.101), ships in bottles, love tokens, carvings, scrimshaw – that either reminded them of home or were based on the ship and its surroundings. Although scrimshaw (a word first used in 1821 to describe decorated or carved objects of marine ivory) was mostly produced between 1830 and 1870, the earliest datable example is a wood and baleen box made *c.*1630 and engraved with a design of Dutch whaling vessels in the Arctic. It was largely sailors on board the whaling boats who used marine ivory – narwhal and walrus tusks, sperm-whale teeth, baleen (whalebone) – to produce carved objects such as love tokens in the form of stay busks, lace bobbins and knitting sheaths; walking sticks, towel rails, rolling-pins, clothes pegs and pastry jiggers; and tools needed on board ship, such as liners for folding sail seams, and marlinspikes, or fids, for working knots. The surface of the marine ivory was prepared by scraping or smoothing or soaking; the design was scratched, pricked out with a sailor's needle or chased with a chisel, and the engraved lines filled in, commonly with black (usually pitch or Indian ink), but also with coloured sealing wax, and red, green or blue pigment. As with the horn beakers on page 12, the skill of the decoration varies from finely executed scenes of battles, whaling and fully dressed ships to less skilled (but from the folk-art point of view equally interesting) personal and domestic motifs – names, dates, hearts – which, although executed with just as much care, reflect a lack of expertise that may in fact enhance their charm.

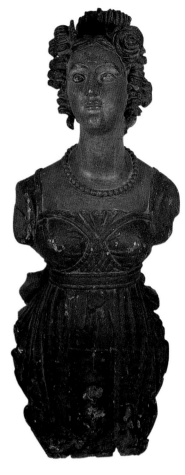

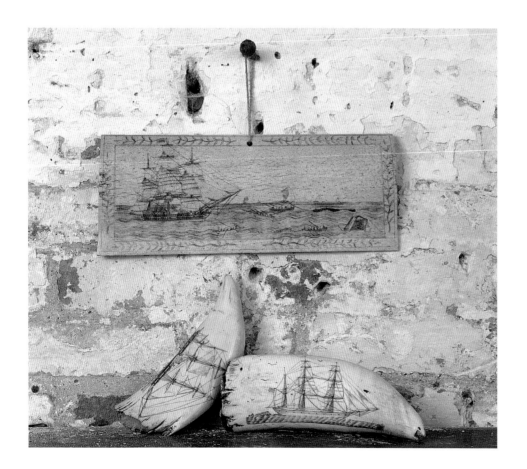

ABOVE *A three-quarter-length carved wooden polychrome figurehead (ht 122cm/48in) from the sloop H.M.S.* Favourite, *which was reduced to a coal hulk in 1859. The figurehead was evidently removed and stored, which has enabled the detail – including the necklace of pearls and the rose in the hair – to survive.*

LEFT *A scrimshaw plaque depicting a classic panoramic whaling scene, and two teeth (c.1835) carved by an anonymous British whaler.*

A highly popular collecting area, scrimshaw is widely and expertly faked. Later copies on marine ivory tend to have a less fluent line; faked plastic "scrimshaw" will melt if touched with a hot needle; and ostensibly very good quality but slightly "over-worked" scrimshaw, with a wealth of dates, names, hearts and other detail, and with a notably "distressed" surface (genuine scrimshaw is usually in good condition), should be viewed with extreme suspicion.

During the Napoleonic Wars, French prisoners held on ships in the Thames Estuary made their captivity more tolerable by carving small decorative objects which they sold in order to supplement meagre rations. They used what was to hand – small pieces of marine ivory, or even bones – to make games boxes, dominoes, spillikins, dice, cribbage boards and pegs, often finely carved with minute attention to detail.

The boat-builder's model – the marine equivalent of the architectural model – was a skilful, accurate scale model of the boat to be built. Sailors and fishermen often made their own bas-relief versions. These have nothing like the precision or accuracy of naval or nautical architecture, but, mounted on wooden panels that were painted with seascape backgrounds to create three-dimensional pictures or dioramas, have a peculiar charm of their own.

Ropework, an essential skill, was another vehicle for creativity. Sailors and off-shore boatmen used their ropeworking talents to make both decorative and functional objects. Their virtuosity with knots might be displayed by making string and leather

BELOW *Although inspired by a boat-builder's precise hull model, this 19th-century English diorama mounted on a wooden panel has none of the accuracy of a naval architecture original, but has been presented as a "picture" complete with hand-painted seascape background.*

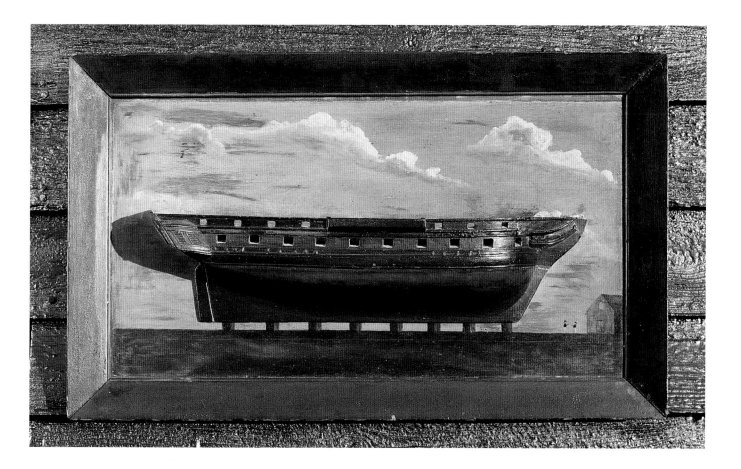

LEFT *Fids, or marlinspikes, were made in a variety of materials and sizes, depending on the type of rope knots they were used to work. This scrimshaw whalebone fid (1775–1800; l. 20cm/8in) is engraved "P.D.".*

handles for seamen's chests (opposite), fishing nets, or even lobster pots, whose construction was as characteristic of certain regions as the pattern on seamen's jerseys.

Ships' figureheads, by contrast, were part of a long tradition of land-based wood-carving and were produced at the ports where the ships were made. Now very rare and expensive, they were made by skilled carvers who were often part of a dynasty of wood-carvers which might also have made trade signs (see pp.68–73). Some of the specialized carvers, such as William Dodd of Liverpool and A.E. Anderson of Bristol, have been well documented. Few figureheads survive from before 1800, but during the 19th century, as their use on Royal Navy vessels declined, the clippers of the merchant fleet provided a flourishing new arena for ships' figureheads until the steamship became fashionable after 1870. The generals, kings and admirals found on the Royal Navy vessels were often replaced on merchant ships by portraits of the owner and his family. Because of their status and their exposed position, figureheads were well maintained, but old weathered paint is especially appealing, as are the voluptuous female figures that were increasingly common after the mid-19th century.

OPPOSITE *The shape and ropework of this 19th-century lobster pot are typical of examples from the Atlantic coast of north Devon. Having been retrieved from the sea, it has a glorious coat of barnacles.*

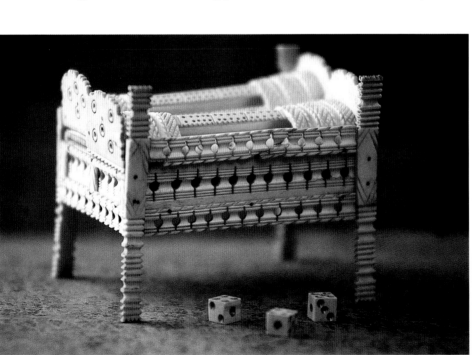

LEFT *This tiny games box (c.1820s; l. 15cm/6in), probably of marine ivory, in the form of a double-berth crib and with stylized geometric chip carving, is one of the hundreds of decorative pieces carved by French prisoners during the Napoleonic Wars.*

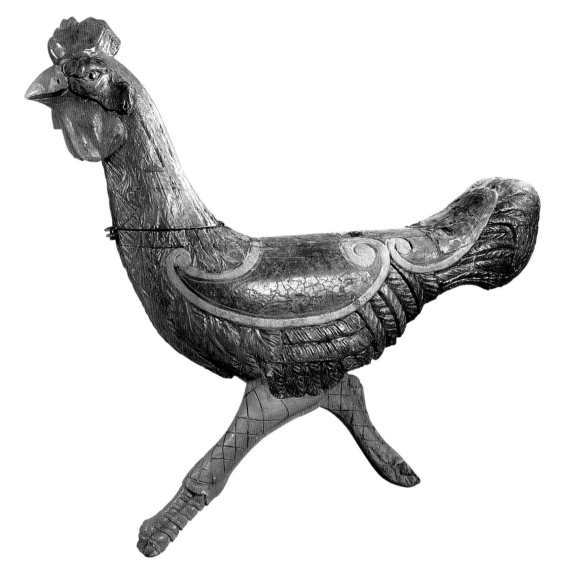

RIGHT *This magnificent carved and painted double-seat cockerel (l. 140cm/55in) was made by Orton & Spooner c.1910. Charles Spooner's status as one of the most prolific and imaginative carvers earned him the nickname "King of the Roundabouts".*

Although the development of steam led to the demise of the wooden ship's figurehead, it also opened up a new area for the wood-carver: the steam fair, in particular the roundabout, or carousel. The itinerant fair was one of the major forms of rural amusement. Traditional fairs and markets had always played an important social and economic role in rural life; market day was one of the few times when farmers and their wives from isolated areas came into town to sell and buy stock, do any household shopping, meet their fellow farmers and exchange news and gossip.

With the growth of towns, railways and shops, fairs took on a more frivolous role. People came to enjoy themselves: colour, noise and excitement provided entertainment for a largely illiterate population. Aunt Sallies, skittles and above all the steam-driven rides became the new arena for the wood-carver. A whole menagerie of both exotic animals – lions, tigers, zebras, giraffes, elephants, ostriches – and farm ones was carved, thickly painted with a protective oil-based paint and gilded.

Ready access to pine and a strong tradition of wood-carving account for the prevalence and proficiency of German fairground sculpture. German horses were made in

quantity in the toy-producing regions, such as the Erzgebirge, and by the late 19th century were exported throughout Europe. Large numbers were imported into Britain, where demand for roundabouts peaked in the 1880s.

There were national differences in roundabouts. In Britain, carved wooden horses were suspended on wrought-iron rods from a wheel or spinning top. These "Dobby" horses were superseded by "Gallopers" – horses with overhead cranks that allowed them to rise and fall – and "Platform Gallopers", powered by wheels below the platform. Gallopers were carved with flying or "eclipse" legs, which were not anatomically correct but conveyed the impression of speed and meant the horses could be stacked and transported easily. On the Continent, standing carousel horses had their hind legs fixed to the platform and front legs held high, supported by fixed metal stands, which allowed for greater variation in the position and carving of the legs.

Other fairground sculpture was associated with particular games. The French cockerel (right) was made to stand, with ribbons attached to it, on top of a greasy pole. The aim of the game, which was played in Normandy in the 18th and 19th centuries, was to clamber up the greasy pole and retrieve a ribbon.

Rare and exotic animals are always popular, as is any animal with "presence" – usually the result of a good form. Original surface is particularly important. Most fairground sculpture was regularly repainted for protection and to maintain its colourful appeal, but often the repaint was not properly keyed in and can be dry-scraped back to reveal the paint and patina of the original worn surface, as seen on the English horse below, that is a fundamental part of the appeal of all outdoor sculpture.

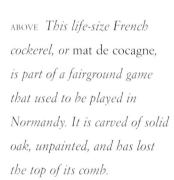

ABOVE *This life-size French cockerel, or* mat de cocagne*, is part of a fairground game that used to be played in Normandy. It is carved of solid oak, unpainted, and has lost the top of its comb.*

LEFT *This early English fairground horse (first half of 19th century) has an unusual bristle mane and tail. It has lost an ear, and its "eclipse"-shaped legs are broken, but it has enormous character and a wonderful dry original painted surface.*

Trade signs

In traditional small, close-knit communities, street numbers and signs were superfluous. As towns grew, however, so too did the need for a method of identifying properties and tradespeople's premises that would be accessible to all, including the majority of the population who were illiterate and innumerate. The solution was the sign – a visual symbol – and in 1625 Charles I granted the citizens of London the right to erect signs to identify both private houses and business premises. These signs, most of which were made of wood, were either specially commissioned or, from the early 19th century, bought ready-made. They were carved, and possibly painted, by skilled wood-carvers, many of whom became specialist signmakers, and whose descendants produced the ships' figureheads and fairground animals that can have much the same kind of appeal in their sculptural forms, their surfaces and their often polychrome painted or gilded decorations.

The signs themselves often took the form of giant-sized objects that provided striking visual images of particular trades: an over-size boot for a shoemaker, a carved and gilded fish for a fishmonger, an enormous pen, quill or bottle of ink for a stationer, a huge key for a locksmith, a pestle and mortar or serpent for an apothecary. Carved and painted pigs and cows (and horses in France) stood outside butchers' shops. Other symbols became closely identified with particular trades or professions: the three balls of the pawnbroker's shop are thought

OPPOSITE *Displayed in front of an 18th-century painted screen, this group of French wigmakers' and milliners' papier-mâché marottes (mannequin heads), made in the second half of the 19th century, illustrates the varying degrees of modelling and sensitivity of decoration found on such heads.*

RIGHT *This magnificently detailed wrought-iron and gilded trade sign for Charlut Fils is a* tour de force *of the locksmith's art, incorporating various metalworking techniques together with the traditional locksmith's symbol of St Peter holding the keys to the kingdom of heaven. It was made in south-west France in the 19th century, and later painted and regilded.*

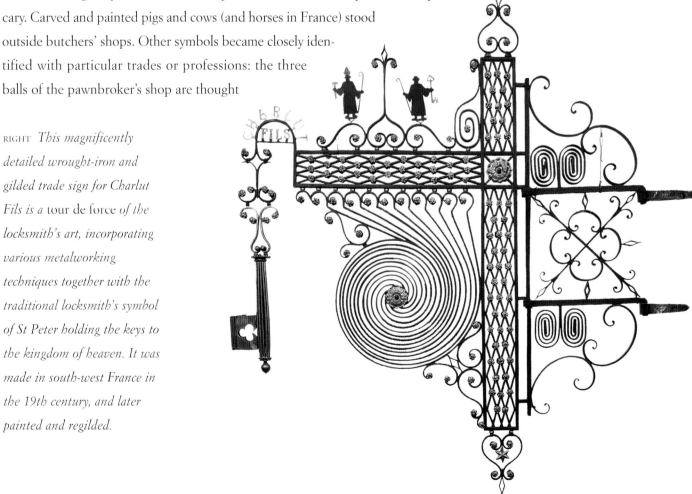

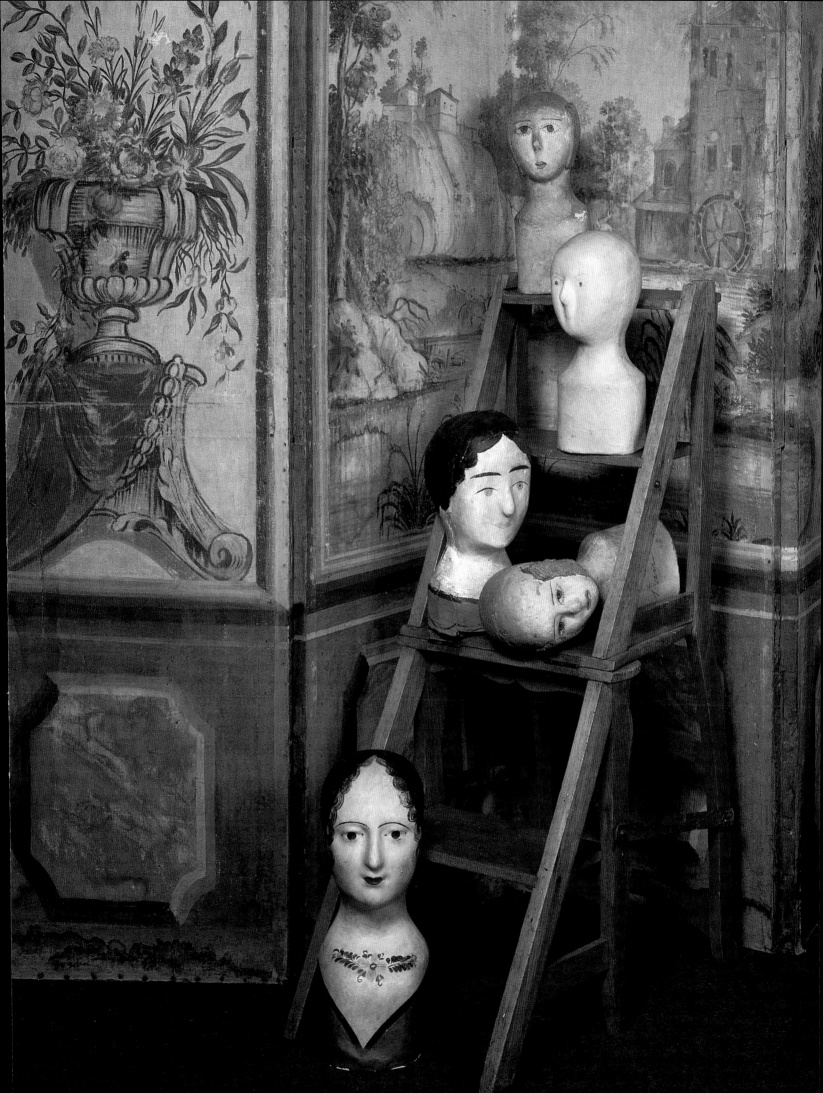

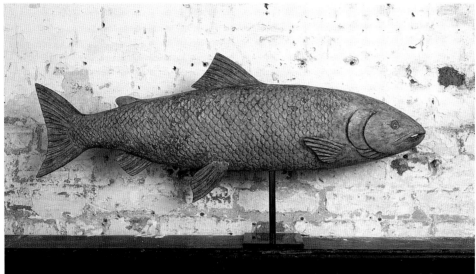

LEFT *The traditional sign for a fishmonger was a carved wooden fish. This finely detailed mid-19th-century example (l. 91cm/36in) was made in Britain, possibly Scotland, and retains traces of its original gilding.*

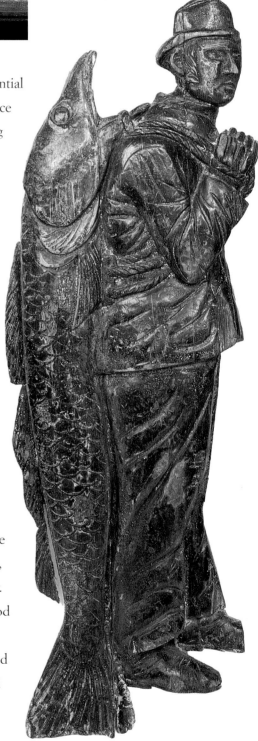

to be derived from the coat of arms of the Medici family, the famous and influential dynasty of Italian bankers; the red and white striped barber's pole was a reference to the fact that barbers were allowed to let blood. Signs were either made to hang outside the shop or carved in the round: as large free-standing figures to stand outside, or as smaller figures designed for the inside, the window or the counter.

Wigmakers and milliners often used mannequin heads for their window and shop displays. French moulded papier-mâché *marottes* (heads) were sold either as blanks to be painted, or ready decorated. As shown on page 69, there was an enormous variety. Some heads were relatively plain, with minimal painted decoration; others had applied printed features such as eyes, mouths or ears, or engraved mouths; the finest examples are distinguished by the subtle palette and sensitive draughtsmanship of their features, freely hand-painted on a fine gesso ground, and by their wonderfully elaborate hair. Although English mannequin heads were usually carved in solid elm and were rarely painted, they show the same varying degrees of quality in their stylized carved features.

Tradespeople such as locksmiths and blacksmiths who were also crafts-men often made their own signs, taking the opportunity to show off their skills. For example, the French locksmith's sign on page 68 is an amazing feat of different metalworking skills; the elegant and delicate silhouette incorporates the traditional figure of St Peter holding the symbolic "keys of the kingdom", together with the makers' names, and, for absolute clarity, a large decorative key. The precision and accuracy of the sign is a reassuring indication of the skills a good locksmith would be able to provide.

Similarly, the fish-oil merchant's sign (right) in the form of a strongly carved large wooden figure carrying a huge cod conveys the sense of the strength and

robustness demanded of the offshore fisherman. The size and design (the fish's tail is too long for a freestanding figure) suggest that this sign would have been mounted on a wall, where its strong silhouette and painted surface would have caught the eye of passing trade – as well as catching the full brunt of the weather, allowing the salt from the sea air to penetrate the varnish and create a wonderfully textured surface. The wooden fish shown opposite offers a marked contrast, with its finely detailed carved scales, gills and fins which would have been seen to advantage from close range, perhaps when it was raised on an iron bracket, as seen here, in a fishmonger's window, or hung from hooks above a shop doorway.

Portrait busts of famous authors such as Shakespeare or Virgil were as commonly used as booksellers' signs as carved fish were for fishmongers' and could be bought "off the peg". It seems likely, however, that the bookseller's sign shown below was a commission, combining what appears to be a bust portrait of the Scottish poet Robert Burns with a pile of books. Although probably based on a bronze original, the carved and painted wooden bust, which has, unfortunately, been repainted for protection,

OPPOSITE *This large English carved and painted pine sign (late 19th century; ht 165cm/ 65in) would have been wall-mounted outside a fish-oil merchant's premises. The heavy ship's varnish, now weathered and pitted with sea salt, has protected the authentic painted surface.*

RIGHT *This late 19th-century sign, a bust of the Scottish poet Robert Burns raised on three carved wooden books, follows the tradition of using portraits of famous authors as booksellers' signs.*

has a warmth and informality that reflect both the difference between the medium of bronze and that of wood (wood was essentially a non-academic material, carved by hand rather than cast) and the fact that Robert Burns was probably a favourite with this particular bookseller.

The popularity and prevalence of snuff-taking by both men and women and the use of tobacco ensured a flourishing trade for the tobacconist, and a large number of associated accessories were produced, often given as love tokens (see pp.32–7). There were several signs associated with the tobacconist, including the Blackamoor, the tobacco roll, the Highlander, the Jolly Jack Tar and the snuff rasp. The Black Boy or Blackamoor was generally shown wearing a "kilt" and a head-dress of tobacco leaves, and usually also carried a tobacco roll under one arm. The explanation for the apparently somewhat incongruous choice of a Highlander is that after the Act of Union between England and Scotland in 1707, Glasgow became one of the major ports for the importing of tobacco to Britain, and many tobacconists' Highlanders are shown carrying snuff-mulls or offering pinches of snuff. Life-size or over-life-size figures stood outside the shop, while smaller-scale figures, carved in the round, were free-standing inside the shop.

Exterior signs were painted, often in very bright colours, and gilded, both to attract attention and to protect vulnerable wood. Almost invariably, exposure to the elements resulted in severe weathering, broken and missing parts, and heavily distressed surfaces, all of which are part of the history of the sign and should only be sensitively restored. The Highlander figure of the early tobacconist's sign (right), for example, has lost its arms and lower legs, but has retained its original polychrome paint and integrity, which, together with the stiff, naive charm of the thin, stylized body and distinctive almond eyes, more than compensate for the missing limbs and the replacement feather. The style is in complete contrast to the Jolly Jack Tar opposite, also a tobacconist's sign, here shown proffering a pinch of snuff. Made in the second half of the 19th century, this figure, with its rounded form, owes its inspiration to the tradition of ship's figurehead carving, and its repainted surface has the bright, colourful appeal of the fairground figure.

A rare form – such as three-dimensional umbrellas, top hats, guns – or signs that are nostalgic reminders of a bygone era – such as the fish-oil sign on page 70 – are generally more appealing than the barbers' poles and pawnbrokers' signs that still feature in city streets. Trade signs were originally designed to catch the eye, and the most interesting surviving examples still continue to do so today through the same blend of strong silhouette and original or naive form, although time and weathering may well have created an interesting surface – faded, flaking or missing paint and gilding, pitted varnish – that, for the collector, will have infinitely more appeal than the once bright paint, gilding and lettering.

OPPOSITE *This handsome free-standing tobacconist's sign (ht 148cm/58in) modelled as a sailor holding a pinch of snuff is typical of the English vernacular wood-carving tradition.*

BELOW *This rare early 18th-century British Highlander tobacco sign (ht 102cm/40in), with its naive, slender form, has retained its original paint.*

Paintings

The evolution of the itinerant "colourman", who painted furniture, houses and signs, into a painter of animal and family portraits and domestic still lifes has left us with a legacy of pictures that share a wonderful stiff, naive, graphic quality, vibrant colour, and an unselfconscious disregard for academic preoccupations with perspective and scale. They offer an objective visual record, rather than an "artistic" interpretation, of an event, an animal, a place or person, with freshness, vitality and immediacy.

LEFT *This highly proficient 19th-century handwritten version of the Lord's Prayer in Norwegian, which may have hung in a bedroom, is the work of a skilled itinerant painter, who would also have decorated walls, furniture and bowls.*

OPPOSITE *This glorious portrait of "The Zebra" (oil on canvas; 94cm/37in square), signed "R.G." on the back, is one of the rare studies made within 50 years or so of the animal's arrival in Britain in 1762.*

Painted signs

Until the early 19th century painting was seen as a craft. Before *c*.1830, ready-mixed paint was not produced commercially, and itinerant craftsmen colourmen ground and mixed their own pigments in order to paint implements such as handcarts and wheel-barrows, as well as houses, furniture, coaches and signs. From the late 14th century English innkeepers had by law to display signs when they traded, and thus inn signs were common throughout the country, often extremely elaborate, each consisting of a metal frame, a painted and gilded double-sided sign and a carved bunch of grapes. In London, from the early 17th to the mid-18th century, tavern and other street signs were virtually a public art form: brightly coloured, double-sided and swinging.

The people who made these signs were craftsmen; their job was to create a colour-ful, graphic image, a bold silhouette that would read well from a distance and would be readily identifiable by a largely illiterate population. Signwriters were not trained artists; their skill was in two-dimensional painting, and their treatment of figurative

LEFT *This mid-19th-century double-sided sign for The Greyhound inn (l. 92cm/36in) was made by W. Flanagan. Framed in metal brackets, it is painted in oils on pine board, now split with age; its long life is a tribute to the thoroughness of the priming and the quality of the paint.*

LEFT *The reverse side of The Greyhound sign is less heavily weathered and reveals the competence of the lettering. The stylized landscape and greyhound dog are even more rudimentary than those shown above, but still retain the graphic quality that would have made the pub identifiable from a distance.*

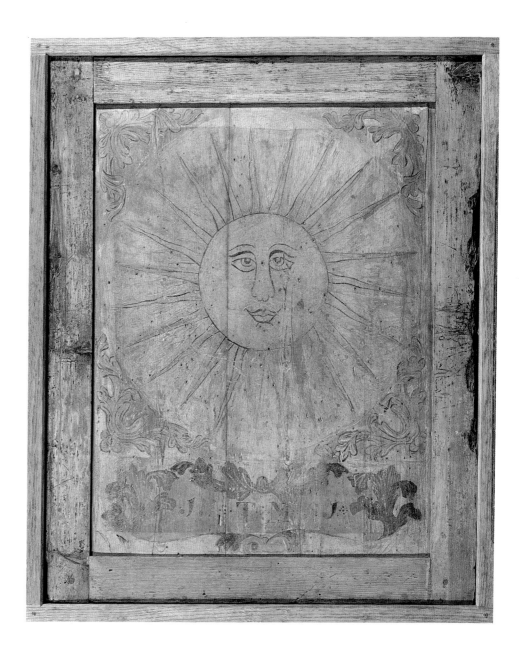

RIGHT *Dated 1751, this sun in splendour English tavern sign (83 x 68cm/32 x 27in) is one of the earliest wooden pictorial signs known to have survived with its original painted decoration. Painted in oil on panel with gold leaf, it carries the initials "T.M." – probably those of the landlord.*

elements often reflects this. Such qualities are clearly shown in W. Flanagan's double-sided sign for The Greyhound inn (opposite). Commissioned by the landlord to identify his pub for both literate and illiterate customers, and entirely without academic or artistic pretensions, it is a bold, professional piece of painting and lettering. The greyhound has none of the elegance of line usually associated with the breed, but has a delightfully static quality and a graphic silhouette that enabled it to do its job at the time and contributes to much of its appeal today.

Originality was not part of the signwriter's brief. The image had above all to be recognizable: many of the motifs used were formulaic and often copied from engravings or a pattern book. The image of the sun, or the sun in splendour (a reference to the golden rays), is one of the oldest known signs and was associated with brothels as well as taverns. The double-sided sun in splendour tavern sign above has survived with its original decoration from the mid-18th century – again a tribute to the craft of

the signwriter, although it may have been brought inside by the landlord or licensee after a proclamation in 1762 prohibited the use of swinging double-sided signs hung at right angles to the façade. Over the years the once vibrant colours have faded to soft, muted golds, blues and reds on a driftwood-like surface. Again, what has survived well is the graphic quality of the central image, outlined in black, together with sign-written details – the date and the initials of the licensee.

By the late 19th and early 20th centuries specialist signmakers were producing customized signs: two-dimensional boots, keys, candles, cows (for dairies), serpents (for apothecaries), spectacles (for opticians); some had lettering, perhaps including the name of the shop or the proprietor. A traditional sign in France was the briar pipe (superseded by a red double cone with white or black lettering) hung outside the *tabac* (tobacconist). These highly graphic signs are recognizable from a distance, and the dark background enables the light-coloured lettering to stand out. Wooden signs were superseded by painted tin, which was lighter but prone to rust, and eventually by sheet metal, and there was a strong tradition of wrought-iron and copper signs (see p.68).

Itinerant signwriters were also commissioned to produce calligraphy, which might range from an edifying religious text to memorial boards for municipal buildings,

ABOVE *Made of painted tin and measuring some 107cm (42in) across, this strikingly graphic late 19th-century sign, advertising briar pipes, is part of the strong tradition of bold French* tabac *signs.*

LEFT *This beautifully laid-out English sign-painted board, dated April 8th 1812, itemizing the rules of the servants' hall at Apley House, is both a fascinating piece of social history and a model of professional signwriting.*

OPPOSITE *This is an engagingly amateur attempt at signwriting by one Izikiah O'Donivan, in the form of rules to be observed at his lodging house, and details of other facilities. The sign was hand-painted by O'Donivan in the mid-19th century on an old 18th-century cupboard door.*

toll-gate boards, rules for boarding and lodging houses, and rules for servants' halls. These are interesting because of their social history, and a known provenance, such as the mention of Apley House on the sign on page 78, and a date will add greatly to their appeal. While the historian may be primarily interested in the content, the collector of folk art will find the object itself fascinating: its form, surface and execution, and its subsequent history. An interesting contrast here is between the rule board for the servants' hall and that for the lodging house on page 79. The former is a model of good typography and fine execution; the skill of the layout and brushwork is a perfect illustration of the craft of the professional signwriter, as opposed to the pleasing amateurism of the lodging-house rules, roughly painted on a recycled

ABOVE *A rare surviving example, made in the south of France, this exterior clockface (c.1831) has lightly incised and painted numbers and painted decorative motifs in now faded red, white and blue, with a central cockerel. The cleated pine frame allowed for shrinkage.*

18th-century cupboard door by the proprietor of a would-be respectable lodging house who has to remind his customers "NO BOOTS TO BE WORN IN BED".

Many less skilled signpainters used recycled wood. The antiques sign (left), probably made in the late 19th century, is painted on an 18th-century panel with chamfered edges. It has several "mistakes": the carefully worked letters become smaller and smaller in a vain attempt to fit them on – the final S slips over the edge; the letters are hard to read because the spacing is so tight, and from a distance the T and I blend into each other. But it is precisely these apparent "flaws" that make it so appealing.

Skilled signwriters also produced exterior clockfaces, often with lightly carved and painted numerals and perhaps another central motif. Few clockfaces have survived, and the example opposite has the attraction not only of rarity and a strong graphic quality but also of a wonderful dry, crusty surface, with soft, faded colours.

Another face of French provincial life is shown in the somewhat pretentious shop sign (below). A sign for a provincial shop that sells fine gunpowder for hunting, it is given an extraordinary self-importance through the use of a formal cartouche flanked by stiff flags and rudimentary cannons. This is an attempt by a craftsman whose skill was primarily signwriting to move into the arena of pictorial representation.

ABOVE *This charmingly amateur antiques sign, probably late 19th century, was painted on an earlier panel. Although cramped, the lettering has been executed with great care and use of outlining to create a three-dimensional effect.*

RIGHT *This delightfully self-important 19th-century French provincial shop sign, with its imitation gold leaf, has distinct nationalistic and militaristic overtones in its choice of lettering and rather poorly executed pictorial and decorative motifs. The immaculate surface may have been retouched.*

From painted signs to portraits

Family trees, the inscriptions inside huge family Bibles, and baptism, marriage and death certificates are all evidence of a desire to record events – a way of saving a moment for posterity. A pictorial image, however unskilled, could both act as an alternative form of recording and supplement or decorate a written account.

The plan of the estate (below), made and signed by "Rich. Richardson", is clearly based on the concept of an important map and includes several rather grand cartographic devices: cartouches, dividers, a compass, and elegant lettering. The amateur mapmaker's desire to include three-dimensional detail in the otherwise plan perspective has resulted in a charming and naive attempt to reproduce the elevation of trees, hedgerows and buildings – a trait also common to many naive portraits (see p.75). The map (opposite) is a record of a preaching tour made by J. Raynsford in 1830–50, recorded by James Raynsford, possibly the same person or a close relative. It is an amateur execution, and the desire to record combined with the aim to create something "artistic" has resulted in a fascinating presentation of highly original, personal and precise documentation embellished through colour and extraneous detail.

In Scandinavia itinerant craftsmen decorated houses by painting furniture or walls, but framed pictures were scarce. However, on ceremonial occasions rooms were

OPPOSITE *"J. Raynsfords Labours in Preaching the Gospel from the Year 1830 to 1850 in 5 counties, 54 chapels 64 houses and 3 barns as founded on scriptural alligrity Drawn by James Raynsford Spring 1850".*

BELOW *The "Plan of Elston, the Estate of Robt Chaloner Esq" (1761) is a blend of grand details and attempts by the amateur cartographer to integrate three-dimensional trees and houses into a bird's-eye perspective.*

ABOVE *This Swedish* kurbitz *(cucumber flower) painting (c.1830; l. 122cm/48in), probably made to commission by an itinerant painter, depicts the famous battle between the Swedish hero Burman and his arch enemy Holgerdansk.*

decorated with *kurbitz* paintings, named after the stylized *kurbitz* or cucumber flower that was traditionally incorporated. These narrative paintings, part of a long-standing tradition, but particularly widespread and well executed between 1800 and 1860, depicted stories from the Bible or folklore on long narrow rolls of thick paper or canvas, which were pinned up round the room like a frieze and stored after use. Their format and style resemble that of the Bayeux Tapestry – a vigorous, unselfconscious depiction of a heroic narrative in strong primary colours in a naive flowing style characteristic of much Scandinavian painting. The painters of the *kurbitz* paintings worked within an established tradition, making no claims for individual originality.

The English watercolour by Humphrey Powell (below) has gone a step further. It seems to be a hybrid between a trade card – depicting what appears to be Humphrey

RIGHT *This early 18th-century English watercolour is inscribed "Humphrey R Powell his hand". Why he made it is a mystery. It seems to be a portrait of him at work and at leisure; perhaps it was intended as a trade card. The purpose is less important than the process – a delightful blend of closely observed detail and careful but unskilled execution. (20 x 15cm/8 x 6in; pen, ink and watercolour on paper)*

at his work table, carrying his certificates and surrounded by the tools of his trade – and a personal record of what may be his house and himself playing the violin. The picture is full of carefully observed details rendered with great fidelity but without regard to perspective or scale, as seen in the extremely long arm of the violin player. This blend of meticulous observation and deliberate but unskilled execution can be seen in the equally mysterious carved and painted English wooden panel on page 38.

The attempt to record or reproduce sometimes had "painterly" overtones, not the result of a self-conscious artistic imagination but an inherent part of recording an event that had given pleasure at the time and gave pleasure in the depiction of it. The desire was not to be original, rather to make a personal translation of a known image, as shown in the painting of the hunt (above). It has all the qualities of a painted sign: static, two-dimensional images that yet convey movement; strong silhouette; skilful juxtaposition of light and dark tones to emphasize the graphic quality; and a disregard for scale and perspective; but there is an overwhelming sense of strong narrative, that this was a particular hunt on a particular day, painted by someone who was there.

ABOVE *A stage in the gradual evolution of the signwriter to the portrait painter can be seen in this English painting of a hunt (c.1800; oil on board), in which the primary objective – to record a particular event – has become imbued with the painter's personal response to his subject.*

Animal portraits

The British love of countryside pursuits established a strong tradition of academic portraits of horses and dogs with their proud owners, but this was primarily the preserve of the landed gentry and the "artists" they patronized. In the mid-18th century there was an increasing interest in the science of animal husbandry and crop management; new breeds of livestock were produced, and owners and breeders commissioned portraits of their monster animals from local or itinerant and generally anonymous painters. The fashion for paintings of farm livestock thrived from *c*.1780 until *c*.1900, when painted portraits were largely superseded by photography.

These painters were still without formal academic training, and their job was simply to record a given animal in a given place at a given time. Their treatment remained that of a signwriter: a bold, graphic image that read well from a distance; an attention to detail; and a static quality that nevertheless retained a vitality born of a freshness of vision and an unselfconscious use of colour and line, with little concern for scale and

BELOW *This anonymous Dutch painting "De Zomer" (Summer) (c.1860) was probably commissioned by a well-to-do country gentleman who wished to record his prosperity. The stylized landscape draws the eye to his grand house. (87 x 97cm/ 34 x 38in; oil on canvas)*

perspective. Indeed, patrons often required them to exaggerate specific qualities. The Dutch painting (opposite), for example, makes no attempt at naturalism. It records the station of a bourgeois landowner, seen, with his wife, tucked into one corner so that the eye is drawn past the flock of stiff, stylized sheep – a status symbol – down the avenue of trees to the smart house. There is no attempt to record the landscape; the stylized, uniform trees and perspective closely resemble a formula used on samplers (see p.140), in marked contrast to the liveliness of the gamekeeper's dog on the right.

The same scant attention to landscape is apparent in the portrait below, again commissioned as a record, perhaps of success in a ploughing competition. It has an

ABOVE *This wonderful early 19th-century English portrait, "Joseph Lawton's Midland Plum Pudding Pig" (whose vital statistics are displayed), was probably commissioned by Joseph Bradbury, of Little Hayward, Staffs. (67 x 106cm/ 26 x 42in; oil on canvas)*

LEFT *This mid-18th century European portrait, with its strong, static, graphic image of a ploughman dressed in Sunday best and two horses decorated with rosettes, may be a record of a ploughing competition. (36 x 28cm/ 14 x 11in; gouache on paper)*

ABOVE *This English portrait, "A Boy on a Horse" (c.1840), is an interesting provincial interpretation of mainstream portraiture, combining a static, naive depiction of the horse and boy with a more painterly landscape background.*

RIGHT *The stiff, formulaic quality of this English portrait "Feeding a Pony" (c.1880) and the closely observed architectural detail suggest it was the work of a signwriter or coachpainter, and offers a marked contrast to the portrait above.*

extraordinary graphic quality, with the strong silhouette of the horses and the figure further emphasized by the light background. The man was probably painted first, with particular attention to the detail of his clothing; the same attention to detail can be seen in the depiction of the horses' tack. Both ploughman and horses share the same stiff-legged wooden quality, with no naturalistic detail or perspective.

By contrast, in the superb picture of "Joseph Lawton's Midland Plum Pudding Pig" on the same page, landscape, pig and proud owner are all given equally detailed treatment. So accurate is the depiction that the location has been identified as the Lichfield Arms (now the Lamb & Frog). The owner's dress is accurately rendered, as is every hair on the vast piebald pig, which dominates the picture with its huge shape supported on tiny feet. This picture has all the elements that make up a great naive animal portrait: a known provenance and an authentic, identifiable setting; a combination of animal and handler; documentation within the picture; and above all an animal (and pigs are always popular) with a personality to match its size.

The same is true of the portrait of the draught horse "Leopard" (below) – another gargantuan animal whose statistics are proudly recorded in the picture. He has an almost heraldic quality, combined with carefully painted tack and a very domestic feed bag. The characteristic sign-like side-on view is also found in the strange picture shown opposite (bottom). It is entirely without "painterliness"; instead it offers an extremely workmanlike recording of observed detail: windows, shadows, brickwork are depicted with minute attention to detail, while the pony has a formulaic stiffness

LEFT *This magnificent English portrait of a draught horse, commissioned by the owners, is inscribed "Leopard the property of Barcley, Perkins & Co. In harness 2 ton, 8 cwt. Shoes 28 pounds. Aged 28 years". Although the use of shadows is rudimentary, the composition of the painting is quite sophisticated: Leopard is outlined against the sky; the brick arch echoes the arch of his huge neck; and the eye is led past the horse through to a stylized port. (c.1860; oil on canvas; 48 x 58cm/19 x 23in)*

LEFT *Although the huge scale of this English rabbit closely resembles that of the prize livestock animals, it may have been painted as a portrait of a pet for the child owner, as it has a more romanticized, naturalistic, painterly treatment by a very confident hand. (c.1860; 15 x 20cm/ 6 x 8in; oil on canvas)*

and lack of anatomical verisimilitude that leaves us in no doubt that this is the work of a signwriter. The story behind the picture can only be guessed at.

The gradual move towards a more painterly approach is evident in the portrait of a boy on a horse on page 88. This is a provincial painting, but executed by someone who had seen and understood the language of the mainstream equestrian portraits. The horse and rider retain a stiff naive quality, but the horse's legs are rendered with greater anatomical accuracy, and the depiction of the surroundings is more painterly, in contrast to the treatment of the landscape in the portrait of the zebra on page 75.

An increasing naturalism is also evident in the portrait of the rabbit (above). The scale of the monster rabbit with its large bold eye is that of the livestock portrait, but the treatment is far more painterly and romantic; the same rather sentimental tone is equally strong in the portrait of the spaniel and puppies on page 92. The slightly over-worked fussiness bears no relation to the just as densely worked but crisp, precise, detailed brushwork, giving a strong graphic quality, in the portraits of the pouter pigeon (right) and the cat on page 93. This graphic quality has been replaced in these ostensibly more painterly and conventionally charming pictures by proficiency and sophistication.

The topographical accuracy found in the portrait of Joseph Lawton's pig was a feature of a school of signpainters who produced, essentially, portraits of provincial market squares, often unpeopled, with precise architectural detail and a characteristic skewed perspective. These are primarily architectural portraits, with token figures giving a sense of scale. But in the painting opposite (top), the precisely painted cobbles,

ABOVE *"A Travelling Circus with Elephants Passing the Peacock Inn"* (c.1840; oil on canvas; 44 x 63.5cm/ 17 x 25in). The attention to architectural detail owes much to a school of paintings of market squares; but whereas these are usually unpeopled, here the painter has captured the moment in time that the circus passed through.

RIGHT *The presence of another pair of pigeons in the background of this delightful portrait of a pouter pigeon on a pedestal by J.W. Pigg suggests it may have been commissioned by a breeder.* (c.1870; oil on canvas; 33 x 28cm/13 x 11in)

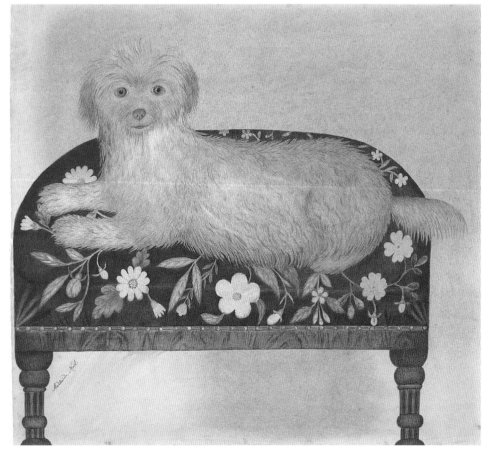

ABOVE *In this English portrait "A King Charles Spaniel and her Two Puppies" (c.1830; oil on panel), boldness and graphic image are replaced by a more romanticized treatment, with deliberate exaggeration of features such as ears and eyes that would add to its "charm" and appeal.*

LEFT *The highly competent and precise painting of the furniture in this charming French portrait (second half of 19th century) contrasts with the tentative treatment of the dog, which appears to float weightlessly in space.*

RIGHT *This is an exceptionally fine portrait of an exceptionally imposing cat. The tremendous static, naive quality and imposing silhouette are combined with such painterly details as dramatic lighting and the use of shadow and perspective. (c.1810; English Naive School; oil on canvas; 36 x 43cm/ 14 x 17in)*

roofs, windows and railings are accompanied by closely observed figures, dogs and horses, frozen in the moment of the circus's passing through. The unusually well-observed elephants and the elaborate coach may have been inspired by a circus poster.

Paintings of domestic pets were not so much a record as a portrait that went some way towards capturing the personality of the animal. By the mid-19th century ready-mixed paints were available, and the growth of amateur "artists", along with the Victorian predilection for sentimentality, encouraged a tendency towards a more romanticized style and setting, as evident in the rabbit on page 90 and the spaniels (opposite top). In both portraits, features such as ears and eyes are exaggerated to create a self-conscious charm, rather than a strong, graphic image being allowed to speak for itself, as it does so eloquently in the needlework picture of the gun dog on page 139 and the portrait of the magnificent cat (above). This painting exemplifies many of the qualities that make up a great naive animal portrait: scale – the cat fills the canvas effortlessly; a strong graphic quality; colour; and careful attention to detail. Any self-conscious painterliness is confined to technique – skilful use of highlight, shadow and discreet perspective – and used to heighten the presence and personality of the subject.

Not all signwriters were at ease with their new role. The French portrait shown opposite (bottom) was clearly painted by a highly competent draughtsman, a designer who recorded inanimate details impeccably (the wood grain, the patterned fabric). He was more tentative in his treatment of the picture's subject – a rather fey little dog, who appears almost to float on the surface of the canvas but for whom the whole composition has been moved off centre in order to accommodate the tail. This engaging blend of style and confidence lies at the heart of the appeal of much folk and naive art.

Domestic portraits

From the late 18th century the burgeoning middle classes increasingly commissioned portraits of their families. Unlike the wealthy upper classes, who could afford to patronize leading academic or society painters, the provincial middle classes usually commissioned their portraits from itinerant or local "ornamental" painters. Although a significant minority of such painters is well documented, especially in the regions where they worked, many remain anonymous under the umbrella title "provincial school". While date and signature can add to a painting, the quality of the portrait itself ultimately determines its appeal. By the mid-19th century the availability of ready-mixed paints led to a proliferation of amateur portrait painters, often young women, whose informal portraits often have a delightful intimacy.

Portraits of children are especially endearing, partly because their lives were often so precarious at this time, but also because they are so often painted with their favourite toys, pets or other attributes that suggest their sexes and stations, and something of their histories and personalities. Group watercolour portraits of children are rare; much more readily found are individual portraits, such as the amateur watercolour of Louisa Betts (right), which illustrates many of the qualities found in the most appealing portraits: a static, stiff, doll-like quality; carefully painted dress, precise

ABOVE *This charming and intimate watercolour portrait (13 x 10cm/5 x 4in) is inscribed "Louisa Betts 9 months old. Drawn 2nd April 1847 by A. Marsingale". The painter was probably a close friend of the child's family.*

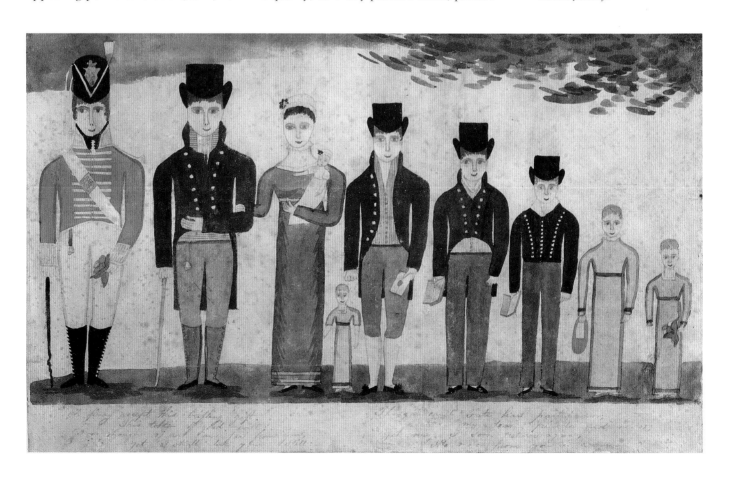

RIGHT *This oil portrait, "A Boy in a Field …" (c.1850), by an unknown provincial artist, may have been commissioned by a nouveau riche family and is full of symbols emphasizing its newly acquired status and prosperity.*

OPPOSITE *This delightful portrait of William Winter and family was executed by a professional letter-writer, in Dublin, together with a letter, dated "15 Jan 1816", which was sent to England shortly before William deserted from his regiment. (20 x 30.5cm/ 8 x 12in; watercolour and ink on paper)*

hairstyle and tiny feet; and a wonderfully personal quality, partly due to the small scale and the medium, as she sits centre stage, clasping her doll with its vivid blue dress.

Portraits of young military men are quite common, as many officers were accomplished draughtsmen, and often painted self-portraits which they sent home to their families. The watercolour portrait of William Winter (opposite), however, was executed by a professional letter-writer, and accompanied a letter he had written for William. It shows William, in scarlet, with his family. Each figure is depicted face on, in virtually identical poses. They stand like a row of wooden skittles, clasping a book, a bag, a flower, even a baby, with touches of primary colour and immense attention to such details as the rows of buttons. This portrait has great appeal; first and foremost a professional letter-writer's illustration, it is a piece of social history that, with its bold, precise execution, makes an exceptional example of folk art.

The intimacy of these amateur watercolour portraits, in which figures take precedence over background, is missing in the more formal portraits commissioned as much to record the status of the family as the individual. The portrait above, for example, is almost certainly that of the young son of a nouveau riche family, whose newly acquired prosperity is symbolized by the horse and cow, the acres of land, and the boy's smart clothes. The painter's limitations are seen in the strange proportions of the

ABOVE *This important portrait of a prosperous couple, of Latin origin, was probably painted in the second quarter of the 19th century. The same woman, with the same directness and strength of gaze, appears in the portrait below, which is also unsigned and by the same hand.*

LEFT *This unusual group portrait includes what appears to be a younger version of the woman in the portrait above, shown here with her children, and displays the same painterly skill and presence.*

"The Gibson Children in the Garden of Their House at Southall, Middlesex" is a delightful blend of individual portraits and discreet symbols of the family's prosperity. (c.1840; English Provincial School; 56 x 66 cm/22 x 26in; oil on canvas)

figure – essentially a compacted adult. But the clothes are well executed; the rich, thick fabric of the coat is almost tangible. Such unevenness is an integral part of the appeal of this slightly pretentious picture, itself part of a new tradition in which the middle classes set out to record their emergence onto the social and artistic scene.

The same motives may have inspired the portrait of the Gibson children (above). Signs of affluence are present: parkland, a gazebo, mature trees, pets and other symbols of leisure and, above all, eight healthy children. But the painter has managed to retain an intimacy; the children are recorded as individuals, and the composition emphasizes them rather than their attributes. The use of colour – the vibrant blue and the contrast of black and white – gives a strong graphic quality, as do the delightfully stiff front legs of the greyhound, echoed in the stiff legs of the standing children.

The anonymity of many domestic portraits – we know the identity of neither painter nor sitters – is highlighted when there are two or more portraits of the same family, and by the same artist, as in the portraits on page 96. The bold, static figures are closely observed as individuals; the family is obviously of Latin origin and, judging by the lace and jewellery, prosperous. The symbolism of the rest – the laurel wreath, books, pigeon, the scissors and fabric – is unknown. Beyond doubt are the painter's skill in rendering details of costume and the painterly use of shadow and highlight.

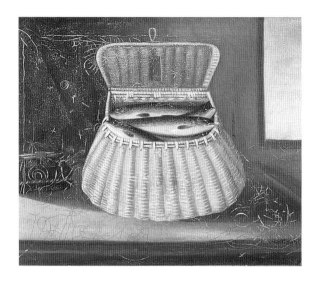

This English mid-19th-century still life of a fisherman's creel, which retains an original surface and craquelure, was probably painted by a signpainter, who has used highlighting to bring out the quality of the wicker-work creel and the strangely static, stiff fish. The dry surface has natural breakup.

A distinctive characteristic of folk and naive painting is the rejection of perspective in favour of portraying the picture plane, bold colour and form that emphasize the subject of the painting, as evident in the French still life (opposite), which combines plan and elevation. The painting of the fisherman's creel (above) also jettisons conventional perspective in favour of being able to look simultaneously into the basket to see the fish, and at the shaped lid and flaring body of the basket.

The superb still life of the coffee tray (below) blurs the distinction between provincial painting and folk art. The pleasure taken in the actual painting is tangible. The strong graphic quality and the slightly skewed perspective are essentially naive; the objects themselves might be expected to be 20 or 30 years behind the times in a provincial painting, but here they are at the height of fashion.

This superb late 18th-century French still life, "Le Petit Déjeuner ...", is one of several known paintings by L. Dupomchel, probably a provincial painter. (oil on canvas; 45 x 57cm/18 x 22½in)

This consummately graphic French still life, "The Festive Feast", encompasses bold silhouette, meticulously rendered detail, and a perspective combining both plan and elevation.

Mixed media pictures

By the mid-19th century, the former itinerant artisan signwriter was far more likely to be town-based, and was now increasingly likely to be described in the local trade directory as a "decorative and pictorial artist" rather than the sign- and furniture-painter of 40 years or so earlier. Furthermore, painting was now a recognized accomplishment for a young lady and a leisure-time activity for the middle and upper classes. In Britain the Victorian passion for decoration led to a craze for pictures in a wide variety of media. Straw, sand, feathers, seeds, stamps, cut paper, embossed paper; collages of fabric, hair, sequins, shells and buttons; stencilling; Berlin woolwork – all were grist to a seemingly endless mill of framed pictures that jostled for room on the walls of the Victorian home.

This use of different media reflects a typical aspect of the folk-art tradition, that of making use of whatever material was to hand. Sailors, in particular, made ingenious

BELOW *The pride that sailors took in their ships is clearly shown in this fine, probably French, portrait (c.1800; 80 x 102cm/31½ x 40in). As much emphasis is given to the portrait of the ship as to that of the distinguished captain, who is shown here with the tools of his trade – an imposing navigation map and a pair of compasses.*

RIGHT *Woolwork ships'
portraits were produced by
sailors serving in the British
navy. This depiction (c.1840;
58.5 x 44.5cm/23 x 17½in)
of a fully-dressed ship, flying
the flag of St George and
the Union Jack, has all the
characteristic minute
observation of details.*

use of a variety of materials, including marine ivory (see pp.62–4), rope, shells and
scraps of wool to make portraits of their ships – both merchant and navy. Portraits of
ships are as important and popular as those of houses, and fakes are known; a portrait
of a very well-known ship or a very famous battle, or one that includes a particularly
memorable date, should be approached with caution.

Most sailors were justly proud of their ships, and this pride in the seafaring tradi-
tion is clearly evident in the three very different portraits shown on these two pages.
The fine oil portrait of the ship's captain (opposite) is obviously the work of a profi-
cient painter, who has paid equal attention to the figure of the captain and the portrait
of his ship. The composition subtly reinforces the balance: after an initial preoccupa-
tion with the closely observed, carefully reproduced features of the captain's face and
the dramatic black and white contrast of his costume, the eye is inexorably drawn

RIGHT *The grand, militaristic
tone of this English water-
colour portrait (c.1790;
48 x 69cm/19 x 27in)
celebrating a naval victory
at Gibraltar, complete with
nationalistic figure of
Britannia, is offset by the
unselfconscious charm of the
hundreds of tiny sailors and
the naive perspective of
the cross masts.*

to, and remains on, the portrait of the ship, with its static sails on a stylized sea, which appears to be floating in the air, hovering above the large navigation chart.

Some ships' portraits commemorated famous naval victories. The watercolour on page 101 (bottom) is a wonderfully detailed example; hundreds of tiny sailors – lined up on deck, on the masts and in little boats – are dwarfed by the imposing ship (sailors often exaggerated the size and importance of their vessels) which fills the picture, bedecked with flags and surrounded by allegorical figures of the wind and Britannia and a grand cartouche. This same minute attention to and faithful reproduction of detail can be seen in the woolwork ship's portrait on the same page (top). These woolwork pictures, carefully and neatly executed on ship's canvas, were an almost exclusively British, and naval, phenomenon, largely produced in the middle of the 19th century. Invariably the ship was shown side on, with no attempt at perspective, as is the case with the ship shown here. It is set against a laboriously worked sky with clouds, in which the direction of the long and short stitches is used to enhance the texture of the picture. Other ships' portraits were painted on the insides of the lids of seamen's chests, or were executed in marquetry or as low-relief dioramas. From the end of the 19th century, when clear-glass bottles became plentiful, many sailors chose to make their portraits in the form of the ship in a bottle, often set against a detailed landscape, executed with characteristic patience and skill.

It is precisely this evidence of careful, considered working that characterizes many of these amateur mixed media pictures: this was an area not so much for spontaneous

RIGHT *One of the many mixed media techniques popular with accomplished young ladies was the theorum picture – a design stencilled onto velvet. Favourite subjects included birds, baskets and fruit, here combined in this mid-19th-century picture in a strong graphic design executed in subtle muted colours.*

creativity as for carefully planned execution or a well thought-out translation of a personal vision. Theorums – stylized imitation "paintings" stencilled on velvet – were one well-known school of amateur pictures. A "romantic" design and treatment combined with bold images, bright colours and a strong graphic quality all add to the appeal of these now sought-after pictures. Favourite subjects were cornucopia, animals, baskets and, in particular, exotic fruit. The "artistic" element lay in the choice of colour – more exotic fruits such as pineapples were popular because they tended to be worked in brighter colours and offered a more dramatic silhouette – although the soft, subtle muted palette of the picture (opposite) is perhaps more appealing to today's taste and provides a good contrast for the graphic black head, tail and legs of the bird. Velvet was also used to produce pincushions, and a highly popular collecting area is the giant three-dimensional velvet "fruit" pincushions, filled with sand and seeds, which were awarded as prizes at horticultural shows throughout Europe.

Feather pictures were another vehicle for the creative, accomplished young woman, and were made throughout Europe, especially in Sweden. Although abstract geometric feather pictures are known, as might be expected the most common subject was birds. The form of the bird was painted in watercolour and then carefully decorated with feathers, as shown in the two examples above. The resulting purely decorative pictures are often almost too proficient: the images may become too detailed to read from a distance; they frequently have a self-conscious painterly hand; and they may be almost too naturalistic, losing that static, naive quality that was translated from the sign to the portrait, and which is so evident in the extraordinary and unusual stamp picture on page 104. This picture is a perfect example of the care, planning and attention to detail that so often characterizes the "naive" eye. All the details have been minutely observed and reproduced – picket fence, gate, glazing bars; and the elements that could not be reproduced with stamps – the gardener silhouetted

ABOVE Birds were inevitably one of the principal subjects of feather pictures. In the English examples shown above (c.1850; 48 x 36cm/ 19 x 14 in), feathers have been stuck onto the watercolour forms of the poultry to create a very "painterly", naturalistic portrait.

ABOVE *This delightful and unusual picture of a house, garden and gardener has been carefully worked in blue and beige stamps depicting the head of Queen Victoria, with additional hand-painted detail. The picture (44 x 61cm/17½ x 24in), by Henry Goddard, is signed and dated "1862, Croydon", and inscribed "589 stamps".*

against his shed, the smoke from the chimneys, the trees and bushes – have been meticulously painted in to create a totally engaging combination of formal design and intimate effect, printed image and hand-painted detail.

Another popular amateur technique was the pinprick picture. Probably derived from "pouncing" (marking out an image to be painted), the technique was adapted to produce decorative pictures. A print or an engraving was laid on a piece of paper, and the major elements of the design were pricked through, using a needle, pin or even a toothed wheel, onto the sheet of paper below, which was then painted in water-colour; the paint collected in the pinpricked holes to create a characteristic strong outline, as shown in the picture opposite (below). Finer lines of pinpricks, usually executed with the toothed wheel, were used to create detail – as seen here on the bod-ies of the dog and the hare, the stockings, breeches and jacket of the young hunter, and the stylized foliage, which is echoed in the feather and trim of the hunter's hat. These ephemeral pictures were essentially amateur, produced largely by young ladies for family and friends, and their appeal for the collector will depend to a great extent

LEFT *These felt and watercolour portraits of "Elizabeth Horne, the Goose Woman" (left) and "Old Bright, The Postman" (both c.1830) are by George Smart. The famous tailor of Frant described himself as an "Artist in Cloth and Velvet Figures".*

on the charm of the image (religious subjects were very popular at the time but are less so today) and the strength of the outline.

Not all mixed media pictures were the work of amateurs. One of the best-known British exponents was George Smart, a tailor, of Frant, near Tunbridge Wells in Kent, whose work and career have been extensively documented. Smart used leftover pieces of felt and other fabric to create pictures of birds, animals and – most sought after today – portraits of various local "characters" on watercolour backgrounds. Later examples have printed and aquatinted backgrounds. Smart was patronized by the Duke of Sussex and, following the success of his pictures, described himself on the trade label that appeared on the backs of them as "Artist in Cloth and Velvet

RIGHT *Most pinprick pictures were the work of young ladies. Many had religious themes, although such pictures are less popular today than ones like this French example depicting a successful hunter with a particularly engaging dog (end 18th century; watercolour on paper; 37 x 30.5cm/14½ x 12in).*

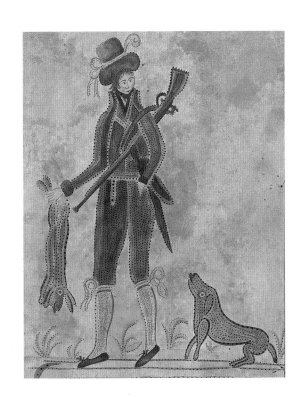

Figures". Yet for all its artistry the appeal of Smart's work is essentially that of the naive painting – a delightfully static, often humorous portrait with a strong graphic quality that is a direct descendant of the pub sign. Smart pictures are well documented and eagerly collected, and normally retain the original Smart trade label to the reverse.

Another arena for the professional signwriter was carved and painted wooden dummy boards. These were known throughout Europe, but were particularly popular in Britain and The Netherlands, and may first have been produced in the early 17th century. Early examples were invariably "companion" figures – often maids – painted on wooden panels with chamfering to the back. Later examples were sometimes in the form of animals – in particular dogs and cats, and even pigs. The outline of the image was drawn on a wood panel, then cut out and painted, and the wood given a chamfered edge to the reverse. Later, less sought-after examples were made by cutting out portraits on canvas and then laying them on wooden panels.

Dummy boards were companion pieces, placed around the room in winter, and in summer commonly used to decorate an empty fireplace. With their distinctive cut-out silhouettes, dummy boards – rather like weathervanes (see pp.52–7) or the *tabac* shop signs (see p.78) – are the ultimate graphic image, and the cat and dog shown here (opposite) both have exactly the static, stylized quality found in the best examples, which are essentially objects rather than paintings. By contrast, the delightful greedy pig (below) is far more painterly, with an attention to detail – the inclusion of a feeding trough – that has obscured the clarity of line of its front trotters and nose and tends to distract from the graphic quality of the image. The surface of the dummy board is as important as the form; ideally it should be in untouched original condition – as seen in the cat and dog – displaying evidence of a long life often spent in close

ABOVE *This rare mantelpiece ornament in the form of a cat is dated "August 24 1816". Made of wood covered with felt (now worn), it has eyes made from mirror glass.*

RIGHT *This rare pair of wooden dummy boards (c.1780), three-quarter life size, have highly desirable untouched original painted surfaces.*

LEFT *Pigs are popular animals with collectors. This wooden dummy board (c.1820; l. 44cm/17½in) has a highly worked, detailed, painted surface, which offers a marked contrast to the subtle, aged surfaces of those opposite.*

ABOVE *This dummy board blackbird (first quarter 19th century; ht 18cm/7in), made of wood and felt by George Smart, is a companion piece for the cat opposite.*

proximity to an open fire, perhaps knocked by brooms during cleaning, and having been lifted and moved by generations of hands.

A rarer, smaller type of dummy board was influenced by Victorian painted cast-iron chimney ornaments, often in pairs (Punch and Judy and vases of flowers were popular subjects), that sat on either side of the mantelpiece. The boards were cut out of tin or wood, and the bold graphic outlines were then covered in felt or velvet and either applied or hand-painted with details such as eyes and whiskers. The cat shown opposite (top) has applied mirror-glass eyes and freestanding whiskers, and carries a label with the details "S. Jones Knowle August 24 1816". Its blackbird companion (left) was made by George Smart, whose label can be found under the stand. These very rare and sought-after pieces share all the graphic qualities of the larger dummy boards, but have a surface appeal of worn fabric rather than worn paint.

Following the Industrial Revolution, many previously itinerant craftsmen and artisans were employed in the newly established workshops and factories. And with the development of the production line came the division of labour; it became increasingly rare for the factory-based craftsmen to retain autonomy over their work, and as they made the distinction between paid work and creative work, many joined the swelling ranks of the "amateur artists" for whom creativity was a leisure pursuit.

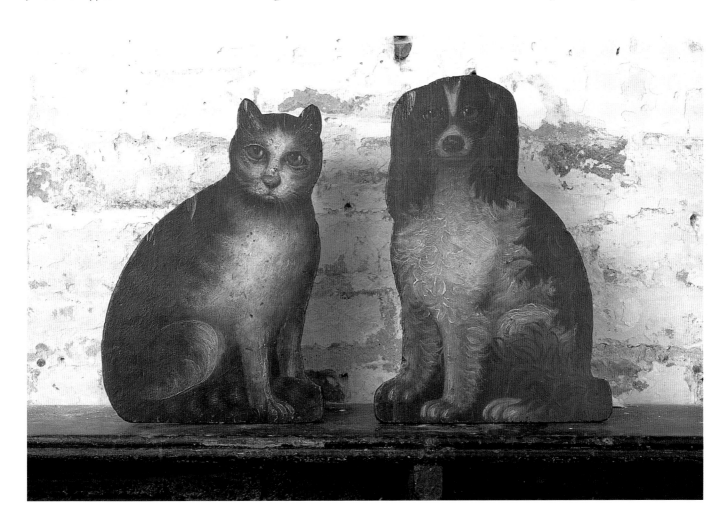

Toys and games

Toys are potent symbols of childhood, whether fashioned from wood by a craftsman or home-made from scraps of fabric. Eye-catching silhouettes, sculptural or original forms and interesting surfaces mark out those special toys that ooze personality and become both poignant links with childhood and tangible expressions of the care with which they were made and the pleasure of the children who played with them.

RIGHT *This unusual Norwegian carved and painted pine jumping jack on a frame (ht 30.5cm/12in) is an engaging blend of naive static charm and personal detail; the base is carved with the name "ELISE", for whom it was made, and the date "26/1/[18]66".*

FAR RIGHT *These hand-made children's chairs and carved and painted wooden animals, and the watercolour portrait (c.1820) of a young girl, create a nostalgic evocation of a 19th-century English childhood.*

Soft toys and dolls

Soft toys were a simple and an inexpensive home-made option for people who had neither the skills nor the resources to fashion toys from other materials. Scraps of fabric were recycled to make soft, cuddly forms that often owed more to the imagination than to accuracy and were stuffed with whatever was to hand; these hand-sewn dolls and animals had rudimentary sewn features or perhaps commercially available glass eyes. The few that have survived the ravages of moths or years of cuddling are very difficult to date; basically they are as old as the latest feature – fabric, stuffing or commercially made eyes – that can be identified by fashion or style. Following the success of Margarete Steiff's hand-made, commercially produced soft toys, launched *c*.1880 in Germany, cottage industries sprang up to capitalize on the newly popular form.

The stiff, static, precise silhouette of a pristine or commercially made soft toy can be far less interesting than the drooping head or splayed feet of a much-hugged and shabby favourite animal, or the mismatched proportions of the commercially

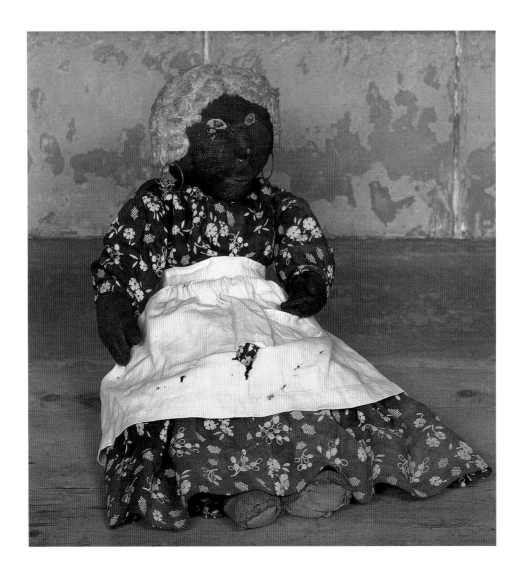

LEFT *This hand-made stuffed black doll (ht 30.5cm/12in) has fabric hair and hand-stitched features and hands. Of uncertain origin, it was made* c.1900 *and is obviously slave-related. The clothes, made from recycled fabric, include long bloomers that almost reach down to her delightfully "crashed" feet.*

OPPOSITE *Although different in style, these early 20th-century toys have strong sculptural silhouettes. The plush elephant, with its long trunk, and the perky white rabbit may have been commercially made; the worn brown velvet rabbit and the canvas donkey are home-made and full of personality.*

made elephant whose pendulous trunk has lost its curl. Old, recycled fabric, balding velvet, loving repairs and mending all add to surface interest. And form and surface together may have created a very particular personality – a hang-dog donkey or a weary brown rabbit whose worn plush is echoed in its floppy ears and flat feet – which endeared the toy to its original owner and may prove as appealing to collectors.

Home-made dolls have been whittled and carved in wood from early times. Many were crudely made, with unshaped bodies, roughly carved heads and rudimentary features. In northern Europe, by the 16th and 17th centuries, wooden dolls were being produced on lathes by chairmakers and sold at fairs; by the 18th and 19th centuries, in forested regions of Germany such as Berchtesgaden and Sonneberg, and in Grodnertal in Austria, whole families were engaged in producing wooden dolls with jointed arms and legs and "spade" hands, which were sold across Europe. These carved and painted dolls – country cousins of the more expensive wax and china-headed ones – were known as penny woodens

ABOVE *Of uncertain origin and date, this charming naive animal of recycled velvet, with saddle-shaped marking, was probably meant to be a horse.*

(they cost 1d (1p)), Dutch dolls (probably a corruption of *Deutsch*) or peg dolls (a reference to the peg-fastened arms and legs). They varied in quality from tiny carved dolls (2.5cm/1in), with peg-jointed arms and legs, crude wooden bodies and blobs of paint for features, to more sophisticated larger dolls (61cm/24in), with ball joints and swivel waists, expressive painted features and elaborate painted hairstyles. Towards the end of the 19th century such dolls became more formulaic and mass-produced; they were usually carved and painted by different people, and although they retained a delightfully stiff naive quality, they lost much of their earlier vitality and character.

At the other end of the scale are the dolls and dolls' furniture crafted for a particular child and a particular occasion, and including personal details as decorations. The Norwegian bed below is a copy of a style that was current some 30 years earlier than the date on the side – styles lingered far longer in rural communities, although the date could have been added later. The beautiful original blue paint, the careful but unfussy architectural detail and the hand-made quilt share an intensely personal quality and a loving attention to detail that make them highly compatible and collectable.

Early dolls' houses were status symbols rather than playthings. The earliest known dolls' house, commissioned by Albrecht V, Duke of Bavaria, in 1558 for his daughter, became part of his art collection; the 17th-century cabinet houses made in Nuremberg were really adult toys, designed to hold collections of miniatures. More toy-like, if essentially educational, were miniature rooms and shops. "Nuremberg Kitchens", made in Germany from the 18th century into the 20th, were replica kitchens, filled with utensils and used to instruct girls in housekeeping; delightful English butchers' shops, made from *c.*1850, came complete with miniature joints of meat, chopping blocks and other accessories.

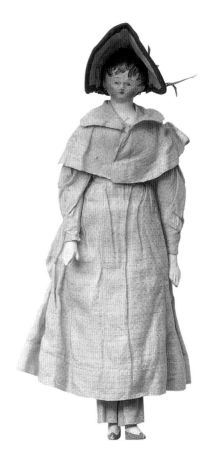

ABOVE *This 19th-century doll (ht 28cm/11in), dressed in its original clothes, was made in Germany, a major centre of production of pine dolls.*

LEFT *This Norwegian hand-made doll, quilt and pine bed were probably not made as an ensemble. The quilt dates from the late 19th century; the bed (l. 35.5cm/14in) is in a traditional style introduced c.1850.*

OPPOSITE *This fine early English dolls' house (c.1780) has its original paint. Above it is seen a painted wooden doll in superb condition, made in Scandinavia or The Netherlands c.1860.*

Carved and painted toys

Wooden toys seem to have been produced in remarkably similar forms for centuries. Stylized figures of people and animals, spinning tops, balls, hobby-horses, boats, puppets, jumping jacks and a variety of pull-along toys on wheels – all have been whittled, carved or turned with varying degrees of sophistication by craftsmen and enthusiastic amateurs alike.

In the 19th century, tin plate gradually superseded wood as the most widely used material, but most tin-plate toys were still hand-painted, allowing for interesting variety and individuality within a largely standardized form. The strong silhouette of the virtually two-dimensional parrot (right), for example, is enhanced by the bold, vigorous hand-painted decoration. Parrots and other types of bird on perches were relatively common, especially in France – and were often used as wager toys, with people betting on how long the bird would rock on its perch once set in motion.

Toys often reflect the specialist knowledge of the maker. The wooden Norwegian boats (below) have been dug out and then carved by someone who understood boat-building. Their strong silhouettes are enhanced by the surface interest provided by the original paint and a stained, aged, original fabric sail. By contrast, the home-made English boat on page 109 is much more a triumph of improvisation. The rather clumsy body is coated with yacht paint and powered by a recycled clockwork motor that turns

ABOVE *This late 19th-century toleware parrot (ht 30.5cm/ 12in) still has its original paint and stand.*

LEFT *The Norwegian sea-faring tradition is clearly reflected in these hand-carved and dug-out boats. Made in the late 19th century, they have retained their original paint, and the larger boat still has its original fabric sail, now wonderfully stained and faded.*

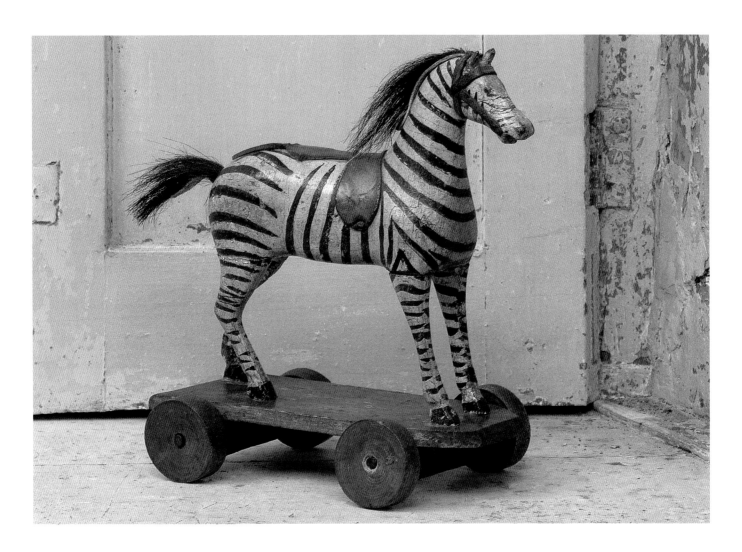

ABOVE *This delightfully static and naive pull-along zebra (l. 23cm/9in) on a plain pine plinth was made in England c.1870. It was obviously closely based on a horse, and has even been fitted with a leather saddle and harness.*

the paddles, but what it lacks in elegance or shipbuilding expertise is more than offset by the charm of a toy made with love and care, probably by a father for his son.

The popularity of toys that moved, especially pull-along or pushalong animals on wheels, is confirmed by the number of portraits in which they appear with their young owners, and pull-along toys were commonplace by the early 19th century. Some pull-alongs had added interest in the form of articulated limbs: the carved and painted wooden rabbit on page 109, for example, has articulated ears, body and front legs, yet never quite manages to reach the carrot at the end of its plinth. In the late 18th century, the German town of Altdorf was a centre of production for small, simple moving toys, and in the 19th century the Erzgebirge region, celebrated for its Noah's Arks, was also well known for more complex moving toys. Such toys were by their nature fragile, and comparatively few have survived. The robust Norwegian jumping jack on page 108 is a delightful exception. Most jumping jacks were operated by sticks that fitted into the backs; others were designed to sit on pieces of wood that were used to "bounce" them. This Norwegian example is unusual in that it is suspended from a robust frame set in an equally solid base, which may explain its longevity. Its tight waist is a typically Norwegian feature, as is its neat appearance, from the smart cap

and tiny hands down to the worn tips of the little black boots. It was hand-made, possibly as a birthday or Christmas present, for "Elise", who must have enjoyed playing with the toy, as the paint has been worn away beneath its dancing feet.

The importance of the horse – as both a draught animal and a vital form of transport, and as much a status symbol of its time as a car is today – is reflected in the large quantities and types of carved wooden horses that have survived. The difference in style can be seen in the delightfully solid, almost lumpen, carthorse-like form of the English pull-along horse on page 109, whose robust, solid shape has withstood hours of play; at the other end of the scale is the elegant pony and trap on the same page, finely and delicately carved, whose quality and immaculate condition suggest that it was one of those "special" toys that could only be played with at certain times under supervision.

Exotic, non-indigenous animals are rarely found other than as miniatures in Noah's Arks. The zebra imported to England by King George III *c.*1783, which toured the country, aroused enormous interest and inspired prints, paintings (see p.75) and carved toys, where it usually took the form of a horse with black and white stripes, often accompanied by traditional horse's tack. The example on page 115 is superbly constructed; the legs were carved individually, allowing for a fine, elegant line, and then joined to an equally fine body, which was fixed to a relatively plain pine plinth – a contrast that somehow adds to its appeal and integrity.

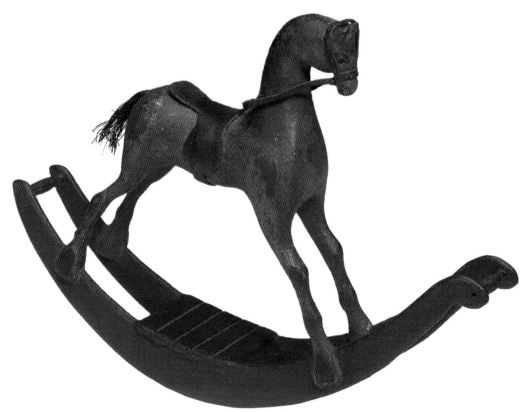

ABOVE *The superb condition of this endearingly self-important carved wooden soldier (mid-19th century; ht 20cm/8in) and wood-frame papier-mâché horse suggests that it was a cabinet or showpiece toy.*

LEFT *The high arched neck of this rare miniature rocking horse (l. 23cm/9in) is characteristic of Scandinavian wooden horses, as is the fine quality of the carving and other details such as the leather saddle and bridle and the horsehair tail.*

Part of the appeal of a well-loved toy is the evidence of the years of enjoyment it has given: original paint may be faded or worn; tails and manes may have been replaced; leather saddles or bridles may be worn or repaired. Other toys have survived in remarkably good condition because they were kept as cabinet or mantelpiece toys and were played with only rarely and then while being watched over. They were usually professionally made and therefore more finely carved, more fragile and more expensive. Their appeal lies in their quality, attention to detail and a surface interest created by the passage of time rather than by hours of play. The superb condition of the rare and very fragile mounted soldier (opposite) indicates that it belongs to this category. The horse, made of papier-mâché on a wood frame, has stiff, naive front legs, which contrast with the almost doughlike, rubbery quality of the head. The soldier himself is a dashing fellow, with his finely modelled and painted body, jaunty angled head and self-confident pose. The fine quality of the horse and rider is continued into the plinth, which has chamfered edges and pegged wheels. A similar attention to detail and fine modelling can be seen in the equally rare carved, knobbly-kneed miniature rocking horse shown opposite (below), complete with harness, saddle and horsehair tail.

Other toys have an appeal based on the sheer ingenuity of their design, such as the extraordinary French carousel (right), and, to a lesser extent, the English clockwork boat on page 109. The rather clumsy wooden base has a handle that turns the carousel, and rudimentary stiff-legged flying horses move up and down on their wire rods underneath the original waterproof *toile ciré* top. It is a triumph of mechanics blended with enormous aesthetic charm – the subtle powdery blue of the fringed carousel floor – and the maker's feeling of satisfaction as he wound the handle and saw his pig-like horses fly is almost tangible.

Noah's Arks were some of the few toys that children were allowed to play with on Sundays, partly because of the obvious biblical reference and partly because they were considered "educational", and as a result they are often found in good condition, with original paint and a complete

BELOW *This unique French home-made carousel (ht 51cm/20in) is a blend of ingenious mechanics, original design and charming execution. Made c.1875, it is still in working condition; when the handle is turned, the carved wooden horses move up and down on the wire rods.*

quota of animals. They have a timeless appeal, combining as they do a myriad different small animals (some even come with tiny slugs), figures – Noah and his wife are essential, extra members of the family an added bonus – and a hand-painted ark with the symbolic dove either painted on the side or attached to the roof.

By the mid-19th century, the Erzgebirge in Germany was a leading centre of production, and large numbers of arks and animals of varying quality were being made, again as part of a cottage industry, for both the home and the export market. The better quality arks were furnished with individually hand-carved three-dimensional animals, with fine, detailed carving and hand-painting and a significant difference of scale between large and small ones. Towards the end of the century, semi-mass-production techniques were introduced in the form of ring-carving. A circle of wood with a central hole was turned on a lathe to create an animal outline and then "sliced" to produce large numbers of individual pieces, which were then finished by hand. These rudimentary, often almost two-dimensional forms, which tapered towards the front, were used to produce quantities of animals, with little attention to scale or fine detail.

In Scandinavia, individually hand-carved and painted solid-wood farm animals – such as cows and pigs – were made to be given as prizes at agricultural shows and village fetes, and later often became used as toys. Domestic, indigenous animals are rarely as popular as more exotic, wild animals, but the important symbolic role played by the horse in Scandinavian folklore and life has inspired some carved wooden horses of the highest quality which were not always intended as toys. One famous legend, which is often recorded in the form of a carved horse with a woman seated on its back

ABOVE *In Norway, hand-carved and painted animals were given as prizes at agricultural shows and fetes. This group, which is standing on a cobbler's seat, was made in the mid-19th century and retains its original paint. The cow standing in the cobbler's tool box is 25cm/10in long.*

LEFT *This late 19th-century hand-painted Noah's Ark with stencilled windows was made in Germany. The worn paint and fine patina indicate that it was a much-loved toy; but it was treated with care – all the animals and figures are intact.*

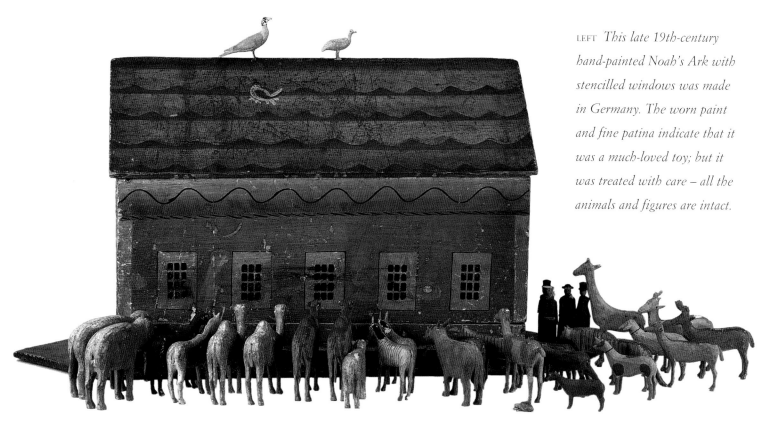

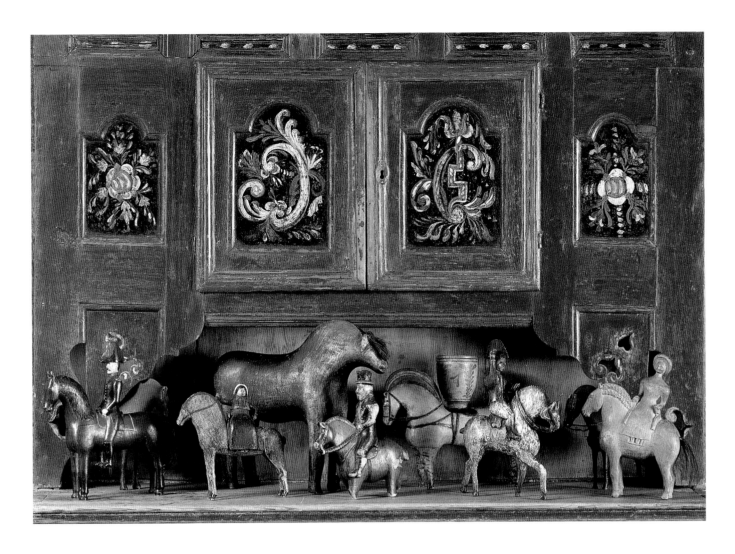

(above), is the Fall of Sigrid. Traditionally, Norwegian brides rode to the church on the back of a horse, as did the unfortunate Sigrid, who, the tale relates, when the bridegroom failed to appear, fainted, fell off the horse, broke her neck and died. Most Scandinavian horses are carved with distinctive high, arched necks, often accentuated by stiff straight manes, supposedly based on the strong Scandinavian fjord horses. The neck emphasized the masculine nature of the stallion, a status symbol among the Vikings and a symbol of masculinity that is found on many Scandinavian love tokens (see p.33).

With all carved animals, the appeal will be a blend of the form – either stiffly naive, with the curiously static quality seen in naive animal portraits (see p.86), or a finely carved subtle profile, with a shapely neck and delicate legs, or the delightfully lumpen, roughly carved form of a hand-made pull-along toy – with the surface interest, which may be original paint that is faded and worn after years of handling; or the immaculate condition of a cabinet toy; or names, initials and dates that tell us for whom the toy was made and when. But a really special piece will also have another very particular quality, an almost indefinable but immediately recognizable character that clearly reflects its status as a well-used but well-loved toy.

ABOVE *The horse is a potent symbol in Scandinavian folklore and appears with its distinctive arched neck and straight mane in many different guises. The magnificent collection of carved and painted miniature wooden forms seen here was made between 1780 and 1880.*

Board games

Many early board games first appeared as scratched marks on tavern table tops; these gradually evolved into separate boards, made in a variety of local woods – oak, pine, fruitwood, elm and ash. In Britain from *c.*1800 mahogany was often used for formal, commercially made boards. Chess, draughts and backgammon sets were made in a range of materials to suit different ranks, but there was an almost equally wide variation in quality among the home-made examples. A coachmaker might produce a well-made double-sided board, with a drawer for counters, precise squares and delicate tendril decoration; at the other extreme is the primitive, roughly painted, one-sided draughts board, with a grimy surface and worn edges from years of use in a tavern.

Whatever the board's quality or condition, the appeal will be primarily graphic. Games boards are essentially two-dimensional, often decorated with painted or carved geometric designs that reflect the nature of the games: the two-colour squares

ABOVE *A fine double-sided English draughts board, made c.1830, with an integral drawer for counters, and hand-painted decoration of exceptional quality.*

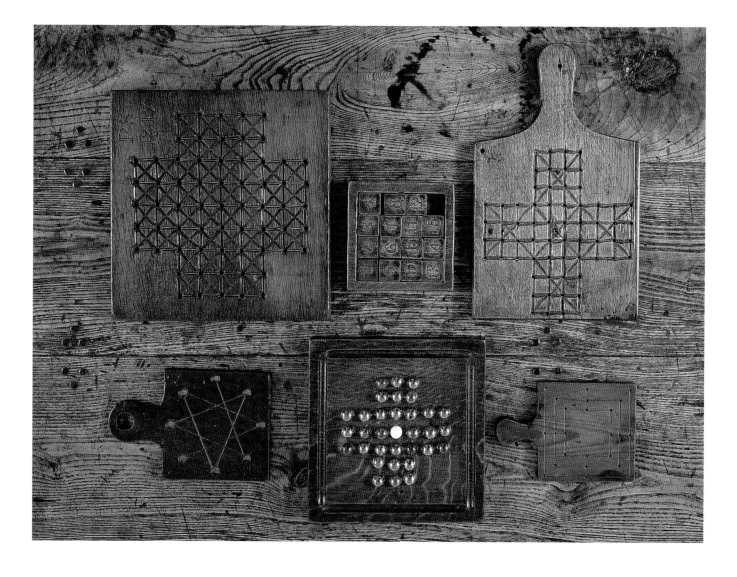

ABOVE *The colour, patina and worn edges of this late 19th-century single-sided board (28cm/11in square) give it great charm and testify to its life as a tavern games board.*

RIGHT *The shape and design of this English target board (ht 91cm/36in), together with the surface pockmarks, suggest that it was for a form of darts. Made in the late 19th century, it has retained an old paper label and its original paint.*

OPPOSITE *This superb collection of English board games, all made in the late 18th/early 19th century, illustrates the subtleties of grain, colour and patina found on unpainted indigenous woods such as fruitwood, elm, oak and pine.*

of draughts and chess, the chevron-like pattern of the backgammon board, the bright circles and segments of a target game, or the formal arrangement of holes in solitaire. High-quality painted decoration may have retained its precision and colour because a fine board has been carefully handled and stored. Just as interesting are the patina, wear, pockmarks and faded colour on a more primitive board, knocked up from scrap timber for a tavern or a village fete. Unpainted boards often acquire a wonderful deep patination that reflects the wood's natural colour, grain and ageing process.

Form may be as important as surface. Many games hung on the wall where both shape and decoration could be seen to advantage, and although an interesting board will have visible evidence of often boisterous enjoyment, this should not detract from the original profile. Even though many of the games are now lost to us, folk-art collectors can derive from the graphic appeal, surface, colour and patina of games boards a similar pleasure to that the players once enjoyed from their games.

Pottery

The basic forms of everyday domestic pottery – the jug, the pitcher, the platter, the dish – have, over the centuries, been freshly interpreted by generations of rural potters, using local clays, glazes and decorative techniques to respond to the needs and traditions of their communities. Their legacy is a wealth of well-used and well-loved original earthenware and stoneware pots whose forms and surfaces capture the character both of the hands that made them and of the people who used them.

RIGHT *This French glazed stoneware jug (first half 19th century; ht 28cm/11in) was made in La Borne, probably by a certain member of the Talbot pottery dynasty who was well known for his irreverent use of the clergy, army and nobility as models for his anthropomorphic jugs.*

OPPOSITE *Distinctive slip-resist decoration could transform an anonymous standard pot, as shown here by the use of local ferns on the Welsh Ewenny Potteries' imitation of a classical urn (c.1880; ht 30.5cm/12in), and by the owner's initials on an English West Country flowerpot.*

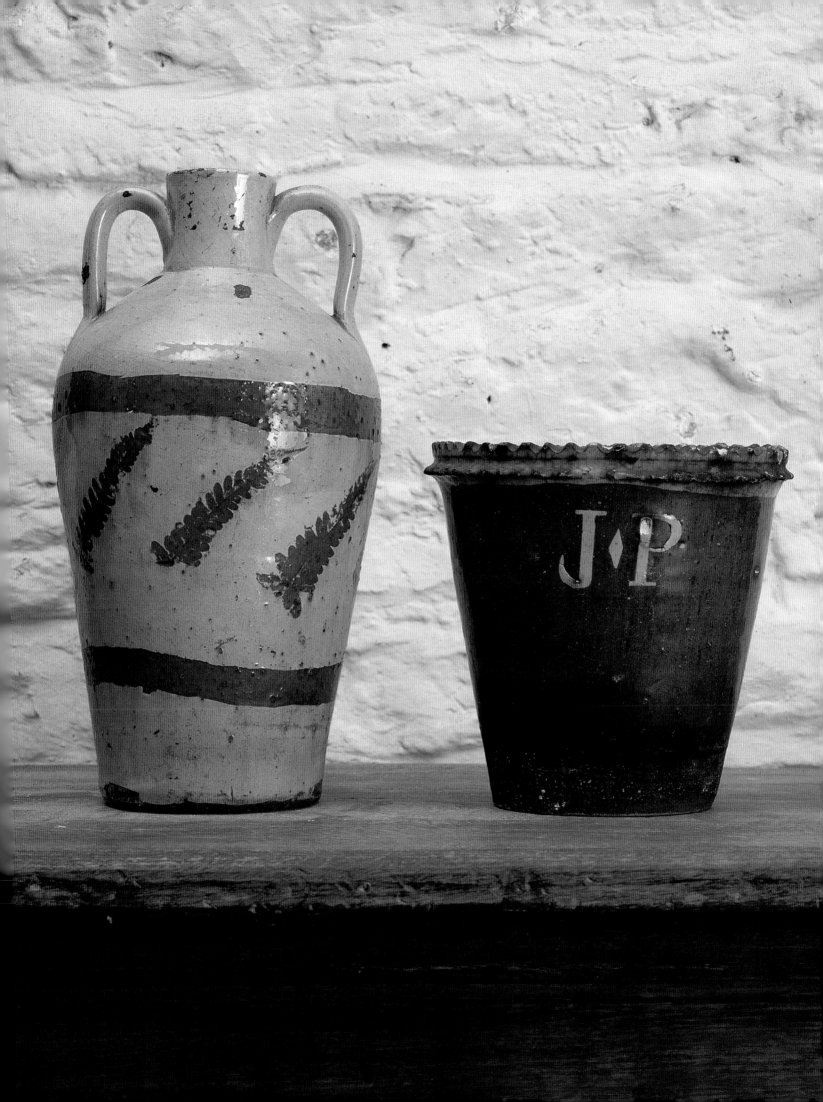

Slipware

Academic study of rural domestic slipware has provided comprehensive technical and historical information on regional variations of form, decoration, clay, glaze, factories and workshops. What makes slipware so interesting as pieces of folk art is that they were made as functional objects, which gives them a character that is demonstrated by an almost infinite variety of form and decoration, by a surface reflecting a long and useful life, and by the innate artistry of the maker of everyday objects.

Simple heatproof and waterproof pots related to eating and drinking were produced in abundance. Most were of earthenware, which could be coiled, slabbed or wheel-thrown and fired at low temperatures, but remained porous unless glazed; or stoneware, which was fired at a higher temperature, after which it became impervious to liquid. Slip – a semi-liquid mixture of clay and water with the consistency of cream – was used for a variety of decorating techniques, including trailing (when it was piped on, rather like icing a cake), combing (a blunt-toothed wooden, leather or metal comb was drawn through the moist slip), marbling (different coloured slips swirled together), sponging and stencilling. Slip could be applied with a brush or a feather, used on its own or combined with another technique such as sgraffito (where a design was scratched or incised through the slip to reveal the body below). From the mid-19th century slip-resist decoration was popular. A thin, flexible motif – such as leaves or paper shapes – was placed on a pot coated with a layer of half-dry slip, the pot was dipped in a layer of contrasting colour and the motif peeled off (see p.123).

OPPOSITE *The wonderfully textured surfaces of these late 19th-century French earthenware* confit *pots reflect their long and useful life, as does the chipped surface of the garden urn, which reveals the pale clay against the contrasting dark green glaze.*

BELOW *The Buckley Potteries in Wales made fine jugs and storage vessels, seen here. The central crock, with a characteristic lead glaze, was made in Sussex in the 19th century.*

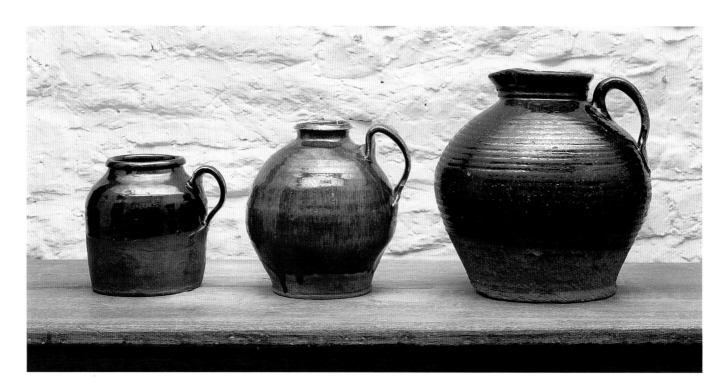

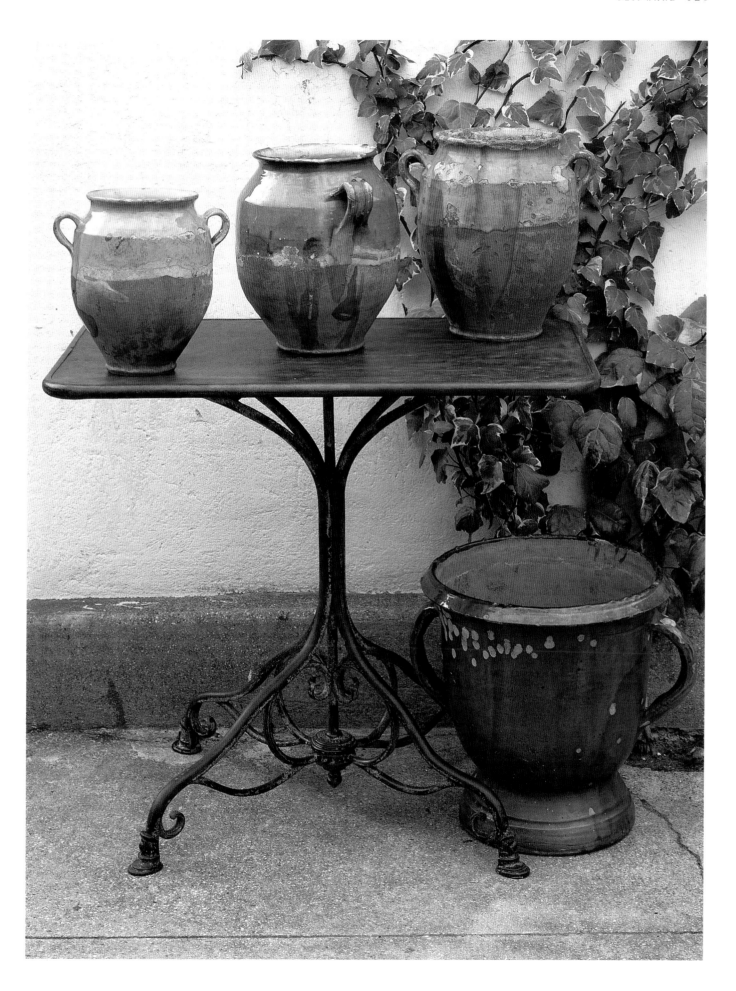

The natural cooling property of earthenware was exploited in a wide variety of storage crocks. The inside of the pot and the upper part of the outside would be glazed to make them impervious and easier to clean; the unglazed area remained porous and, when the pot was stood in cold water, would absorb the liquid, which then evaporated when the pot was removed, keeping the contents cool. In France, from the late 18th through to the 19th century, potters whose stock-in-trade might be tiles or chimney-pots also produced domestic wares and inexpensive earthenware storage vessels, in huge quantities and in various shapes and sizes dictated by function. Such pots are seen at their best when grouped together, much as they would have been in the farmhouse larder, when the infinite range and subtle differences of size, colour and coverage of glaze can be displayed to advantage.

British earthenware storage crocks tend to reflect more sophisticated throwing skills, as shown by the more individualistic character of the hand-thrown pots on page 124, which range from the pleasing and highly functional proportions of the straight-sided "honey-pot" shape, with a wide, open lip and sturdy handle, to the splendid round-bellied jug, with a finely moulded rim and lip and a surface whose horizontal girth grooves testify to the strength and skill needed to throw and control

ABOVE *This late 19th-century earthenware hair-comb holder (ht 30.5cm/12in) from Alsace has moulded and applied slip decoration.*

LEFT *French 19th-century* poteries rustiques: *clockwise from left: a* pichet à barque *with slip-trailed decoration, from Macon (ht 35.5cm/14in); a cockerel* moule à gâteau *(cake mould) from Alsace; a stylized flower-shaped cheese strainer from Le Mans.*

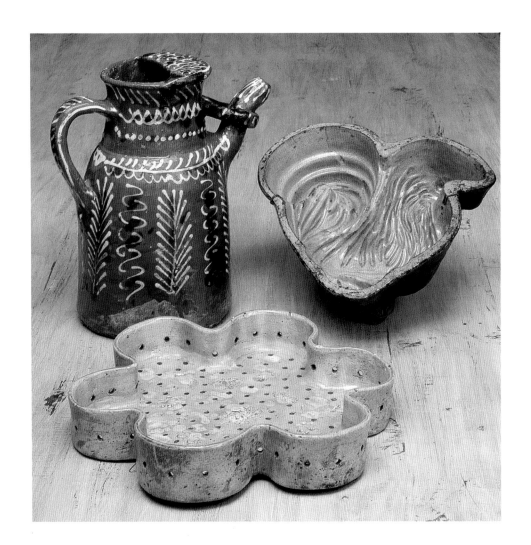

a large piece of clay. Further evidence of the weight and mass of this jug and of its long life is the wear on the front of the foot – a gradual erosion as time after time the heavy, full jug was set down on a hard surface or tipped to fill yet another tankard or mug. The glaze is equally distinctive: a rich dark-brown treacle glaze (the thicker the better) with a marked step down (the more pronounced the better) to the unglazed earthenware. In other cases, particularly treasured storage crocks may have been given a set of initials or a date, or even the name of a house, all of which can transform an otherwise unremarkable form.

Surviving examples of traditional French earthenware cooking accessories date from the mid-17th century, and descendants are still being made today. For example, cheese strainers were produced in numerous shapes, sizes and depths determined by the local cheese, from tiny, deep, straight-sided stoneware pots for goat's cheese to the charming decorative shallow flower-form seen opposite. The *moule à gâteau* (cake mould) used to produce the local "cake" associated with the Alsace region was also made in a variety of forms, including lobsters, rabbits, bunches of grapes, nuts and hearts as well as the cockerel shown here, many of which were associated with a particular fete. Holders for wooden spoons were made as circular plaques, with both single and double pockets, and, in Alsace, often as two separate short cylindrical pots with a common handle.

Inevitably, earlier examples will have the appeal not only of interesting, often worn, shapes but also of a surface patina acquired from years of use and exposure to

ABOVE *The spontaneity and variety of the characteristic multicoloured marbled slip decoration of jaspé ware is seen to advantage on this group of jugs, made in the second half of the 19th century in the Savoie region of France.*

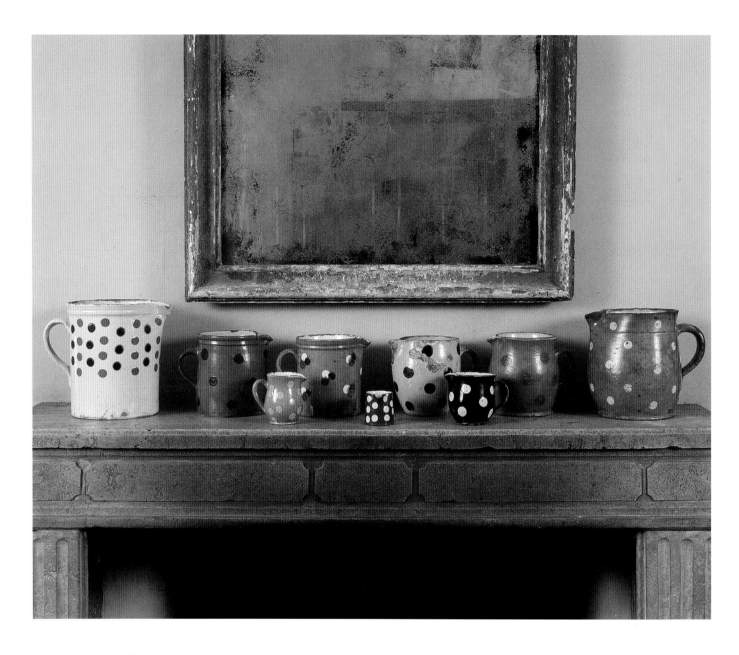

the fireplace and the range, or the cool slate shelves of the dairy, larder or pantry; and cooking vessels often have a wonderful blackened "cruddy" surface.

Certain types of slip decoration are closely associated with particular areas. The Savoie region, for example, is the centre of production of jaspé ware with its characteristic marbled slip decoration (see p.127). Few very early pieces have survived, and 19th-century wares are the major collecting area, although jaspé was produced into the 20th century. The random nature of the decoration means that no two pieces will ever be the same. Marked colour contrasts add to appeal; pieces in which white predominates tend to be later and less popular, and pieces with thick, broad patterns tend to be passed over in favour of finer, swirling bands of colour. Invariably jaspé ware was hand-thrown on the wheel, and the distinctive mark on the foot, where the cutting wire removed the piece from the wheel, is as interesting as the magnified thumbprint it closely resembles.

ABOVE *This group of French jugs illustrates the random nature of spotted slip decoration with its almost endless permutations of size, colour and density of pattern.*

Pottery from the Alsace region often reflects the area's confused nationality as the French/German border advanced and retreated. The often stiff, formal decoration, such as the stylized floral and foliate motifs and geometric patterns created from applied pieces of moulded slip and found on hair-comb holders (see p.126), has much more in common with the tight, restrained and precise decoration seen on the German jug on page 130 than with the engagingly imprecise latticework on the French jug below.

Jugs are common to all regions and are one of the most popular collecting areas, combining a highly satisfying and useful form with a good surface for decoration. The ultimate test is function: a good handle sits well in the hand, feels comfortable and allows a jug full of liquid to be lifted easily; a good lip pours easily and cleanly; and a jug that meets these criteria, like the example below, usually looks good as well. This jug also has the appeal of complex freehand decoration that still retains its spontaneity: the maker, starting confidently at the top, has had to make last-minute adjustments at the bottom, where the latticework is increasingly restricted and the dots collide and fall off the foot.

Mocha-ware jugs are largely an English phenomenon. The technique, developed in the late 18th century, was used by small factories in England in the 19th century on inexpensive utilitarian wares, in particular large beer jugs for public houses. These white or cream-coloured earthenware jugs were decorated with broad bands of wet, coloured slip onto which the potter would brush or drop his or her own version of a dark acid colourant known as "tea" (a mixture that might include manganese, tobacco juice and even urine); this reacted with the alkaline slip and fanned out into a branching tree-like shape found also in the mocha stone, an ornamental Arabian quartz after

ABOVE *Although spoon holders were made throughout France, they are now relatively rare and keenly collected. This example (diam. 36cm/14in), with double pockets, has polychrome slip decoration of stylized crickets, which suggests that it was made in southern France.*

RIGHT *This well-modelled French jug (ht 20cm/8in), made in Savoie c.1860, has delightfully imprecise latticework slip decoration.*

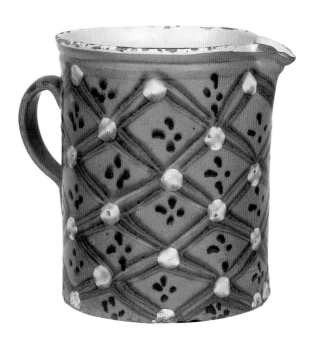

which the design and the wares were named. Other mocha-ware creamware jugs are decorated with horizontal bands of colour that include such traditional designs as the looping earthworm pattern, wave patterns or engine turning.

Although few jugs are marked, the sophisticated forms and the precision of the decoration betray their factory origins. However, each jug was thrown and decorated by hand, so no two are identical, and the variety of design, colour and pattern of the decoration reflect the creative input of the individual potters. Surface damage detracts from the appeal of these large, bold pots, but a loving and skilful repair that would be unacceptable to a pottery collector may appeal to the collector of folk art.

In countries with a strong ceramics tradition, such as Britain, France and Germany, earthenware was usually seen as the poor relation and used for everyday wares. By contrast, in Scandinavia slip-decorated earthenware vessels enjoyed considerable status, and such pieces as the large bowls below were used only on special occasions. Their decoration is an interesting example of how the neat geometric motif precisely executed with a wood-carving tool on many wooden Norwegian pieces (see p.11) takes on a freedom and lightness of touch through the fallibility of the human hand and the fluid quality of slip; it has become a recognizably Scandinavian frame for exuberant paintings of birds and plants that know no national boundaries.

In Scandinavia porridge was an essential part of any communal feast or celebration. At weddings or christenings each family would bring its own porridge dish, and guests helped themselves from each in turn. Such dishes were usually of wood (see p.14), so the earthenware porridge jar shown below would have been treasured. This example has a characteristic Scandinavian combination of bright colours.

ABOVE *The exuberant, naive sgraffito decoration of this rare and exceptional earthenware plate (c.1800; diam. 35.5cm/ 14in) from Trondheim has been loosely and freely painted with polychrome slip to create a highly individual interpretation of a traditional Norwegian motif.*

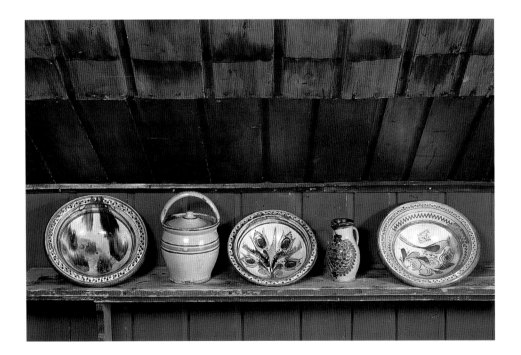

LEFT *Left to right: Scandinavian bowl; Swedish porridge jar; Norwegian bowl; German jug; Norwegian bowl (diam. 30.5cm/12in); all 19th century.*

OPPOSITE *19th-century English mocha-ware jugs. Bottom: jug with earthworm and wave pattern; second step, centre: jug marked T.G. Green; third step, left: jug with blacksmith repairs; fourth step: mug with marbled slip decoration.*

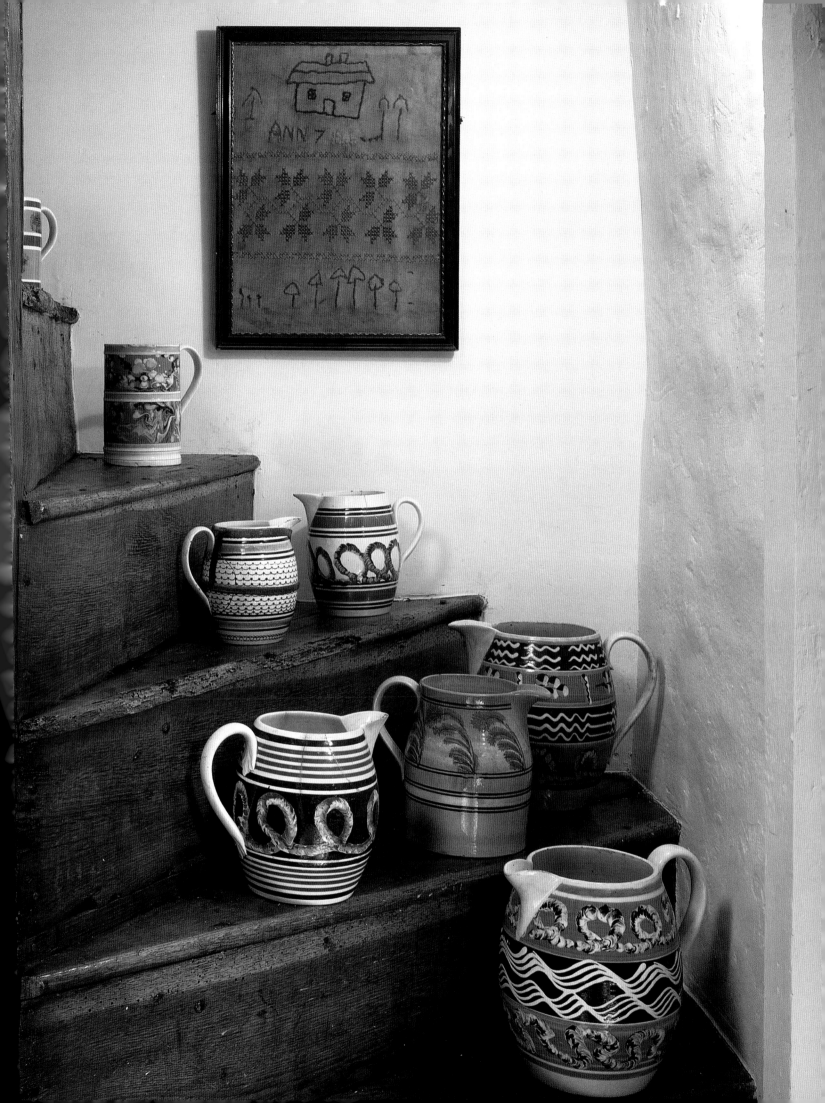

Spongeware

Sponging was an inexpensive and simple technique which was used particularly in Britain, from about the end of the 18th century, to decorate huge quantities of factory-made white ware produced for the lower end of the domestic market and for export.

The technique, named after the natural sponge it employed, was extremely simple. Spongeware began to be commonplace by the end of the 18th century, and earlier examples tended to have random patterns created by filling the absorbent spongehead with colour which was then spattered over the pot; several such spatterings built up a denser pattern and colour, as seen on the eggcups on the top shelf of the dresser shown opposite. By about the second quarter of the 19th century, the cut sponge technique had become fashionable; in this the design motif was cut in relief on a section of the thick fibrous stem or root of the sponge, which was then dipped into a pot of colour and used to print the design onto the pot. The resilience of the natural fibres of the sponge meant that the design could be repeated time after time and achieve the same crisp definition. In Ireland, the softer surface of the ubiquitous potato, which was sometimes used in place of a sponge, was less successful in maintaining the same precision, and such loss of definition is a useful way of identifying potato-printed spongeware.

Such a simple, labour-intensive technique was ideally suited to piecework, and cottage industries sprang up around the factory sites, with employees and pieceworkers alike decorating quantities of plates, mugs, honey-pots, mustard-pots, bowls, jugs, dishes and eggcups. Notable centres of production included Llanelli in Wales, Methven and Portobello in Scotland, Belleek in Ireland and Quimper in Brittany; the last was known for its characteristic freely painted decoration used with sponging.

Earlier pieces, made before 1860, tend to be more finely potted, typically with a blue-green tinge to the pooled glaze on the underside of the foot, and a softer, more random decoration. In the second half of the 19th century many more factory-made

ABOVE *The stencil-like quality of the rim decoration, the slightly formal treatment of the bird and the presence of two painted rings all suggest that this English plate (diam. 28cm/11in) was made professionally in the second half of the 19th century.*

RIGHT *Probably made in the second half of the 19th century, this bowl is given great appeal by the delightful elephant motif.*

ABOVE *This eclectic collection of late 18th and 19th-century British spongeware includes large, thickly potted earthenware dishes with multiple printed decorative motifs; small, finely potted mugs, honey-jars and mustard-pots with soft spattered monochrome decorations; and dishes decorated both with abstract geometric designs and with floral and figural motifs.*

plates included a painted line or lines that could only be produced on the wheel, and there was increasing use of a combination of brushwork with sponging that finds less favour with collectors; this was particularly common on Dutch spongeware. Decorative designs are many and varied, ranging from geometric patterns to figurative images. Animals, such as the naive and charming, if somewhat incongruous, elephant on the bowl shown opposite, are the most popular spongeware motif.

What appeals, above all, is a pot that catches the eye, whether because of its size and bold mixture of polychrome decoration (as seen on the large bowls on the top shelf of the dresser above); or a dense, vigorous and free design (as seen on the blue-and-green jug on the second shelf); or a particularly strong and attractive repeat monochrome pattern (as seen on the blue reindeer plate in the centre). Spongeware was not a sophisticated technique, and in the hands of the factory craftsman had a tendency, at times, to become somewhat stiff and formal, assuming an almost stencilled perfection. What gladdens the eye and the heart of the collector is a dense, bold pattern undiluted by brushwork; plenty of colour; a determinedly individual nature that precludes any attempt at building a matching set; the use of motifs not normally considered "suitable" for ceramics; and the unashamed vigour and vitality of an inexpensive and simple earthenware pot that never aspired to the refined perfection of hand-painted porcelain.

Textiles

Spinning, weaving, dyeing, knitting and needlework have traditionally been seen as women's work, and textiles are an area in which women of all ages and classes have, over the centuries, been able to express their creativity, whether in the form of the delightful, intensely personal samplers worked by young girls, the elegant silk pictures that ladies of leisure "painted" with their needles, or the colourful patchwork quilts, homespun blankets, domestic linen and embroidered working clothes that were an essential part of the working family's life.

LEFT *This exceptionally fine English sampler on a linen ground embellished with silver thread was embroidered by Elizabeth Maivel, aged 14, in 1705. It has retained its excellent, strong colours.*

OPPOSITE *The brilliant colour and bold design of this English appliqué patchwork quilt are a tribute to the vitality of Marian Pettit, who made it for her husband in 1853, aged 82.*

Needlework

In the 17th century huge quantities of domestic needlework were produced. From as early as the 1630s fine canvaswork pictures were introduced as an alternative to professionally woven tapestry. Canvaswork wall panels, screens, carpets and chair seats and backs were worked in coloured wool. From the mid-17th century, linen and cotton textile furnishings – bed hangings and curtains – were embroidered with a fine two-ply wool yarn known as crewel, usually in shades of green, blue and brown, in a variety of motifs that were often inspired by printed fabrics imported from India.

A girl's needlework education at this time culminated in a piece of stumpwork (a term used from the 19th century) – a laborious type of raised needlework that might take several years to complete and was used to create bas-relief panels; these were made into boxes or caskets, used for mirror frames, or mounted as pictures. Favourite subjects included scenes from the Old Testament (less popular today) or mythology, and the monarchy. The design was traced onto a ground, usually white satin. The flat detail was worked in different stitches and threads; the raised detail was built up from hundreds of tiny stitches; and the figures – sometimes with wooden, satin-covered

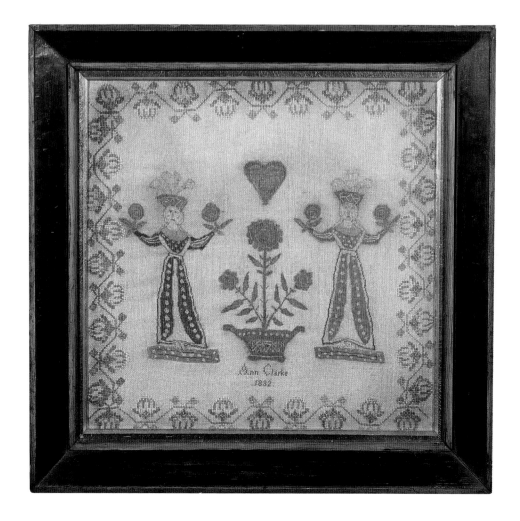

LEFT *This Welsh needlework picture (30.5cm/12in square), signed Anne Cross and dated 1832, depicts the Lady Eleanor Butler and Miss Sarah Ponsonby – the Ladies of Llangollen – clasping red flowers, together with other symbols of the garden they created together at their house, Plas Newydd, in the late 18th and early 19th centuries. The heart reflects their "romantic friendship" of some 50 years.*

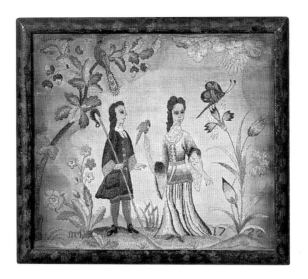

LEFT *This English silk needlework picture, signed NM and dated 1722, of a romanticized shepherd and shepherdess in a stylized pastoral setting, is in genuine untouched condition. The borders are stained, but it has retained all its subtlety and depth of colour as well as its original painted frame.*

and embroidered heads, arms and legs – were made separately and then applied. Extra detail was added using beads, sequins, metal thread, seed pearls and even human hair.

The stumpwork picture below depicts Flora, goddess of spring, in a contemporary costume that helps date it to the second half of the 17th century. The appeal for the folk-art collector lies in the static quality of the figure and the naive, out-of-proportion details of the background: huge butterflies, birds and plants dwarf the leopard and

RIGHT *Stumpwork was popular from the middle to the end of the 17th century. This English provincial stumpwork picture (second half 17th century) with original frame depicts Flora, goddess of spring, with wax face and chest and seed-pearl necklace, in a typically stylized landscape, with giant birds and butterflies and heraldic beasts.*

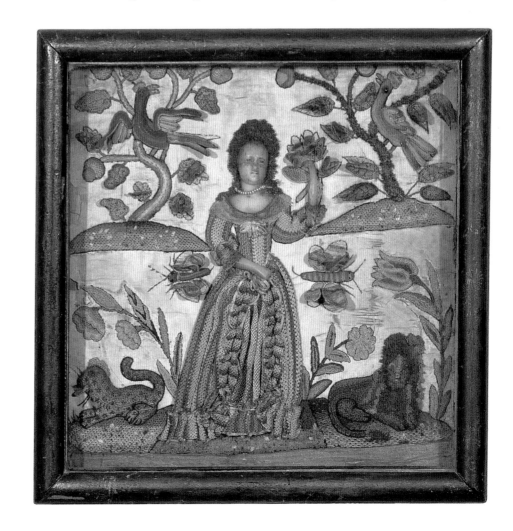

lion. A charming distortion of scale is also seen in the silk needlework picture (previous page, top), which features over-size insects, animals and flowers. The fashionably dressed "shepherd" and "shepherdess" retain a static quality despite the subtle colours and the sinuous lines that reflect the influence of early crewelwork – a contrast to the formal, virtually monochromatic, sampler-influenced design of the Welsh needlework picture (p.136) in which the Ladies of Llangollen stand stiffly in their red gowns.

Personal details and a documented provenance add to the character and appeal of any piece. The charm of the elegant, feminine French needlework picture (above), with its delightfully irregular silk stitchwork, is enhanced by the careful copperplate-style inscription. In spite of its delicacy, it retains a strong graphic quality, especially through the use of black detail on the two birds – the same graphic quality that is found in abundance in the huge, densely stitched needlework portrait of the gun dog (opposite).

Needlework pictures are vulnerable, and good condition is paramount; insect damage, over-zealous cleaning or restoration, and faded, muddy or bleeding colours will inevitably detract from even the strongest image. A certain amount of wear or discoloration of the ground can be acceptable, and such "as found" condition is infinitely preferable to any restoration of these pictures painted with a needle.

Samplers

Samplers are the very core of needlework; they were both a grammar, as needlework became acknowledged as a formal discipline, and a showcase of ability. Once they were commonplace; their unique blend of personal and social history, individual skill and creativity now makes them one of the most popular textile collecting areas.

The earliest 16th- and 17th-century samplers were practical works of reference rather than decorative objects, compendiums of stitches and motifs that were used by both amateur and professional needlewomen and rolled up when not in use. British and German examples were usually worked in coloured silks on long rectangular strips of unbleached linen. During the 18th century the shape of the British sampler gradually changed to the square that was commonly used on the continent. Fine linen was replaced by less expensive, coarsely woven linen on which young girls practised their needleworking skills, progressing to finer wool or unbleached linen as their expertise improved. These samplers became increasingly pictorial: houses, figures, plants and animals appeared alongside the alphabet, names, dates and edifying religious and moral verses. The golden age of samplers was between c.1780 and 1830; many fine examples were worked in a wide range of stitches, with good detail and motifs. With increasing mass production after the Industrial Revolution, the general decline in embroidery skills resulted in the use of coarser materials – coloured silks were replaced by coloured wool, and linen grounds by woollen and canvas; there was less variety in patterns and designs and also in stitches, with a preponderance of

ABOVE *This English sampler by Elizabeth Herbert, dated August 21st 1789, is a lovely combination of an edifying verse and a creative depiction of house and animals, with clever use of perspective.*

LEFT *This Scottish sampler, made by Mary Anne Ford c.1820, includes an instructive verse, family initials and a charming Adam and Eve (top centre), and is worked with complex spot motifs and delightful pictorial detail.*

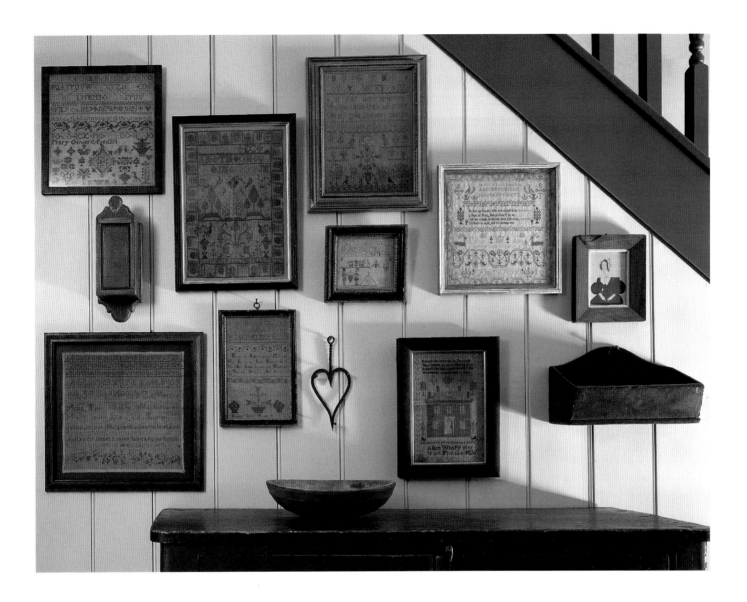

ABOVE *Samplers can benefit from being grouped together, when their complementary shapes and colours often appear to advantage. This eclectic group, including late 18th- to early 19th-century needlework samplers, displays a wide range of pictorial and graphic qualities, colours and textures.*

cross-stitch. However, the many Victorian institutions set up to provide poor girls with a useful skill led to a revival of the sampler, and many fine plain-sewing samplers were produced in orphanages, board schools and asylums (see p.142).

Dating is not always as straightforward as it may appear; most pre-1750 samplers are undated but can be identified by the use of the 25-letter alphabet (the I and J were interchangeable), and dates may have been deliberately obscured by women who in later life were reluctant to allow their childhood samplers to reveal their ages.

Samplers are intensely personal, being genuine heirlooms that were kept and passed down; particularly appealing examples tell us about the young girls who made them – details of ages, names, dates and locations all add to their personal histories. Mistakes in spelling (the transposed letters U and V on the sampler on page 143) or errors in stitching add a sense of intimacy and charm. Bold image is as desirable as fine technique, and age is often less important than an engaging pictorial design, with figures, animals and a strong graphic and formal, naive quality that reads well from a distance. Good colour is especially important; in general, silk retains colour better

than wool, and colours that have run or faded from exposure to bright light or from being washed inevitably detract from appeal, as do any iron stains where the sampler has been nailed to the frame. Original frames and backing are sought after, and sound condition is an essential prerequisite.

Once these conditions have been satisfied, personal taste takes precedence. The sampler on page 140 (top) is essentially pictorial; its deceptive simplicity and clarity are the result of an unusually sophisticated grasp of perspective and composition translated into needlework: the dog and stag are clearly delineated in the foreground against a plain background, and the densely worked trees lead the eye back to the house, and from there up to the verse. The Scottish sampler shown on page 140 (bottom) is an exercise in a complex series of spot motifs, carefully laid out in a well-spaced symmetrical design that rewards closer examination; the Scottish sampler shown opposite (top) is crowded by comparison, but with a strongly graphic central image of the couple whose marriage it celebrates. The sampler shown opposite (bottom left) is full of tiny, personal details, closely observed from daily life: the dog with its kennel, the man on horseback, the house, the couple sitting in the field of sheep;

ABOVE *This is an exceptionally fine collection of late 18th- to early 19th-century English school samplers. These miniature replicas are rare and demanded excellent needleworking skills, yet still manage to retain their graphic qualities and individual personalities; this is particularly evident in the tiny Cheltenham Female Orphan Asylum sampler (bottom centre; 10cm/4in square).*

RIGHT *This densely worked, complex Scottish sampler commemorates the marriage of John Campbell and Isabella Campbell. Made in 1836 by Anne Campbell, it includes a host of stylized spot motifs.*

BELOW RIGHT *Made by Ann Matters in 1783, this sampler (probably Scottish) is worked in coloured silks and metal threads, with a pretty border, family initials, and stylized hares under the trees.*

BELOW *This English sampler was made by Sarah Knight in 1801. The delicate border is a typical stylized Neoclassical motif that complements the Georgian-style house.*

the example next to it, worked with coloured silks and metal threads, is far more stylized, with a delightful back-to-front Y among the carefully worked family initials.

The extraordinary variety of colours, stitches, designs and treatments becomes even more apparent when samplers are grouped together, when the apparent uniformity of items that were intended as formal exercises and demonstrations of a basic skill is revealed to be extraordinarily diverse and appealing.

Homespun and quilts

Homespun, hand-woven, plain-weave coarse linen and woollen cloth was used to meet all the needs of the working family, from clothing to bed linen – sheets, pillow-cases, bolster and eiderdown covers, towels, kitchen cloths and even sacks for grain and flour. The relatively narrow width of domestic handlooms meant that blankets and other larger pieces were often woven in two strips and then sewn together. Colour was provided by natural dyes such as indigo and cochineal, and decoration usually took the form of woven coloured stripes or checks, stencilled motifs (especially on sacks), or embroidery using silk or wool threads for traditional and regional designs.

A popular collecting area is quilts. Quilting – in which a layer of padding is secured between two layers of fabric using decorative stitching – has been used from earliest times to produce warm clothing and bedcovers. Plain quilts were made from single pieces of fabric, decorated only with brightly coloured fine stitching in intricate

ABOVE *An Irish quilt, made c.1860 by Jane Pizar, from scraps of recycled fabric in a symmetrical design that combines a strong graphic centre with muted colours.*

RIGHT *Different examples of homespun sit well together: this group, woven in linen and wool, includes quilts, eiderdown covers, pillowcases, blankets, kitchen cloths, cushions made from old fabric and rag balls.*

OPPOSITE *Homespun bedlinen: a double eiderdown cover and a bolster cover, both with plain backs and characteristic check patterns; right: a Welsh woollen quilt with geometric patchwork design.*

patterns and motifs such as birds, flowers and trees. Patchwork quilts were made from pieces of fabric "patched" together, in Britain usually joined one by one, rather like a mosaic; alternatively, motifs were cut out and applied to a ground fabric in various patterns to form an appliqué quilt. The fabric reflected the social status of the maker, from silk for the affluent to scraps of leftover printed cotton for the working family.

Most quilts collected today date from the 19th and early 20th centuries. The appeal for the folk-art collector is not so much the quality of the stitching or an elaborate pattern as a strong graphic quality: good colour, and a strong design. The English appliqué quilt on page 135 is a perfect example: the bright, bold colours have lost none of their vibrancy; the strong, freehand appliquéd motifs have a freedom and vitality rarely found in geometric designs; and an added bonus is the inscription: "This quilt was wrought by Marian Pettit aged 82 years for William Pettit AD 1853."

Homespun clothing was first and foremost functional: it had to be hard-wearing, long-lasting and protective. After this, creativity came into play, whether in the form of traditional embroidered motifs or of personal decoration, as seen in Scandinavia on the clothes traditionally given as betrothal gifts to a groom and his close relatives, which the bride-to-be embroidered with initials and dates.

The different decorative styles associated with the valleys of Norway and regions of Sweden are also reflected in woollen garments. The heavy knitted jumper below has the precise geometric style of decoration associated with Setesdal and Telemark that can be found painted and carved on ale hens (see pp.10–11) or ale jugs.

In Britain the decoration on working clothes was often equally clearly linked to specific areas. Regional patterns on fishermen's jerseys helped to identify drowned bodies washed up on the shore. Shepherds' smocks were similarly varied. The smock, or smock-frock, was usually made of some 24 feet (7.3 metres) of plain-woven stout linen cloth, sometimes with deep smocking on the chest and wrists in white or buff thread to control the quantities of fabric. In the west of Britain smocks often had wide cape-like collars that helped to shed rain; deep smocking was used in Worcestershire, Gloucestershire, Herefordshire and Warwickshire, whereas smocks made in Sussex and Surrey were often undecorated and just gathered at the necks. Some smocks were

BELOW *The decoration on Scandinavian homespun garments reflects the region in which they were made. The Sunday-best embroidered stockings, children's gloves, jumper with applied embroidered cuffs and moose-leather breeches are all from Setesdal and Telemark in Norway (19th century). The domed-top chest (1726) is also from Telemark.*

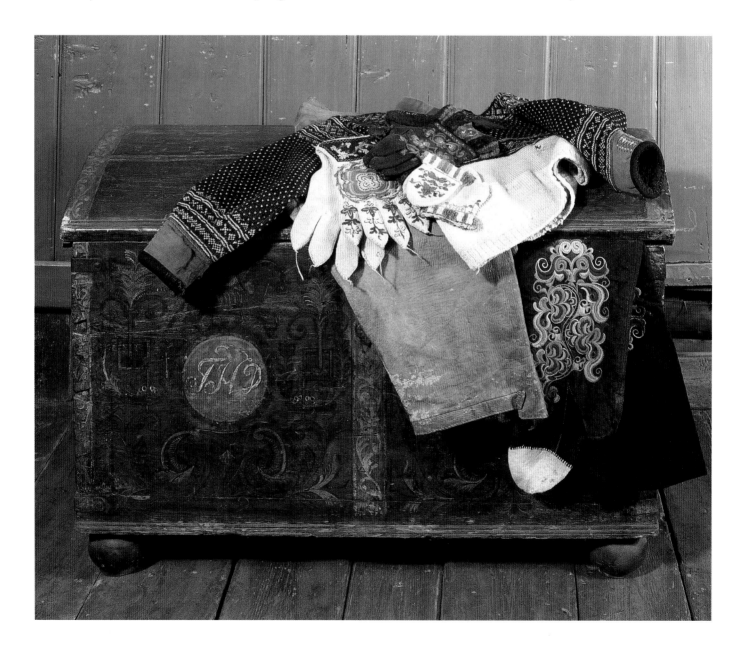

RIGHT *The English smock-frock, or smock, was made of yards of heavy coarse cloth, usually linen, often shaped and gathered by deep smocking at the chest and sleeves. This example was made in the late 19th century. These long-lasting working garments protected the wearer from wind and rain.*

kept for "Sunday best" and handed down through the generations until the last quarter of the 19th century, when even shepherds abandoned this traditional garment.

National costume is a well-researched area. What will appeal to the folk-art collector is the personal rather than the social history of a piece of clothing: the weight and feel of hand-made fabric or heavy, oily wool; the way it has aged over time, the fibres softening after repeated washes; the "feel" both of the person who wore it and of the person who made it and looked after it; original embroidery, however unaccomplished, carefully applied to brighten up everyday garments; darns and repairs.

Made to be durable, much homespun has survived, some pieces in desirable worn but immaculate condition, others with loving and lovely repairs that can greatly add to their appeal. This is a relatively new collecting area, whose appeal is part nostalgia, part interest in the great variety of colours, patterns and textures, and part appreciation of the intimate and essential role these textiles played in people's lives.

Leather

Although produced in quantity and used for almost every area of domestic and working life, leather is perishable; the earliest pieces now collected usually date from the 17th century. Most readily found are drinking vessels – bombards (large leather jugs with integral handles), blackjacks (moulded leather tankards; see p.12) and the ubiquitous leather bottles, or "bottells". In Spain such bottles were made of soft leather, to be squeezed to drain the last drop. French bottles were of harder leather, shaped rather like a full hot-water bottle and often lavishly adorned with embossed foliate decoration, punched motifs or brass studs. English bottles were made from stout leather, with slightly oval bases, heavy side seams and integral lugs or wings for carrying. Costrels were keg-shaped portable leather bottles used for carrying all types of

LEFT *This French leather-worker's device was assembled in the second half of the 19th century from a nest of drawers, used to store nails and wax, and a panel back, equipped with tools. It comes complete with a leather-working apron and an integral heart-shaped pincushion.*

OPPOSITE *Until the mid-19th century most cobblers were itinerant, travelling the country with the tools of their trade, such as this early 19th-century cobbler's oak bench, with some original tools. The cobbler would have sat on the bench, his tools beside him, and worked the shoe on the last – here, a wooden-soled clog with a leather upper and painted red and blue decoration.*

liquid; by the late 18th century they had largely been replaced by wooden barrels, but were often given a new lease of life as candle boxes by cutting out one side. Bombards are rarer and were mainly associated with taverns and country houses (they may sport coats-of-arms or initials). Blackjacks, made for taverns and for domestic use, are more likely to have retained their original function, often as a result of multiple repairs, which enhance their appeal.

Leather drinking vessels were often decorated with branded, punched or painted motifs, initials, dates or armorials, either when they were first made or by later owners (dates may be misleading). Repairs or decoration that served a function and are part of the evolution of the piece add character and appeal; retrospective, deliberately archaizing alterations (often carried out in the mid- to late 19th century) undermine the very nature of the piece.

Another area rich in leather folk art is the history of rural occupations and sports, such as hunting. Obsolete accessories are rare and are collected by social historians as well as folk-art aficionados. The falconer's glove above would appeal to both: its story can be read in its surface, its plainness and the evidence of hard wear suggesting it was owned by someone for whom falconry was an occupation; the lack of personalized

ABOVE *This mid-18th-century English falconer's glove has been well looked after; it has been gently dried and oiled after use so that its texture is now like vellum, slightly glazed, smooth and dry.*

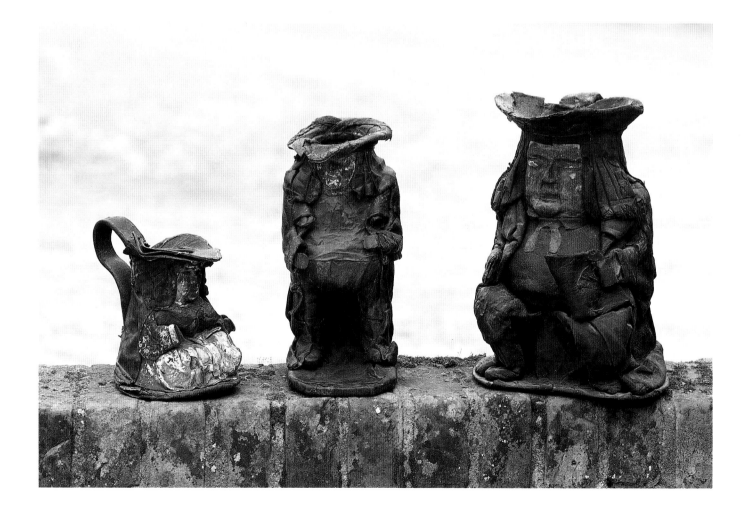

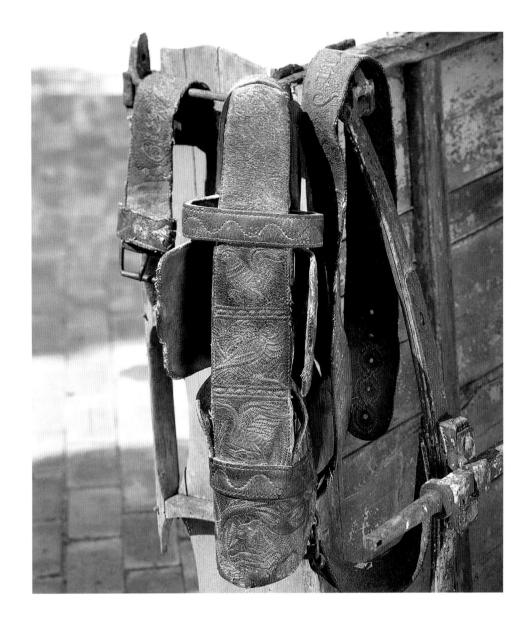

RIGHT *This 18th-century English bridle, discovered buried in a pit, is a tribute both to the enduring qualities of leather and to the skill of Richard Fulljames, whose signature, together with the place and date of making (Wrotham; 1739) have been sewn in lighter-coloured thin strips, or thongs, of leather. Thonging has also been used for the elaborate decoration.*

OPPOSITE *These three unusual leather jugs from the English Midlands date from the second half of the 18th century, shortly after the introduction of the popular pottery Toby jug on which they are based. Although functional in design, they may have been made as novelty items, since the soft, dry surface of the leather suggests that they were rarely, if ever, used.*

decoration is compensated for by a superb sculptural form. In comparison, a pair of well-loved hunting boots should have a rich patina and supple surface that reflect years of polishing and the idiosyncrasies of the shapes of the owner's legs and feet.

Leather horses' tack is infrequently appreciated as folk art. The bridle above is a rarity because of its exceptional decoration, a quintessential folk-art combination of sophisticated workmanship and naive design. Harnesses were rarely decorated in this way; these motifs seem more apt for a sampler or embroidery but have been adapted and applied to leather in an extravagant *tour de force* by a highly skilled craftsman.

The most interesting examples of leather folk art are those well-used pieces whose long lives have left their marks, whether in surface scars, a patina from years of cleaning, repairs, or personalized decoration; or in a "settling", tilting or crumpling of the original form. Such factors, together with the personality of the maker or owner, are what gives a piece its character and appeal. It can shine through in a gamekeeper's bag, a cobbler's apron or the hat boxes and leather luggage of an increasingly remote era.

Furniture

Sculptural form – a curving crest rail, an unusually generous seat – and painted decoration – floral panels on a cupboard door, a coat of blue on a dresser – were the two major vehicles for the creativity of the artisans who interpreted the furniture traditions of their regions. As with all folk art, these elements are enhanced by the passage of time, be it a tavern table stretcher worn thin by hundreds of boots, or a faint tint of colour remaining on the arm of a favourite chair.

LEFT *This English chair (c.1780) has several unusual features: a generous comb with huge ears, a narrow scalloped splat, flanked by sticks, and distinctive naturalistic curved supports, which together give an appealing profile.*

RIGHT *Norwegian furniture was often painted, as seen here on a mirror from Hedmark (c.1800) and on an enclosed bed (1836), a dug-out chair (18th century) and a domed-top box (1750), all from Telemark.*

Sculptural form

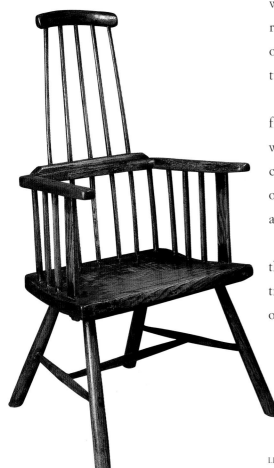

Vernacular furniture was often a country translation of a mainstream style executed by provincial craftsmen. By contrast, indigenous furniture followed its own tradition, with a strong, individual character derived from a very personal interpretation of its regional style. Such pieces were not fashion items; they were made to last and have often survived well, and are now appreciated both for their highly individual sculptural forms and for surfaces that tells the stories of their long, useful lives.

This type of furniture was invariably made from local wood: ash and yew were frequently used for bentwood sections; chair seats were often made of broad hard-wearing planks of elm; in Britain, beech and birch were used for less expensive pieces; conifers were used in Alpine regions. Free-standing furniture such as chairs and stools offered more potential for individuality of form, often the result of the creative use of a piece of wood that dictated the final shape, as in the French stool on page 158.

The ultimate, and very early, examples of this ingenious use of local materials are the dug-out chests and chairs, now keenly collected, which were hewn out of the trunks of trees that were often rotten or had been struck by lightning. Different styles of chair are associated with different countries. In Scandinavia the trunk (usually birch) was left intact and the seat inset into a solid base (see p.152). The English dug-out chair was fashioned from the shell of the trunk (usually oak or elm), with the area below the seat carved out to provide leg room and, in rare cases,

LEFT *This English Windsor chair (c.1800) has a square-cut flat-plank elm seat, simple, strong rectangular lap-jointed armrests and a narrow angular comb back.*

RIGHT *The elegant design of this English comb-backed Windsor chair (c.1770), with its chamfered elm "saddle" or "tractor" seat, curving armrests and turned legs with decorative collars, is enhanced by the wonderful colour and surface.*

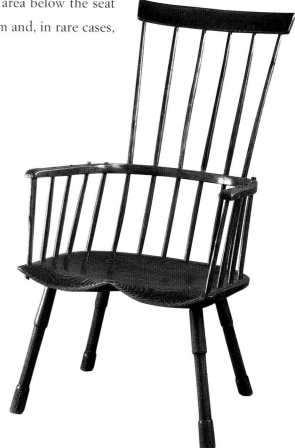

ABOVE *This X-frame trestle table (late 18th/early19th century) is flanked by two variations on the Windsor chair: (left) an unusual oak chair (second half 18th century) with low widely raked legs, long and unusually spaced armrest sticks and a tiny back supporting a huge comb; (right) a highly sculptural painted enclosed chair (c.1800), combining square Windsor legs with a plank back.*

combined with a panelled construction (see p.158). The traditional format allowed for considerable variation in form – the height and shape of the back, the inclusion of armrests and front feet and, in some English examples, the inclusion of a small cupboard under the seat. Decoration was equally distinctive: Scandinavian examples were painted with polychrome decoration and often carved (see p.152), and some more sophisticated English examples have shaped wing sides and decorative crestings.

Another popular technique that allowed for innumerable interpretations was the Windsor construction, used for stools, benches and tables as well as chairs. In spite of popular misconception, the term "Windsor" is used to describe a chair in which the legs and back are socketed into a solid seat rather than a particular regional style. Given this basic construction, the subtle differences of wood, proportion, scale and decoration – the weight and spacing of the sticks; the size and shape of the cresting rail; the shape, weight, angle and decoration of the legs; the scale of the seat; the shape of the armrests – have been used in an almost infinite variety of permutations to create chairs that are as different in form as the people who made them.

BELOW LEFT *This elegant, almost feminine, English "lobster pot" Windsor chair (1780–1800) has an air of restrained distinction, with its long plain legs, well-shaped seat, fine sticks tapering to a small comb, and lovely honey-coloured patina.*

BELOW RIGHT *This unusual 18th-century English Windsor chair is a quirky combination of sophisticated, turned and boldly decorated strong legs supporting an angular seat with a somewhat primitive, angular back.*

For example, the Windsor chair on page 154 (left) is essentially angular. The square-cut flat-plank elm seat is topped by angular, narrow, turned sticks, straight, rectangular armrests and an upright back; the only concession to a curve is the cresting rail. By contrast, the chair on page 154 (right) is a succession of welcoming curves: a chamfered "saddle" or "tractor" seat in elm, a bentwood arm rail, a curving back with a generous crest, and decorative collars on the turned legs. A similar elegant line can be seen on the "lobster pot" chair (below left), where the sticks curve in and taper to meet a curved comb. The long legs support a strong seat, whose thickness is concealed by careful chamfering to retain an overall lightness and elegance. There is no attempt at elegance in the other chair (below right), in which strong legs socket into an angled seat with an angular armrest. Its old dark green paint has acquired a black crust, and in places has worn away to reveal the nutty brown colour of the oak seat.

Evidence of a hard life and interesting, functional repairs can add to appeal. Few chairs have survived unscathed; most have had adjustments to their legs over the years. Indeed, in the chair shown opposite (left), which may have lost a couple of inches, one leg has been replaced upside down. The chair is also missing a front armrest support, but such flaws, provided that they do not jeopardize the integrity or the structure, are infinitely preferable to inappropriate restoration, and are usually more than made up

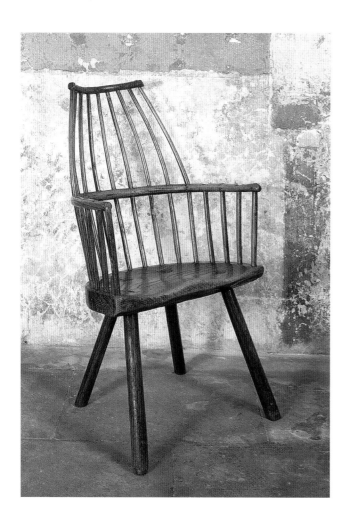

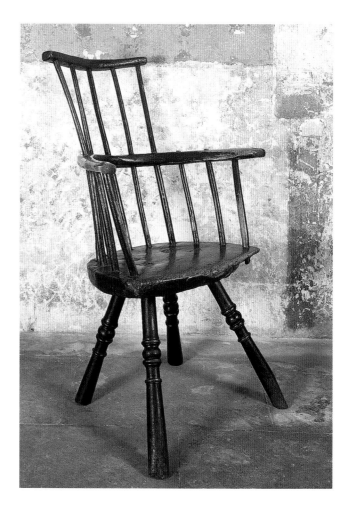

for by other qualities: here, the generous scale of the oak seat, the crest and the encompassing horse-shoe shaped arms. The same generous style is evident in the chair shown below (right), which with its stylized baluster splat, dished seat and double-domed crest rail has been strongly influenced by early 18th-century mainstream furniture.

Other chairs were an interesting combination of Windsor and frame construction, with socketed legs and frame backs, and wings to protect the occupants from draughts and add grandeur. The chair on page 155 (right) has a decidedly masculine strong seat, square legs and gun-barrel turned armrest supports, but a comparatively slight planked back, with shaped cresting, decorated on the reverse with hand-blocked wallpaper. A similar quirky juxtaposition of different elements is found in the shepherd's chair on page 159, which combines Windsor construction of the square back legs and a framed, steeply raked back with decorative wavy cresting and big bold wings. The strong sculptural form retains its original monochrome paint, now pleasingly worn from years of contact with greasy heads, muddy boots and weary arms.

Trestle tables were commonly made. Their elementary strong X-frame or T-frame construction ensured long lives, even in taverns, and their surfaces are often wonderfully worn, with rounded edges from years of scrubbing; they may be carved or scratched with graffiti in the form of initials and dates, or – most desirable – marked

BELOW LEFT *The generous scale and exceptional colour of this 18th-century English chair with its large oak seat, the ears of which are echoed in the outscrolling armrests, more than compensates for a missing armrest stick and the upside-down front right leg.*

BELOW RIGHT *With its stylized baluster splat, double-domed crest rail and dished "saddle" seat, this early 18th-century English chair is, of the four examples shown here, the closest to mainstream chair types of its period.*

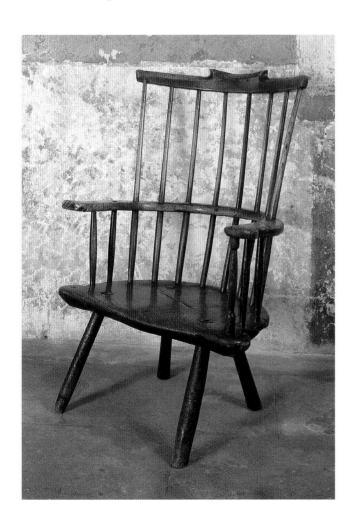

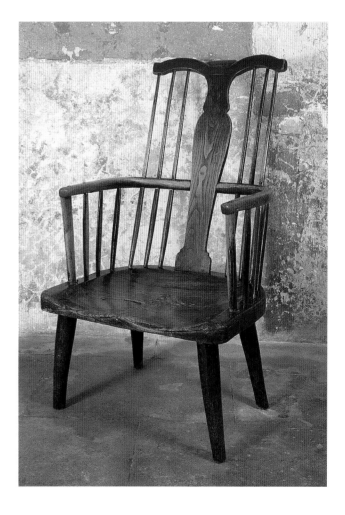

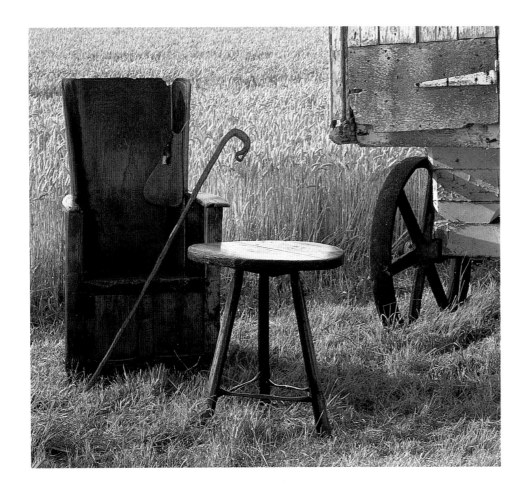

LEFT *This shepherd's hut (just seen) may have housed furniture similar to the pieces shown: a fine English ash dug-out chair (first half 18th century) with a joined and panelled cupboard; a cricket table (c.1770) with a patinated elm top, and a carved fruitwood shepherd's crook.*

OPPOSITE *This English pine shepherd's chair (c.1770), with original paint, steeply raked back and bold, well-defined wings, displays evidence of its long, hard life in the worn surface of the armrests, front panel and backrest.*

BELOW *The shape of an object or a piece of furniture was sometimes dictated by the shape of the wood – dug-out chairs were hollowed from tree trunks, hayforks were cut from three-pronged branches. The organic form of this French footstool was obviously determined by the distinctive shape of the wood from which it was fashioned.*

with board games (see pp.120–21). The tops were rarely painted, but legs were generally given protective coats of paint, and these layers of paint may have developed a highly prized leathery quality. Windsor-type cricket tables had three legs that socketed into solid plank tops, also known as pancake- or cheese tops, sometimes chamfered on the underneath and often made of elm, sycamore or oak. These tables, too, may have wonderful surface patination on the unpainted tops, while, as with trestle tables, the legs were often painted and show similar evidence of wear, sometimes combined with stretchers worn thin and smooth from contact with boots and shoes.

The lines of these quirky and individual sculptural forms have often been further enhanced by use: chair sticks have gradually moved to accommodate the shape of the sitter; arm- and footrests have been worn through constant contact; chair backs reveal exactly where the occupant rested his or her head. Original paint will have become an integral part of the fabric of the piece and reflect the same elements of wear; unpainted wood may have acquired a rich patination or have been gently worn down by repeated scrubbings. These pieces should be sensitively restored; an untouched surface and evidence of age are paramount as it is this blend of personalities – maker, user and the fabric of the piece itself – that combines to create the distinctive character of indigenous folk and country furniture.

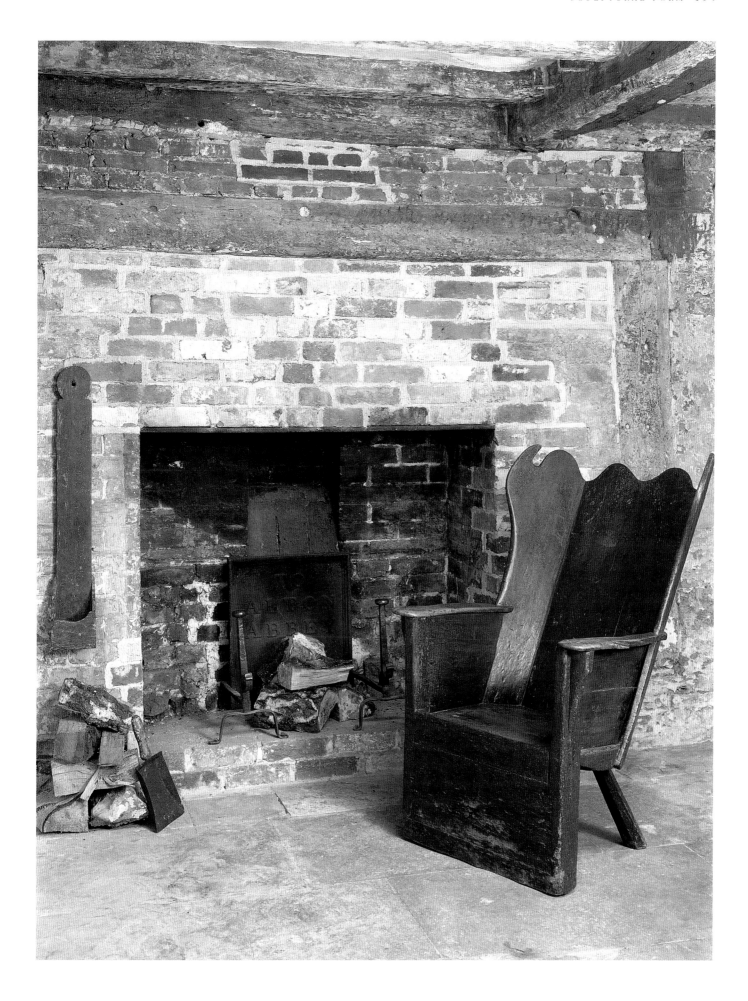

Painted decoration

Most painted decoration on furniture was not fortuitous but served a very specific function. Pine, for example, was essentially a dull, sappy wood, prone to bleeding knot holes, and paint not only protected the wood but also enhanced, and sometimes disguised, an inexpensive timber. Other woods were painted for protection, especially if they were used outside or subject to heavy wear. In general, case furniture offered less opportunity for original sculptural form, and painted decoration often became the vehicle for the maker's individuality and creativity.

This was especially the case in Scandinavia and continental Europe. Working families rarely had pictures to hang on the walls, and painted walls and furniture were the primary form of decoration. Each country and area tended to develop its own style, and Norwegian furniture in particular is famous for its tradition of *rosemaling* ("rose painting" – a reference to both the colour and the motifs) which flourished from *c*.1800.

Much case furniture was made in traditional forms that developed slowly, following some years behind mainstream styles. The formulaic structures could be offset by individual decoration, which while reflecting an established tradition still allowed room for creativity and individuality. For example, furniture was often commissioned and given as betrothal and wedding gifts, and such pieces as beds and blanket chests are decorated with the initials of the couple and appropriate dates. The Norwegian longcase clock (left), which carries both initials and dates, was probably given as a wedding present. An expensive and impressive piece, it is in many ways a piece of mainstream mid-19th-century furniture; its main appeal is in the vibrant polychrome painted decoration, with its rich red and brilliant contrasting blue, and the interesting blend of floral and geometric motifs, the latter reflecting the formal character of this rather grand clock. The Welsh oak longcase "grand-mother" clock (opposite) has a rather grand large hood, but again it is the surface that merits most attention. The clockface is surrounded by a delightful red and black chequered design, but the ultimate appeal is the original label, which over the years has become worn and patinated and now forms an integral part of the surface.

ABOVE *Large thermometers were fairly common in France, but much rarer in Britain. This English example (c.1800; 102cm/40in) consists of a professionally made glass spiral set in a signwritten provincial case and marked "Joseph Franks, 44 Market Street, Manchester."*

LEFT *The presence of initials and a date (1849), in addition to fine* rosemaling *in bright red offset by blue, suggests this fine pine longcase clock from Hallingdal was commissioned as a wedding present. The large finials, turned balusters and slightly oversize hood all add to its air of grandeur.*

RIGHT *The wonderful surface of this late 18th-century oak longcase Welsh "grandmother" clock is made even finer by the hand-painted decoration around the clockface, the painted stars and, above all, the presence of the delightfully worn and patinated original label (just above the upper star), on which the following fragment of verse can still be deciphered: "I labour here with all my might/To tell the time at day and night."*

LEFT *The pleasing form of this early 19th-century English pine seed-chest is considerably enhanced by the superb, original, untouched, dry and worn blue painted surface.*

OPPOSITE *The dry, worn original surface, which was revealed by dry-scraping back later layers of paint, enhances this enclosed glazed English dresser (second half 18th century).*

BELOW *Although this type of English mirror was common in the early 19th century, it is now greatly appreciated for the leathery dry texture that its original black-painted frame has acquired over the years, juxtaposed with the bright, reverse-painted glass panel.*

This combination of mainstream and folk-art elements works especially well in the thermometer on page 160, which imitates the formal barometers with engraved copperplate details. Here the professionally made glass spiral, complete with its original alcohol, has been set in an individual provincial case, probably painted by a signwriter, who has used both Fahrenheit and Celsius scales but added his own interpretations – fever heat, summer heat, temperate, freezing.

The monochrome colour found on English furniture can be just as appealing as a polychrome motif. Blue, originally a difficult and expensive pigment, remains a perennial favourite with collectors. The seed-chest (above) has a good interesting form, but the plain pine carcass has been transformed by a particularly glorious blue painted surface, untouched and in original dry condition, with authentic wear to the drawers. The enclosed glazed dresser (opposite), with its satisfying proportions and fine architectural details, shows similar evidence of wear on an equally dry original blue surface.

Surface integrity is paramount, whether dry and raw or with an extraordinary texture, as on the surround of the mirror (right). Mirrors with reverse-painted panels

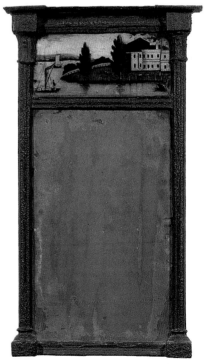

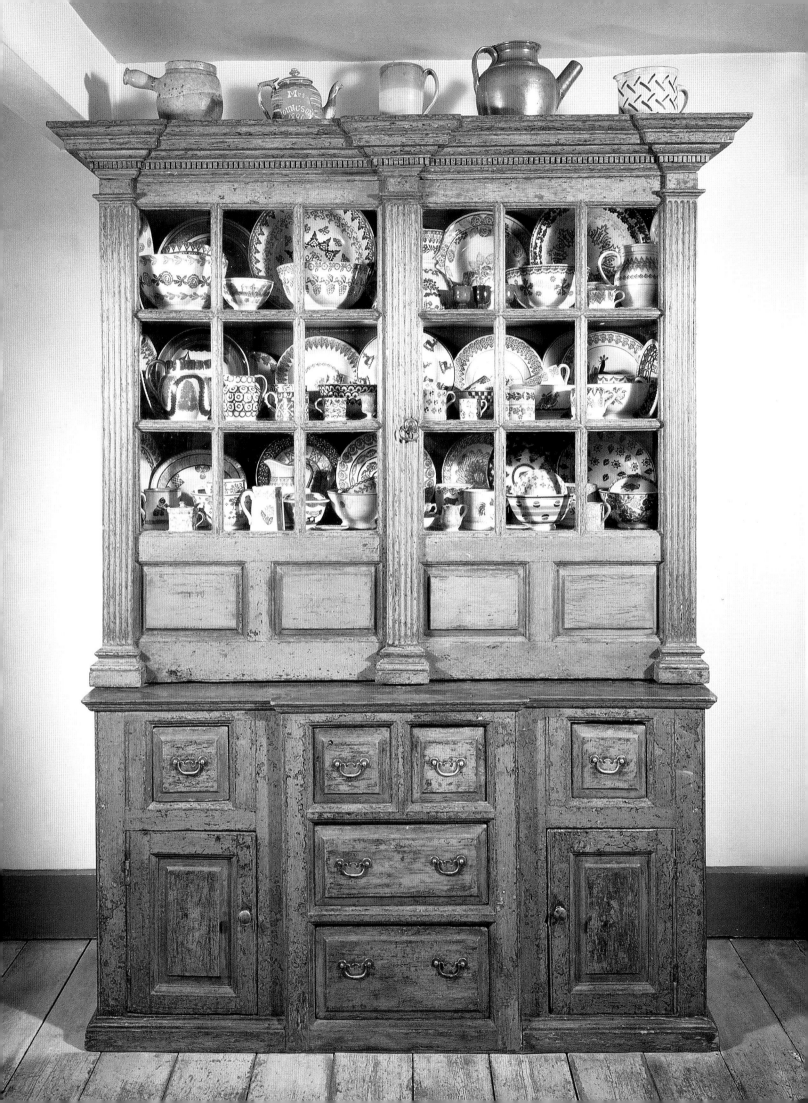

were common by the late 18th century, but were usually more formal than this example, with its colourful hand-painted glass panel. What makes this mirror remarkable is the frame. The original black-painted wood has, over the years, acquired a wonderful texture – like elephant or crocodile skin – with no hint of shininess or "treacle".

Not all painted decoration was the work of professionals. The appeal of some decorated pieces is precisely the spirit of amateur improvisation, that combination of careful but unskilled painted decoration seen in the table shown below. This tripod table, made by a professional furniture-maker, has been embellished by an enthusiastic amateur. The naive symmetrical design has been carefully planned and worked, if clumsily painted, and the bright colour scheme continued on the now delightfully worn feet. Such pieces are now appreciated not for their "art" but for the spirit of improvisation they embody and the courage and vitality of their unselfconscious execution.

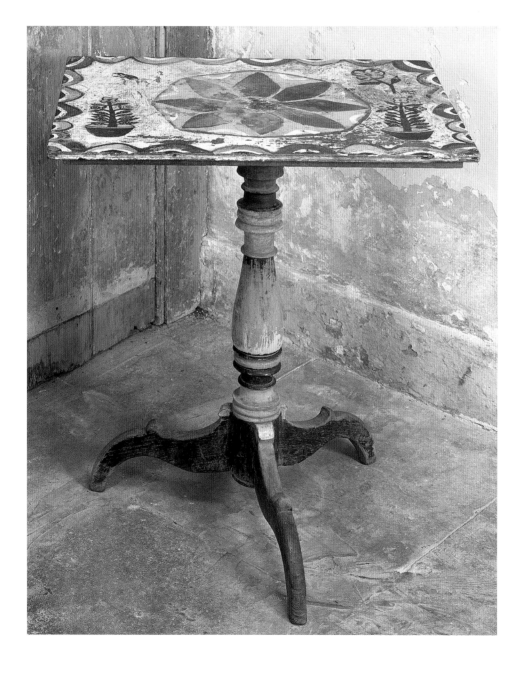

LEFT *Although professionally made – probably in eastern Europe in the mid-19th century – this tripod table has been decorated by an amateur hand in a carefully – if inexpertly – applied design, which is now appreciated for its unselfconscious naive quality.*

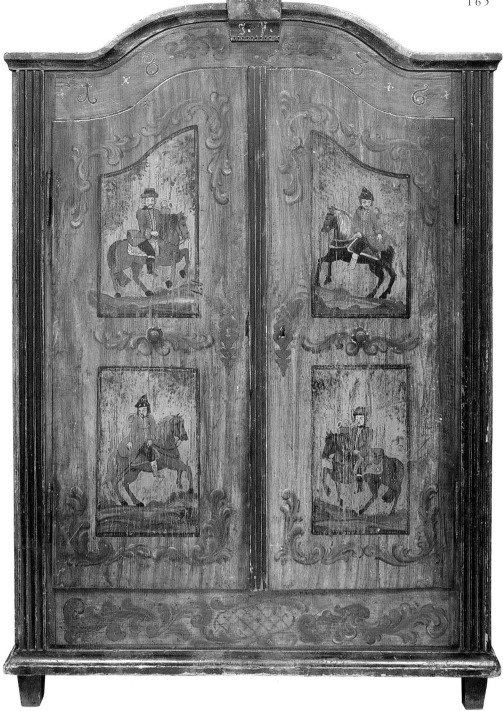

However, most painted decoration was the work of professionals, many of them itinerant painters, working within an established tradition. Such a painter decorated the German armoire (above), a competent if undistinguished piece of softwood case furniture, painted to make it more attractive. The panels are the work of someone whose stock in trade was depictions of men on horseback; what makes this armoire so appealing is the combination of these charming motifs and a surface that, from a folk art perspective, is perfect. The softwood carcass has shrunk, "popping" areas of paint as it contracted; the wonderful slightly faded decoration is a fine example of an untouched authentic paint-decorated surface, and has lost none of its definition and visual appeal.

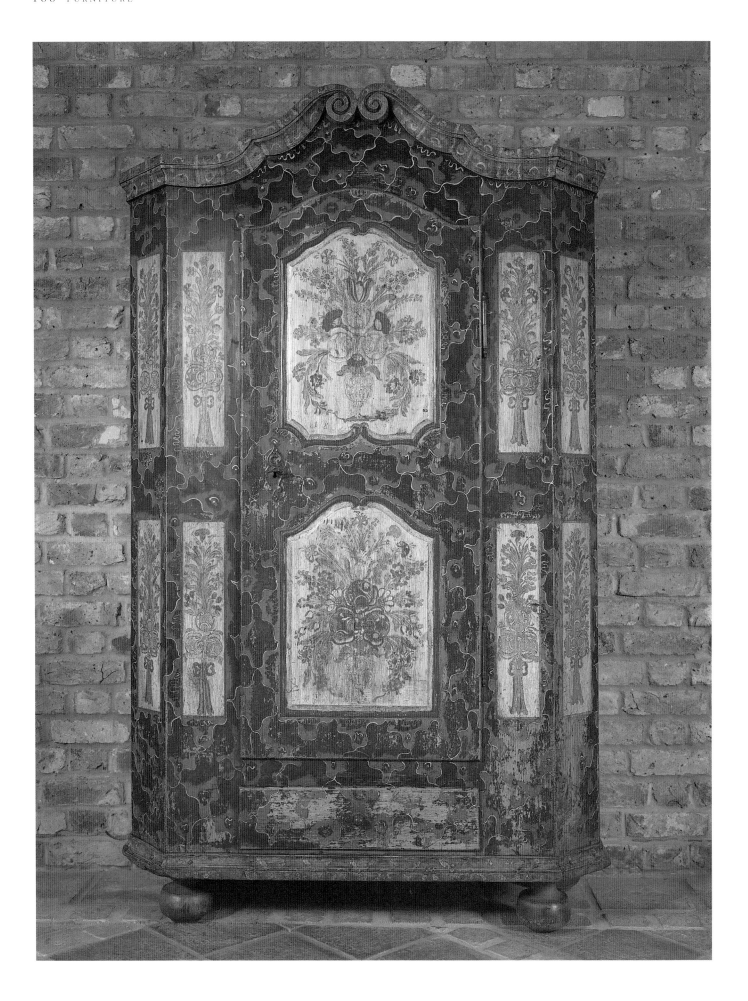

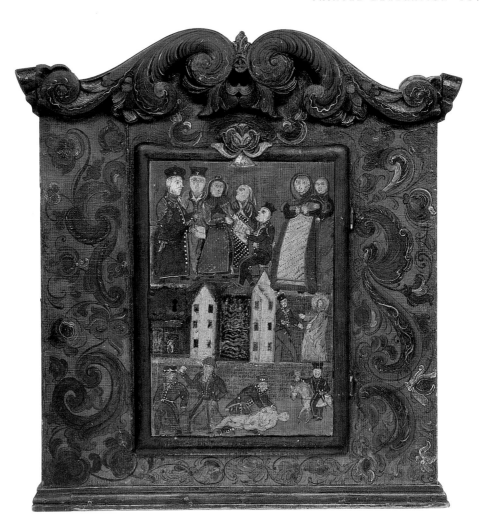

The "jigsaw"-style pattern shown on the cupboard (opposite) was also the work of itinerant craftsmen. Mainly associated with eastern Germany, Austria and the current Czech Republic and Slovakia, the style was used between c.1780 and c.1880, largely on cupboards and blanket or marriage chests. The quality varied, with different colours and designs to suit different budgets. More expensive examples had decorated sides and more elaborately painted panels and applied mouldings. They were designed to be portable, and the doors lifted off so that the cupboards could be transported on carts as the families moved up to summer pastures in the mountains.

One of the distinctive qualities of much folk art is its lack of precedent, even when the work is within an established tradition. The Norwegian mural cupboard (above) was designed to store such precious items as expensive herbs and food. The pine carcass is carved and painted in a traditional style, but the decoration on the door is virtually unprecedented. It probably depicts a folklore scene, and the originality and charm of the mysterious figures are rich additions to an already superbly decorated piece.

The chair on page 169 is also unusual. The birchwood frame, housing a leather-covered seat, is carved with a rare combination of motifs, including a heart on the seat rail, that suggests it may have been commissioned as a love token. In spite of its somewhat clumsy form, this chair has great appeal because of its surface. The original paint

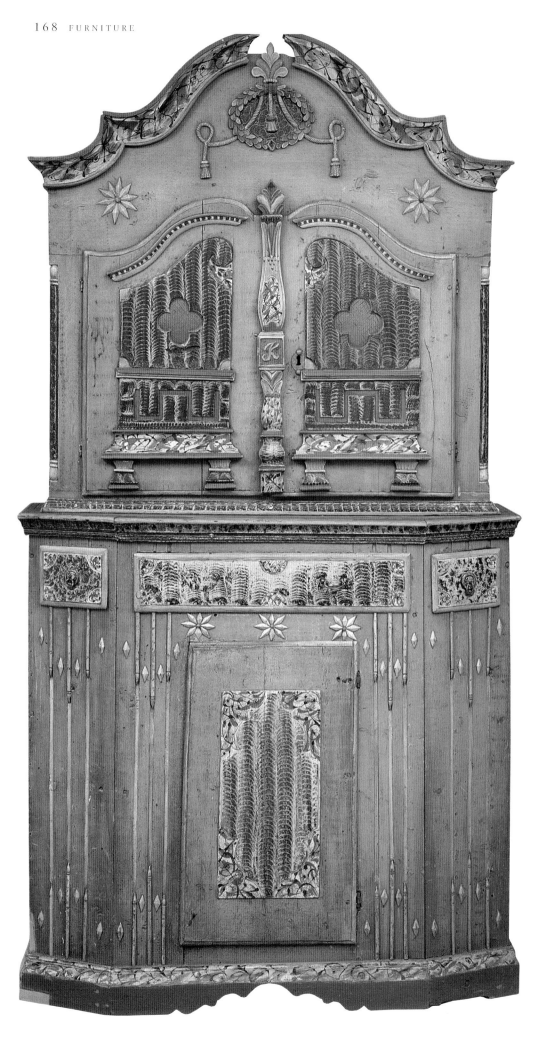

This formal Norwegian pine cupboard was made as an important commission in Numedal c.1780. No expense has been spared: the impressive form has been further enhanced by carved and applied motifs; the colours are bright, with plentiful use of high-quality, expensive red pigment, stylized marbling on the frieze and drawers, and a superbly painted cornice.

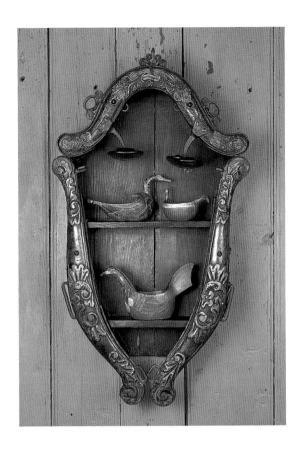

LEFT *This Norwegian hames cupboard, shown with carved, painted drinking vessels, was made from recycled carved birch horses' hames which retain much of their original paint, especially in the protected recessed areas.*

BELOW *This leather-seated birchwood chair (c.1820) from northern Norway combines unusual carved motifs with superb honey-coloured patination and fine original paint, now worn in places to a mere tint.*

has faded in places to a tint, especially in areas that are usually worn, such as the armrests, which now have a wonderful honey patination. As is often the case, the incised carved detail, protected from excessive wear and exposure, has retained the original superb paint, as it has also on the hames cupboard (above). Wooden horses' hames were carved, then painted, and had wrought-iron fittings applied; they were sometimes recycled as mirror frames or, as here, frames for wall cupboards.

In 18th-century Norway itinerant craftsmen produced both furniture for working families and important commissions such as the cupboard shown opposite. While it obviously owes a debt to formal mainstream elements – an impressive domed cornice, a decorative plinth, carved and applied moulding – the carcass is pine and the painted decoration is typically Norwegian.

With all painted decoration, a genuine untouched surface is of paramount importance. Flaking, faded, worn or "popped" paint and shrunken wood are all evidence of ageing and are greatly preferable to attempts at restoration or excessive use of wax or varnish. Where a piece has been redecorated for functional purposes – perhaps to include new initials and dates – this is an integral part of its history, as is a dry, worn surface or a "crocodile-skin" patina – all signs of the life and character of a piece that help tell us who made it, who used it and what has happened to it over the years.

Care and conservation

Most folk art is robust. Care is largely common sense; these objects were made and used in damp, ill-lit houses and will not adapt well to excessive dry heat or direct sunlight; they need a reasonable level of humidity, which can usually be maintained simply by keeping pot plants or vases of flowers in the same room.

Conservation is a more sensitive area. The aim is to preserve the object in the condition in which it was found; or, simply put, what doesn't come off with a moist sponge, a soft dry brush or a duster stays. A piece of folk art is often appreciated for what it has become over time – for the surface it has acquired rather than the one it had when new. A dry leather surface, for example, should be lightly fed with leather cream to protect it and prevent further deterioration; a pair of hunting boots should be treated with boot polish to retain the lustrous, shiny surface. Metalwork may be lightly waxed to reduce further oxidization.

There are exceptions to this rule. With furniture, a working repaint, such as a protective coat on the legs of a table, can be acceptable, but a recent repaint with modern oil-based paints is not. Later paint can be professionally removed, using the time-consuming process of dry-scraping, to reveal the original painted surface. Wooden furniture should never be stained or coloured, nor French-

ABOVE *The original painted wooden surface of this clockface should not be touched: the faded colours should be left, as should the craquelure and the shrinkage in the planks. However, it should be kept indoors, in sufficiently humid conditions, to prevent further deterioration.*

ABOVE *The heat and solder needed to replace the missing tail piece on this gilded copper lion would damage the wonderful verdigris surface. The old secondary gilding should be left as it is, although loose leaf-gilding can be "settled back" by a professional. It should be kept indoors.*

ABOVE *This oil-on-board painting has been lightly cleaned but retains patches of brown varnish. It could be further cleaned to reveal the brightness of the original colour, but a sensitive compromise has been achieved here between revealing the image and allowing the ageing process to show.*

polished. Old paint should be left *in situ*. Most furniture should be waxed only two or three times a year with beeswax, left for several hours, then buffed.

Damage is another sensitive area; working repairs can be very attractive (right), but repairs that would jeopardize the integrity of the surface (opposite, centre) or form (right) should be avoided.

The major exceptions to the "keep it as you find it" rule are textiles and paintings, where the ageing process may damage rather than enhance the piece. All textile conservation should be carried out by a professional, although samplers or needlework may be removed from their frames for dusting, or to be stretched to keep the ground taut. There are two schools of thought on conserving paintings. A weathered outdoor sign should be kept as it is, complete with craquelure, but brought indoors. Today, many oil paintings are professionally cleaned to reveal the original colours; the opposing view is that dust and grime are part of the organic process of ageing, but where this has obscured the image there is room for debate as to whether this surface reflects use or abuse. Frames should be kept as found, without regilding or repainting.

Folk-art conservation is about retaining the integrity of the current surface, rather than restoring it to any former glory or disguising the effects of age. There is no right or wrong, only the surface as it is now and a desire to maintain and protect it, be it raw and dry, richly patinated, rusted and flaking, or worn smooth.

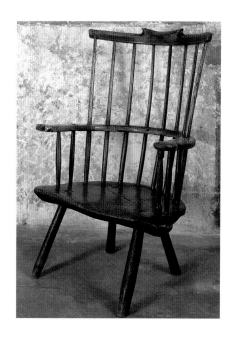

ABOVE *The missing turned armrest support and the upside-down front right leg on this Windsor chair are part of its history and character and are best left as seen.*

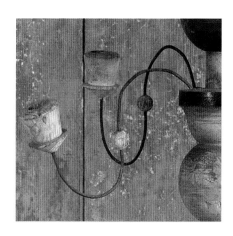

ABOVE *Light waxing can preserve the surface of metal, such as the wire arm here (although wax can produce an artificial shine). The gessoed sconces should not be resilvered, but a light coat of wax will protect them from changes in temperature and humidity and from further disintegration.*

ABOVE *All textiles should be protected from direct sunlight. Loose threads may be professionally tucked back in, and the ground should be kept taut, being restretched if necessary, and replaced in the original frame. Some slight staining is acceptable; heavy staining needs professional treatment.*

ABOVE *Leather does not thrive in excessive heat or direct sunlight. The leather surface should be kept as found – dry or lustrous – but any silver elements may be polished. The inside of a leather tankard should never be waxed, although a dry surface may be lightly treated with leather cream.*

Where to visit

There are few museums devoted to European folk art but many small provincial museums include pieces of interest to collectors. The following list may prove a useful starting point:

Britain
Bethnal Green Museum of
 Childhood
Cambridge Heath Road
London
E2 9PA

Birmingham Museum and
 Art Gallery
Chamberlain Square
Birmingham
West Midlands
B3 3DH
(extensive collection of treen)

Edinburgh City Museums
 and Art Galleries
City Art Centre
2 Market Street
Edinburgh
EH1 1DE

Gloucester Folk Museum
99–103 Westgate Street
Gloucester
Gloucestershire
GL1 2PG

Museum of English
 Rural Life
University of Reading
Rural History Centre
Whiteknights
PO Box 229
Reading
Berkshire
RG6 6AG

Welsh Folk Museum
St Fagans
Cardiff
South Glamorgan
CF5 6XB

France
Musée National des Arts et
 Traditions Populaires
6 ave du Mahatma Gandhi
75116 Paris

Germany
Loschnermuseum
Bahnhofstrasse 20
09544 Neuhausen

Ireland
National Museum of
 Ireland
Kildare Street
Dublin 2

Norway
Norsk Folkemuseum
Bygdøy
Museumsv. 10
0287 Oslo

Sweden
Nordiska Museet
Djurgårdsvägen 6–16
Box 27820
S–11593 Stockholm

Where to buy

New collectors are advised to buy from established auction houses, reputable dealers (such as members of the antiques associations LAPADA and BADA) and vetted fairs such as trade fairs.

Britain
Combe Cottage Antiques
Castle Combe
Wiltshire
SN14 7HU

A. & E. Foster
'Little Heysham'
Naphill
Bucks
HP14 4SU

Gene and Sally Foster
Pennard House Antiques
London Road
Bath
Somerset
BA1 6PL

Malcolm Frazer Antiques
19 Brooklyn Crescent
Cheadle
Cheshire
SK8 1BX

Bernard Gulley Antiques
Lancotbury Manor
Bedfordshire
LU6 1RG
(by appointment only)

Erna Hiscock and John
 Shepherd
Chelsea Gallery
69 Portobello Road
London
W11 2QB

Iona Antiques
PO Box 285
London
W8 6HZ

Bill and Angela Page
11 Little Mount Zion
Tunbridge Wells
Kent
TN1 1YS

Alistair Sampson
120 Mount Street
London
W1Y 5HB

M. & D. Seligman
37 Kensington Church Street
London
W8 4LL

Spencer Swaffer
30 High Street
Arundel
West Sussex
BN18 9AB

Robert Young Antiques
68 Battersea Bridge Road
London
SW11 3AG

France
Huguette Bertrand
22 rue Jacob
75006 Paris

Michel R. Morin
Allée 1, Stand 20
Marché Paul Bert
93400 Saint Ouen

Potron Minet
S. & C. Borraz
Allée 3, Stand 159
Marché Paul Bert
93400 Saint Ouen

Yveline
4 rue de Furstemberg
75006 Paris

Norway
Bjorn Seim
Industrigt 63
0357 Oslo

Bibliography

GENERAL

Ayres, J. *British Folk Art*. London, 1977
Carrington, N. *Popular Art in Britain*. London, 1945
Cooper, E. *People's Art: Working-class Art from 1750 to the Present Day*. Edinburgh, 1994
Hansen, H.J. *European Folk Art*. London, 1970
Jones, B. *The Unsophisticated Arts*. London, 1951
Lambert, M. and Marx, E. *English Popular Arts*. London, 1951
Stewart, J.S. *The Folk Arts of Norway*. New York, 1972

SPECIALIST

Wood carving

Levi, J. in consultation with Young, R. *Treen for the Table: Wooden Objects Relating to Eating and Drinking*. Woodbridge, 1998
Pinto, E.H. *Treen and other Wooden Bygones*. London, 1969
Rossini, G. *Appelants de France du Midi et d'Ailleurs*. Marguerittes, 1994
Stammers, M.K. *Ships' Figureheads*. Princes Risborough, 1983
Weedon, G. and Ward, R. *Fairground Art: The Art of Travelling Fairs, Carousels and Carnival Midways*. London, 1981

Metalwork

Caspall, J. *Making Fire and Light in the Home pre-1820*. Woodbridge, 1987
Glemas, P. *Les Outils de la Campagne*. Paris, 1998
Smith, R.G. *English Domestic Metalwork to 1936*. Leigh-on-Sea, 1973
Mockridge, P. and P. *Weathervanes of Great Britain*. London, 1990
Mouret, J.-N. *Les Objets de nos Campagnes*. Paris, 1994

Marine Art

Banks, S. *The Handicrafts of the Sailor*. Newton Abbot, 1974
Hansen, H. (ed.) *Art of the Seafarer*. London, 1978
Ritchie, C. *Scrimshaw*. London, 1972

Paintings

Ayres, J. *English Naive Paintings 1750–1900*. London, 1980
Larwood, J. and Hotten, J.C. *The History of Signboards*. London, 1866
Moncrieff, E., Joseph, S. and Joseph, I. *Farm Animal Portraits*. Woodbridge, 1996

Pottery

Brears, P.C.D. *English Country Pottery, its History and Techniques*. Newton Abbot, 1971
Jugs, Jars and Jolly-Boys: Tradition in English Pottery. Manchester, 1983, exhibition catalogue
Tyler, S. *Buckley Pottery: The Craft and History of the Buckley Potters from the 1300s to the 1940s*. Llandudno, 1983

Textiles

Humphrey, C. *Samplers*. Cambridge, 1997
Jones, J. *Welsh Quilts*. Carmarthen, 1997
Nichols, M. *Smocks in Luton Museum*. Luton, 1980
Stevens, C. *Quilts*. Llandysul, 1993

Furniture

Davies, A. *Welsh Regional Furniture*. RFS Occasional Publication, 1985
Chinnery, V. *Oak Furniture: The British Tradition*. Woodbridge, 1979
Crispin, T. *The English Windsor Chair*. Stroud, 1992
Csillery, K.K. *Hungarian Village Furniture*. Budapest, 1972
Denoke, B. *Bauernmöbel*. Munich, 1979
Erixon, S. *Möbler Och Meminredning I Svenska Bygder*. Stockholm, 1926
Gilbert, C.G. *Common Furniture*. Leeds, 1972
Loughnan, N. *Irish Country Furniture*. Dublin, 1984
Reynies, N. de *Le Mobilier Domestique Vocabulair Typologique, I*. Paris, 1987
Tardieu-Dumont, S. *Le Mobilier Régional Français Normandie*. Paris, 1980

Index

Acknowledgments

Author acknowledgments

I most particularly owe a huge debt of gratitude to Frankie Leibe, who patiently and painstakingly wrestled and cajoled ideas, memories, beliefs and information from me, ordered and made sense of them, and then transformed them as if by magic into text for this book. Many thanks are also due to Nick Kane for his tireless and dedicated professionalism, his sensitivity to the subject and his easy co-operation with my vision; to Anthea Snow for her guidance, patience and support, and for her wonderful capacity for getting things done (and for introducing me to 'flattie'); to Viv 'art direction' Brar for her gracious acceptance of my input when styling the photographs and for putting them together with such flair; to Alison Starling for her initiative and determination in commissioning the title; to Jon Lewis for his invaluable assistance with the photography.

In a wider sense I owe so much to Frank Berendt and Derek Shrub for the passport they gave me to the world of looking; to Angela and Bill Page for the enthusiasm their collection fuelled in me as a young dealer; to Tom (Ronnie) Regbo for twenty years of warm friendship and close association with all things Norwegian; to my friend Ted Few for sharing much of the journey; to Angelo and Jackie Economou for being there; and to Josyane for her courage, her sensitivity and her eye – my inspiration.

Grateful thanks must be given to all those people who so kindly and generously shared their homes and collections, enabling us to create this book: Erik Anker; Adrian and Brenda Bishop; Stéphan and Carole Borraz; Tony and Elinor Foster; Brian Green at the Hastings Fishermen's Museum; Arne Gurholt; Erna Hiscock and John Shepherd; Stephen and Iona Joseph; Nick and Sanja Kane; Arne Maynard and William Collinson; Huguette and Jean-Pierre Moreillon; Michel Morin; Clive Ringer; Ian and Penny Skipper; Mark and Louise Stephen; Anne Thomas at Yveline; Dick and Lisa Whittington.

To all the kind and enthusiastic collectors, dealers, museums and auctioneers who lent us items for inclusion, my sincere thanks: Keith Banham; Sally de Beaumont; Christopher Bibby; Angelo and Jackie Economou; Anissa I. El-Helou; Bill and Sako Fisher; Gene and Sally Foster; Malcolm Frazer; Kaare Herskedal; David Levi; Bryan and Sue Mayou; Angela and Bill Page; Bjorn Seim; Hans Johan Storesund; Spencer Swaffer; Mrs S. Thomson.

And finally, many thanks for the wonderful support, help and loyalty offered by John Payne, Gordon Maxwell, Jackie Taylor, Sarah Llewellyn, Esmé Terry, Sharon Frazer and Louise Pont; and for the valuable contribution of Thomas Regbo during the photographic shoot in Oslo.

Picture acknowledgments

Key: **t** top; **b** bottom; **l** left; **r** right; **c** centre; **ACC** A. C. Cooper Photography; **BAP** Bill & Angela Page, Tunbridge Wells; **CAGM** Cheltenham Art Gallery & Museums, Gloucestershire; **EH&JS** Erna Hiscock and John Shepherd, Portobello Road, London; **GSF** Collection of Gene and Sally Foster; **IAL** Iona Antiques, London; **MFA** Malcolm Frazer Antiques, Cheadle; **MRM** Michel R. Morin Collection; **NK** Nicholas Kane; **PC** Private collection; **PCs** Private collections; **RYA** Robert Young Antiques, **SS** Spencer Swaffer, Arundel, England.

Front cover OPG/NK/RYA/PC/GSF; **back cover** RYA/ACC; **spine** OPG/NK/RYA; **back flap** OPG/Jon Lewis; **endpapers** OPG/NK/RYA/Clive Ringer; **1** OPG/NK/GSF; **2** OPG/NK/RYA/PC; **5** OPG/NK/A. & E. Foster; **6l** OPG/NK/RYA; **6r** OPG/NK/RYA; **7** OPG/NK/PC; **8** OPG/NK/Huguette Bertrand, Paris; **9** OPG/NK/A. & E. Foster; **10t** OPG/NK/PC/Kaare Herskedal/Bjorn Seim; **10b** OPG/NK/PC; **11t** OPG/NK/PC; **11b** OPG/NK/PCs; **12t** OPG/NK/EH&JS; **12b** OPG/NK/EH&JS; **13t** OPG/NK/A. & E. Foster; **13b** OPG/NK/SS; **14** OPG/NK/PCs/Bjorn Seim; **15t** OPG/NK/PC; **15b** OPG/NK/PCs; **16t** OPG/NK/PC; **16b** OPG/NK/RYA; **17** OPG/NK/El-Helou Collection; **18t** OPG/NK/Huguette Bertrand, Paris; **18b** OPG/NK/PC; **19** OPG/NK/RYA; **20** OPG/NK/PC; **21t** OPG/NK/PC; **21b** OPG/NK/PC/Kaare Herskedal/Bjorn Seim; **22** OPG/NK/PC; **23t** OPG/NK/RYA; **23b** OPG/NK/A. & E. Foster; **24t** OPG/NK/MRM; **24b** OPG/NK/PC; **25** OPG/NK/PC; **26** OPG/NK/PC; **27t** RYA/ACC; **27b** OPG/NK/PC; **28** OPG/NK/PC; **29** OPG/NK/PC; **30** OPG/NK/El-Helou Collection; **31** OPG/NK/MFA; **32** OPG/NK/PCs/Kaare Herskedal; **33** OPG/NK/PC/Kaare Herskedal/Bjorn Seim; **34t** OPG/NK/RYA; **34b** OPG/NK/A.& E. Foster; **35t** OPG/NK/MRM; **35b** OPG/NK/Combe Cottage Antiques; **36t** OPG/NK/A. & E. Foster; **36b** OPG/NK/RYA; **37** OPG/NK/RYA; **38t** OPG/NK/SS; **38b** OPG/NK/PC; **39** OPG/NK/PC; **40** OPG/NK/GSF; **41t** OPG/NK/PC; **41b** OPG/NK/PC; **42** OPG/NK/RYA; **43** OPG/NK/RYA; **44t** OPG/NK/PC; **44b** OPG/NK/RYA; **45** OPG/NK/Huguette Bertrand, Paris/Yveline; **46** OPG/NK/PC; **47t** OPG/NK/GSF/RYA; **47b** OPG/NK/RYA; **48t** OPG/NK/PC; **48b** OPG/NK/PC; **49** OPG/NK/BAP; **50t** OPG/NK/MRM; **50b** OPG/NK/MRM; **51** OPG/NK/PC; **52** OPG/NK/RYA; **53** OPG/NK/PC; **54** OPG/NK/PC; **55t** RYA/ACC; **55b** Sotheby's Picture Library; **56** OPG/NK/PC; **57t** OPG/NK/PC; **57b** RYA/ACC; **58** OPG/NK/EH&JS; **59** OPG/NK/PC; **60l** OPG/NK/RYA; **60r** OPG/NK/PC; **61** OPG/NK/PC; **62t** National Maritime Museum; **62b** OPG/NK/MFA; **63** OPG/NK/MFA; **64t** Scheepvaartmuseum; **64b** Scheepvaartmuseum; **65** OPG/NK/RYA/Fishermen's Museum, Hastings; **66** Christie's Images; **67t** OPG/NK/MRM; **67b** RYA/ACC; **68** OPG/NK/Huguette Bertrand, Paris; **69** OPG/NK/Yveline/Huguette Bertrand, Paris; **70l** OPG/NK/PC; **70r** OPG/NK/El-Helou Collection; **71** OPG/NK/MFA; **72** OPG/NK/RYA; **73** OPG/NK/MFA; **74** OPG/NK/PC; **75** OPG/NK/PC; **76t** OPG/NK/PC; **76b** OPG/NK/PC; **77** OPG/NK/PC; **78t** OPG/NK/MRM; **78b** OPG/NK/PC; **79** OPG/NK/PCs; **80** OPG/NK/PC; **81t** OPG/NK/PC; **81b** OPG/NK/MRM; **82** RYA/ACC/PC; **83** OPG/NK/PC; **84t** RYA/ACC; **84b** OPG/NK/PC; **85** OPG/NK/PC; **86** IAL; **87t** PC; **87b** RYA/ACC; **88t** IAL; **88b** OPG/NK/IAL; **89** OPG/NK/IAL; **90** IAL; **91t** IAL; **91b** IAL; **92t** OPG/NK/IAL; **92b** RYA/ACC/PC; **93** OPG/NK/PC; **94t** OPG/NK/PC; **94b** RYA/ACC; **95** IAL; **96t** RYA/ACC; **96b** RYA/ACC; **97** IAL; **98t** OPG/NK/MFA; **98b** Sotheby's London; **99** OPG/NK/PC; **100** PC; **101t** OPG/NK/SS; **101b** Dreweatt Neate Auctioneers; **102** OPG/NK/EH&JS; **103l** OPG/NK/BAP; **103r** OPG/NK/BAP; **104** OPG/NK/PC; **105tl** OPG/NK/PC; **105tr** OPG/NK/PC; **105b** OPG/NK/Yveline; **106t** OPG/NK/PC; **106b** OPG/NK/PC; **107t** OPG/NK/PC; **107b** OPG/NK/PC; **108** OPG/NK/SS; **109** OPG/NK/RYA; **110** OPG/NK/PC; **111t** OPG/NK/PC; **111b** OPG/NK/RYA/BAP/Combe Cottage Antiques; **112t** OPG/NK/EH&JS; **112b** OPG/NK/PC; **113** OPG/NK/BAP/GSF; **114t** OPG/NK/SS; **114b** Norsk Folkemuseum; **115** OPG/NK/RYA; **116t** RYA/ACC/PC; **116b** RYA/ACC; **117** RYA/ACC; **118t** OPG/NK/PC/Kaare Herskedal/Bjorn Seim; **118b** Christie's South Kensington; **119** OPG/NK/PCs/Kaare Herskedal; **120t** OPG/NK/PC; **120b** OPG/NK/A. & E. Foster; **121l** OPG/NK/PC; **121r** OPG/NK/PC; **122** OPG/NK/PC; **123** OPG/NK/RYA; **124** OPG/NK/RYA; **125** OPG/NK/MRM; **126t** OPG/NK/RYA; **126b** OPG/NK/Huguette Bertrand, Paris; **127** OPG/NK/MRM; **128** OPG/NK/RYA; **129t** OPG/NK/RYA; **129b** OPG/NK/RYA; **130t** OPG/NK/PC; **130b** OPG/NK/PC/Bjorn Seim; **131** OPG/NK/EH&JS; **132t** OPG/NK/RYA; **132b** OPG/NK/RYA; **133** OPG/NK/RYA; **134** Sotheby's London; **135** OPG/NK/EH&JS; **136** OPG/NK/EH&JS; **137t** OPG/NK/EH&JS; **137b** OPG/NK/EH&JS; **138** OPG/NK/Yveline; **139** Sotheby's London; **140t** OPG/NK/EH&JS; **140b** OPG/NK/EH&JS; **141** OPG/NK/PC; **142** OPG/NK/EH&JS; **143t** OPG/NK/EH&JS; **143bl** OPG/NK/EH&JS; **143br** OPG/NK/EH&JS; **144t** Bridgeman Art Library/CAGM; **144b** OPG/NK/PC; **145** OPG/NK/PC; **146** OPG/NK/PCs; **147** OPG/NK/PCs; **148** OPG/NK/Potron Minet, C.S. Borraz, Paris; **149** OPG/NK/RYA/Clive Ringer; **150t** OPG/NK/EH&JS; **150b** OPG/NK/EH&JS; **151** OPG/NK/EH&JS; **152** RYA/ACC/PC; **153** OPG/NK/PC; **154l** OPG/ACC/PC; **154r** RYA/ACC; **155** OPG/NK/A. & E. Foster; **156l** OPG/NK/RYA; **156r** OPG/NK/PC; **157l** OPG/NK/RYA; **157r** OPG/NK/RYA; **158t** OPG/NK/RYA; **158b** OPG/NK/MRM; **159** OPG/NK/PC; **160l** OPG/NK/PC; **160r** OPG/NK/PC; **161** OPG/NK/RYA; **162t** OPG/NK/BAP; **162b** OPG/NK/RYA; **163** OPG/NK/RYA; **164** OPG/NK/SS; **165t** OPG/NK/RYA; **165b** OPG/NK/RYA; **166** RYA; **167** OPG/NK/PC; **168** OPG/NK/PC; **169t** OPG/NK/PC; **169b** OPG/NK/PC; **170l** OPG/NK/PC; **170c** Sotheby's Picture Library; **170r** OPG/NK/PC; **171t** OPG/NK/RYA; **171bl** OPG/NK/PC; **171bc** OPG/NK/EH&JS; **171br** OPG/NK/EH&JS.